The Rough Guide to The Hitchhiker's Guide to the Galaxy

ROUGH
GUIDES

www.roughguides.com

Credits

**The Rough Guide to
The Hitchhiker's Guide to the Galaxy**

Editor: Ruth Tidball
Design, picture research and layout: Peter Buckley
Proofreading: Amanda Jones
Production: Rebecca Short

Rough Guides Reference

Director: Andrew Lockett
Editors: Kate Berens, Peter Buckley,
Tracy Hopkins, Matthew Milton,
Joe Staines, Ruth Tidball

Publishing information

This first edition published October 2009 by
Rough Guides Ltd, 80 Strand, London, WC2R 0RL
Email: mail@roughguides.com

Distributed by the Penguin Group:
Penguin Books Ltd, 80 Strand, London, WC2R 0RL
Penguin Group (USA), 375 Hudson Street, NY 10014, USA
Penguin Group (Australia), 250 Camberwell Road, Camberwell, Victoria 3124, Australia
Penguin Group (Canada), 90 Eglinton Avenue East, Suite 700, Toronto, Ontario, Canada M4P 2Y3
Penguin Group (New Zealand), Cnr Rosedale and Airborne Roads, Albany, Auckland, New Zealand

Printed and bound in Singapore by SNP Security Printing PTE

Typeset in Futura, Minion and Helvetica to an original design by Peter Buckley

Front cover image Corbis

272 pages; includes index

A catalogue record for this book is available from the British Library.

ISBN 13: 978-1-84836-242-0

1 3 5 7 9 8 6 4 2

Contents

Introduction

Don't Crash, the documentary about the *Hitchhiker's* movie, bears the tongue-in-cheek subheading "The Documentary of the Making of The Film of The Book of The Radio Series of The Hitchhiker's Guide to The Galaxy". *The Rough Guide to The Hitchhiker's Guide to the Galaxy* is not quite as ridiculous a title, but it might still sound uncomfortably like pop culture eating itself. ("A guide to the Guide?", would ask the hypothetical dinner party hostess, just before her undergarments leapt one foot to the left in accordance with the Theory of Indeterminacy. "Darling, how very postmodern.")

Yet over thirty years since Douglas Adams's original radio series was broadcast, the *Hitchhiker's* universe continues to absorb and amuse on a tremendous scale: around 16 million novels have been sold alone. More remarkably, the best part of a decade after Adams's tragically early death, the canon is still expanding. Three further "Phases" of the radio series have appeared since 2004, while a film version finally arrived in 2005. Four years later, a sixth *Hitchhiker's* novel, by bestselling children's author Eoin Colfer, is about to be published as we go to press.

For a certain generation, that novel, entitled *And Another Thing…*, will represent a first taste of *Hitchhiker's*. This book aims to fill in some background for such a reader, who is looking to understand the size and scope of the curious phenomenon upon which they've stumbled. Equally, however, the intention is to offer something for the longtime fan, hooked ever since the first radio episode was aired on 8 March 1978 and familiar with every subsequent development in every format from computer game to comic.

As such a devotee would no doubt tell you – probably at considerable length, until, like the President of the Mid-Galactic Arts Nobbling Council at an Azgoth poetry recital, your only means of survival lies in gnawing your own leg off – *Hitchhiker's* is a story of

considerable depth. This book looks, for instance, at the real-life science behind time travel and the Total Perspective Vortex; the echoes in Adams's writing of Zen Buddhism and existentialist philosophy; and the impact of filtering the story's best-known gag, that the meaning of life is 42, through a tridecimal numeral system.

For the neophyte, however, the overriding instruction is that inscribed upon the cover of *The Hitchhiker's Guide to the Galaxy* itself: Don't Panic. *Hitchhiker's* is also a comic space opera, plain and simple; an absurdist but highly accessible intergalactic romp. As well as the series' links to science and philosophy, this book contains thoroughly straightforward information about the main characters and the most prominent versions of the story, including radio, novels, TV and film. No prior knowledge is assumed.

Science fiction can be notoriously geeky, and at times all but impenetrable to those without the time or inclination to familiarize themselves with its mores. Yet despite its cosmic canvas, there's an earthiness – and indeed, Earthiness – to *Hitchhiker's* that is precisely what enabled it to spread so far beyond the usual sci-fi fanbase. Stephen Fry, who would befriend Adams and subsequently provide the voice of the eponymous Guide in the film version, is on record as saying that he became a fan of the early *Hitchhiker's* radio shows without ever thinking of them as science fiction.

That sentiment is shared entirely by the author of this book. More than any two-headed President, for me the initial appeal of *Hitchhiker's* lay in its humour and its Englishness (although the Blimpish national stereotype epitomized by Arthur Dent was almost as outmoded in the immediate aftermath of punk, when Adams was first writing it, as it is today). It's not hard to see why Fry was attracted to a story that makes reference to such quintessentially English phenomena as cups of tea, pints of bitter, games of cricket and the *Guardian* crossword. And notwithstanding the fact that the novels have been translated into more than 35 languages, the humour itself is often described as equally English, with clear antecedents in Monty Python, *The Goon Show* and P.G. Wodehouse.

No doubt other fans have been ensnared by different aspects of *Hitchhiker's*, and any attempt to separate the story's appeal into individual strands is in any case futile. Having mutated into so many different formats in its long history, it's hardly surprising that the story is many things to many people; sometimes, like the formats themselves, these views will flatly contradict each other. It's all part of the charm of a tale that, for all its light-hearted, accessible tone, is so multi-faceted, and so densely packed with ideas.

It does mean, though, that a "guide to the Guide" is perhaps not such a bad idea after all: however well you know the story, there's probably more to learn, and hopefully even the most ardent follower will take something new from this book. Given Adams's oft-repeated (and maybe even true) story that he originally came up with the basic concept for the story whilst hitchhiking around Europe, there's also a certain charm in its being published by a company still best known for its travel guidebooks.

Share and enjoy.

Marcus O'Dair
May 2009

Thanks

To Ruth Tidball and Peter Buckley, for forfeiting the long lunchbreaks that should be compulsory on such a book, and for not locking me in a hotel room whilst writing it; to Alan Sullivan and Sam Duby for their help with the text; to Adam Lavis for the scripts; to Mum, Dad, Loren, Dom, Andrew, Rich and Dr Parsons, for tea and sympathy (if not a sofa); and most of all, to my own personal Infinite Improbability Drive, Kat.

Phase One

1

An infinitely improbable story

It is no easy feat to summarize the basic plot of *The Hitchhiker's Guide to the Galaxy*. Combining science-fiction staples such as parallel dimensions and time warps with thoroughly surreal humour, it rarely follows a linear or logical storyline. The wildly freewheeling style of the original 1978 BBC radio shows was wholeheartedly endorsed by subsequent incarnations: novels, TV series, records, stage productions, short stories, comics, feature film and even computer game.

Matters are further complicated by the fact that the plot actually changes somewhat between these various formats, so precisely which version one favours is ultimately a matter of personal preference. Obsessives will point to minor differences between British and American versions of the same book, or even between different broadcasts of the same radio episode.

However, much of the broader narrative is in fact common to all versions, so it is just about possible to outline a common narrative thread. Of course, this whole chapter should come with a pretty substantial spoiler warning: to paraphrase Adams, if you don't want to know what happens, skip ahead to Chapter 2, which is a good bit and has Marvin in it. Otherwise – going by the novels, which, although pre-dated by the first radio series, provide the definitive version of the entire saga – the basic story goes something like this...

Book One: The Hitchhiker's Guide to the Galaxy

Arthur Dent, a well-meaning if rather dull fellow of about thirty, wakes up one morning to discover that his house is to be knocked down to make way for a bypass. He also learns that his friend Ford Prefect has been on Earth only as a researcher for *The Hitchhiker's Guide to the Galaxy*, and was actually born on a small planet near Betelgeuse (pronounced "Beetle-juice"). Ford informs Arthur that Earth is about to be destroyed to make way for another bypass, this time of hyperspace proportions.

Just before Earth is obliterated, Ford uses his electronic sub-etha signalling device to transport himself and Arthur onto the spaceship responsible for the planet's imminent destruction, crewed by a nasty race known as the Vogons. Unwelcome visitors, they are cruelly tortured by means of a poetry recital by the Vogon captain before being thrown into space.

Arthur and Ford are picked up by another spaceship, the spectacular *Heart of Gold*, and thus we are introduced to most of the

book's remaining major characters. Most immediately striking is Zaphod Beeblebrox, the painfully cool, two-headed President of the Galaxy, who has stolen the ship for reasons he can't quite recall. With him is Trillian, a fellow human whom Arthur once tried to chat up at a party but who, to his considerable chagrin, ended up leaving with Zaphod. Also on board are Marvin, the eternally pessimistic robot; Eddie, the eternally optimistic computer; and two pet mice Trillian brought with her from Earth, whose significance only later becomes apparent.

For reasons that again remain vague even to him, Zaphod takes the ship to a planet named Magrathea, once the centre of a successful planet-constructing industry but now believed unpopulated. While most of the group head down a passage to explore the planet's interior, Arthur and Marvin stay behind on the surface where they meet an elderly planet-designer called Slartibartfast. It transpires that the Magratheans are not dead but have merely been asleep for the past five million years, sleeping out an economic downturn.

Slartibartfast tells Arthur of a race of highly powerful, pan-dimensional beings who in this dimension manifest themselves as mice. It transpires that these beings once asked a supercomputer named Deep Thought to answer The Great Question of Life, the Universe and Everything. However, they were severely underwhelmed when Deep Thought, after seven and a half million years' intense contemplation, announced that the answer was "forty-two". Deep Thought went on to explain that this answer would only make sense once they truly understood the Ultimate Question, but to calculate said question would take a computer far more powerful than even Deep Thought itself.

This computer, so large that it included organic matter in its make-up, was named Earth. All had been going swimmingly until the Vogons destroyed it, five minutes before the end of its ten-million-year programme. Slartibartfast has been woken from his five-million-year slumber in order to create a replacement.

Arthur rejoins Ford, Trillian and Zaphod for a feast, only to discover that their hosts are Benjy and Frankie, the two mice Trillian brought with her from Earth. The mice want to buy Arthur's brain, in the belief that, as part of the Earth computer's organic make-up, it will contain information vital to understanding the Ultimate Question. Arthur, however, isn't keen to sell his precious grey matter. As the mice prepare to forcibly remove it, he and his companions flee.

On the way out, the group come under fire from a pair of policemen, but escape when the cops' life-support systems spontaneously explode. Upon re-emerging on the surface of the

A human brain similar to the one used by Arthur Dent, and coveted by Benjy and Frankie.

planet, they find the *Heart of Gold* – and, parked next to it, the police ship, looking as dead as its former occupants. The craft committed suicide after Marvin shared with it his hopelessly bleak view of the Universe.

The group leave Magrathea, and, relaxing with a highly intoxicating Pan Galactic Gargle Blaster, Zaphod brings the book to its rather abrupt close by suggesting a trip to the Restaurant at the End of the Universe.

Book Two: The Restaurant at the End of the Universe

The second *Hitchhiker's* book joins *The Godfather Part 2* and *From Russia With Love* in that most exclusive club: sequels that are better than the originals. It follows the radio series less slavishly than Book One, fleshing out the characters in the process, but still reads as if Adams was thoroughly enjoying himself – a quality notably lacking in later novels.

As one of the Galaxy's most eminent psychiatrists, Gag Halfrunt is terrified at the prospect of anyone discovering the meaning of life – after all, it would do his profession no end of harm. Indeed, it was Halfrunt who ordered the Vogons to destroy the supercomputer otherwise known as planet Earth. He has now employed the Vogons to finish the business by exterminating Arthur and Trillian, the last remaining humans in the Universe.

In normal circumstances, the *Heart of Gold* would more than likely be able to deal with a Vogon attack, thanks to its Infinite

Brownian Motion producer (aka a nice cup of tea).

Improbability Drive. However, Arthur has chosen this precise moment to reject the unpalatable liquid usually provided by the ship's Nutri-Matic Drinks Synthesizer, and instead inform the machine how to make a proper cup of tea. The enormity of his demand has fully occupied every circuit in the ship's computer.

As Ford counts down the seconds to their certain doom, Zaphod hits upon the bizarre solution of holding a séance with his late great-grandfather. The ghost saves them by catapulting the *Heart of Gold* through time and space, first telling Zaphod that he must find the man who runs the Galaxy (and possibly the entire Universe).

An unexpected side effect of this space-warp is that Zaphod and Marvin disappear from the ship, only to materialize on the hedonistic planet of Ursa Minor Beta, home to the offices of *The*

Hitchhiker's Guide to the Galaxy. Zaphod, who still can't remember why he stole the ship he was onboard only seconds previously, now does something else he doesn't understand. He walks into reception and demands a meeting with a man called Zarniwoop, despite the fact that he's never heard of him.

As Zaphod makes his way to Zarniwoop's office, spaceships uproot the building and carry it off into the sky. To his bafflement, Zaphod is told that these spaceships are after him not because of something he's done, but because of something he's yet to do – but which he decided upon years ago. The flying office block is deposited on the unspeakably evil Frogstar World B, where Zaphod is subjected to the psychic torture of the Total Perspective Vortex, in which victims are forced to acknowledge their complete and utter insignificance in relation to the infinity of existence. Uniquely, however, he emerges unscathed, the machine apparently confirming his belief that he is indeed the most important being in the Universe.

Attempting to escape from the planet, Zaphod discovers a 900-year-old spaceship full of sleeping passengers. Also aboard is Zarniwoop, who rather smugly informs Zaphod that he's been inside an electronically synthesized Universe since arriving on the planet. Equally smugly, Zarniwoop also tells him that the pair had long ago agreed that he would steal the *Heart of Gold* and bring it here, as part of their mission to find the man who rules the Universe.

Zaphod has no recollection of any of this but, discovering that a shrunken *Heart of Gold* has been in his pocket all along, he returns onboard and is reunited with Ford, Arthur and Trillian. He also punches Zarniwoop, having had quite enough of his self-satisfied

explanations. But when Zaphod shouts at the computer to take them to "the nearest place to eat", it does exactly that, sending them five hundred and seventy-six thousand million years through time but no distance at all in any of the other dimensions.

The group emerges in Milliways, better known as the Restaurant at the End of the Universe. Thanks to the joys of time travel, this luxurious eatery offers diners the vicarious thrill of watching the whole of Creation destroyed, night after night. Our protagonists leave with Marvin but soon realize that the spaceship they've stolen is destined to crash into the Sun. Leaving Marvin to his fate, the others escape via a teleport.

Arthur and Ford find themselves on another spaceship, this time with the frozen bodies of fifteen million hairdressers, telephone sanitizers, insurance salesmen and public relations executives. It transpires that a planet called Golgafrinchan has decided to rid itself of the useless third of its population by sending them to another planet, with the not entirely convincing promise that the "useful" two thirds of the population will follow in due course.

Zaphod and Trillian, meanwhile, end up back on the *Heart of Gold* with Zarniwoop, and finally meet the man who rules the Universe. They find him living a simple life in a shack, trusting absolutely nothing beyond his own empirical experience. Zarniwoop seems to find the man's inconclusive answers rather frustrating, although Zaphod and Trillian conclude that the Universe is in good hands. They sneak away in the *Heart of Gold*, leaving Zarniwoop stranded.

The Golgafrinchan ship crash-lands on what Arthur and Ford come to recognize as pre-historic Earth. The new arrivals seem destined to slowly destroy the planet, together with its native

population – terrible news in terms of Earth's function as a mouse-commissioned supercomputer, since these natives are part of its organic make-up. Nevertheless, the book ends with Ford and Arthur in fairly reflective mood, Arthur mentioning in passing that he's thrown his copy of *The Hitchhiker's Guide to the Galaxy* into a river.

Book Three: Life, the Universe and Everything

If *The Restaurant at the End of the Universe* was *The Godfather Part 2*, then *Life, the Universe and Everything* bears uncomfortable similarities to *The Godfather Part 3*. No, we don't see Arthur Dent haunted by his lifetime of sin as a mafia Don. But what felt complete as a two-parter is revisited and the results, though perfectly respectable on their own terms, simply fail to meet the standards of previous instalments. Furthermore, Adams's decision to base much of the story on an unused *Doctor Who* script imposes a kind of action-adventure momentum that doesn't suit the laissez-faire characters of the *Hitchhiker's* world.

The book opens with Arthur, after all his adventures, back in England – London's Islington, to be precise. Unfortunately, however, he's living in a cave, stranded two million years before his own time. Just as he decides to deal with this problem by going mad, Ford Prefect appears, and the pair hitch a ride on a floating Chesterfield sofa. It deposits them some time in the 1980s, a few miles east in the middle of the pitch at Lord's Cricket Ground.

Spelling

For a story that mocks subeditors on more than one occasion, it is slightly ironic that *The Hitchhiker's Guide to the Galaxy* has itself thrown up a surprising number of spelling quandaries. With the potential for both a hyphen and an apostrophe, that apparently innocent word "hitchhiker's" has over the years been subject to the sort of gross cacography that would bring Lynne Truss out in a cold sweat. As writer and comic artist Neil Gaiman has pointed out, there have even been inconsistencies within a single product. Adams himself mixed "hitch-hiker's" and "hitchhiker's" in his original story outline; the first novel went for "hitchhikers" on the cover, but "hitch hiker's" in the main body of the book. Detailing these discrepancies is, of course, a thoroughly tedious business, which is presumably why The Guide's own subeditors spend so much time on extended lunchbreaks. Suffice to say, then, that consensus was eventually reached when Adams himself was moved to put forward his thoughts on the matter: thus the "hitchhiker's" spelling used in this book. Phew.

Moments later, a spaceship arrives, carrying a troop of robots attired in an approximation of cricket whites. Slartibartfast also shows up, having anticipated their arrival, but is unable to prevent them stealing The Ashes, the trophy associated with the long-running Test cricket series between England and Australia. Elsewhere the robots kidnap Marvin and steal the vital Gold Bail

from the *Heart of Gold*'s Infinite Improbability Drive, shooting Zaphod in the process.

Meanwhile, Arthur is discovering just what has made these artificial cricketers so aggressive. He learns of the planet Krikkit, once a happy place, hermetically sealed within a cloud of dust so thick that none of its inhabitants had ever considered any reality beyond. One day, however, a spaceship fell out of the sky, and they copied its design. Learning that there was indeed life beyond their planet, the people of Krikkit concluded that they would have to destroy it, thus beginning the notoriously ferocious Krikkit Wars. When Krikkit was eventually defeated, the planet was placed in a state of slow-motion existence, rendering it harmless. The robots are

Owzat: The Krikkit robot army on the rampage...

now attempting to re-assemble the key to this Slo-Time field, an event Slartibartfast is desperately attempting to prevent.

Ford, in particular, is reluctant to help, but perks up when he hears that it will involve teleporting themselves to a party. Arthur, however, is somehow diverted en route and meets a creature named Agrajag whom he has inadvertently killed on multiple occasions. Agrajag tries to take his revenge but Arthur accidentally kills him once more, having first been told that someone will try to assassinate him in a place called Stavromula Beta.

Caught in a landslide as he makes his escape, Arthur trips and is surprised to find himself flying. He's having a great time until he crashes into the party, which is itself flying, thanks to some clever engineering and rather a lot of alcohol. Here he meets not just Ford and Slartibartfast but also Trillian and a man who's just won the Rory award for "Most Gratuitous Use of the Word 'Fuck' in a Serious Screenplay". However, the Krikkit robots soon arrive and steal the trophy.

The robots have now collected all they need to free themselves from the time-warp by reassembling the Wikkit Gate key. Marvin's leg, the reconstituted Ashes and the Agrabuthon Sceptre of Justice comprise its stumps; its bails are the heart of the Infinite Improbability Drive and the Rory award.

Our protagonists decide there is now no other way of stopping the robots but to take the extremely dangerous step of visiting the planet of Krikkit itself. To their terror, they are discovered almost as soon as they arrive. Rather than exterminating them, however, the Krikkitmen are simply keen to chat. They mention that they have a bomb capable of destroying the whole of existence, but don't seem particularly keen to use it.

Trillian realizes that some greater power has been behind the Krikkit robots all along. It transpires that an ancient computer named Hactar has not been destroyed, as previously believed, but merely reduced to smithereens – its component parts actually constituting the dust cloud around Krikkit. Hactar has been deliberately nurturing Krikkit's population in the hope that one day they would demand of it the supernova bomb that it once built but deliberately sabotaged, a decision it subsequently regretted.

At the same time, Zaphod finds the wreckage of the spaceship that fell through the planet's dust cloud, starting the Krikkit Wars in the first place, and realizes that it's a fake. He also discovers Marvin, hooked up to the Krikkit War Computer and therefore responsible for the apathy that's spread through the robots (and saved Zaphod's life). Admitting its guilt, Hactar's particles fade away and the Universe is saved – although Arthur very nearly destroys it when an ill-advised trip back to Lord's almost sets off the supernova bomb.

In the epilogue, the protagonists meet a character called Prak, who has been given an excessive dose of a truth drug. However, their hopes that he will reveal "the Question to the Ultimate Answer" are crushed when Prak explains that the Question and the Answer cannot both be known in the same Universe. Instead, he tells them where to find God's last message to his creation but Arthur decides to ignore this message, instead opting to live a quiet life on the now becalmed Krikkit. He passes the time flying and talking to birds before realizing that most of their conversation is actually very dull.

Book Four: So Long, and Thanks for All the Fish

The shortest and weakest *Hitchhiker's* novel is, to a large degree, the story of a girl sitting in a café in Rickmansworth and her relationship with Arthur Dent. Apart from the odd appearance from Ford, the other main *Hitchhiker's* characters barely feature.

The girl's name is Fenchurch, and Arthur meets her upon his return to Earth after eight years of inter-galactic hitchhiking – although, confusingly, only six months seem to have passed at home. More confusing still, despite having arrived back after the date when he knows the Vogons destroyed the planet, Earth is still in existence.

Though rumours persist of a mysterious CIA agent found floating in a reservoir, all talk of yellow spaceships and world destruction has been put down to mass hallucination. The sole exception seems to be Fenchurch, who continues to insist that she witnessed a huge explosion. As a result, everyone thinks she's mad. Arthur, however, simply feels an instant and very powerful attraction towards her that goes beyond the fact that she's the first female of his own species he's set eyes on for several years.

He attempts to explain to Fenchurch that they are somehow enormously important to one another, but with little success. They lose contact and Arthur sits around at home in a state of abject depression, slightly perplexed by the presence in his bedroom of a fishbowl, engraved with the words "So Long and Thanks". Deciding that he needs a project to lift his spirits, he tries to pinpoint, via computer, the exact location of the pre-historic cave in which he

used to live (in *Life, the Universe and Everything*). He knocks on the door – and, to his amazement, it's answered by Fenchurch.

This time, things go rather better between them. In fact, this is by some margin the soppiest section of the whole *Hitchhiker's* saga. Several pages pass with Arthur and Fenchurch simply kissing, cuddling and, most nauseatingly, listening to Dire Straits. Fenchurch tells Arthur of her Rickmansworth café experience, when she witnessed what she believes to have been the explosion of Earth. She also says that all dolphins disappeared at that exact moment. In return, Arthur teaches her to fly.

When their airborne romance starts attracting tabloid attention, the pair travel to California to meet a man named Wonko the Sane, reputed to be able to explain the disappearance of the dolphins. In his house, a curious building known as "Outside the Asylum", Arthur spots a fishbowl identical to the one he found in his house – and discovers that Fenchurch had one too. Wonko explains that

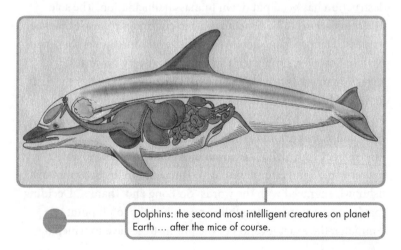

Dolphins: the second most intelligent creatures on planet Earth … after the mice of course.

Three Men in a Boat

Of the books to which *The Hitchhiker's Guide to the Galaxy* might be compared, one which stands out is *Three Men in a Boat* by Jerome K. Jerome (1859–1927). Published in 1889, this is the story of three men dealing with what might nowadays be called a mid-life crisis by taking a boating trip along the Thames between Kingston and Oxford. Although not a direct or acknowledged influence, it has much in common with *Hitchhiker's*. Both are

seen as quintessentially British, sharing a sense of humour based on misunderstandings, misconceptions, pretentiousness, manners and mockery, ranging from the subtle to the brutal. Although *Three Men in a Boat* is firmly rooted in the Victorian era, while *Hitchhiker's* begins in the late 1970s, the comedy remains timeless. In terms of style, the writing of both authors is educated and intelligent, while still being easily readable. The characters of *Three Men in a Boat* – J and his friends Harris and George – have much in common with Arthur and his companions. Disorganized, easily distracted and troubled by non-specific discontent, they don't really know what ails them, so they can't identify a solution: a recurring theme throughout *Hitchhiker's*. Yet in spite of their ongoing, towering incompetence, they muddle through – a very British way of doing things. Arthur Dent would probably be quite happy in their company.

the bowls, whose full inscription forms the book's title, were a farewell gift from the dolphins. Apparently, the creatures saved the planet from destruction at the last minute thanks to some funny business with parallel universes.

Wonko also mentions God's final message to his creation. When Arthur reveals that he knows where to find this message, thanks to Prak's instructions at the end of the previous novel, Fenchurch expresses a wish to go and see it. Arthur is just explaining that finding a flying saucer isn't as easy as all that – indeed, his old friend Ford Prefect waited fifteen years for that very eventuality – when Ford appears. Ford gets them onto the spaceship on which he arrived, and they set off to see God's final message, finally taking this largely Earth-based novel back to the realm of outer space. On the way they find Marvin, in a sorrier state than ever, before eventually reading the hugely anticipated message: "We apologize for the inconvenience".

Book Five: Mostly Harmless

Whereas the first four novels were all published between 1979 and 1984, *Mostly Harmless* appeared a full eight years later (and only then because Adams, whose inability to hit deadlines was notorious, was locked in a hotel room by his publishers). The bleakest of the novels, *Mostly Harmless* is probably superior to the fourth (and, arguably, third) instalments of the *Hitchhiker's* saga, with interesting use of parallel universes and, of course, the wonderfully sinister updated version of The Guide itself. But again, key characters like Zaphod and Marvin are notable by their absence.

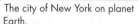
The city of New York on planet Earth.

The city of New York on planet Earth in a parallel universe.

Tricia McMillan, successful news presenter, is living in New York. However, the Earth she is on is in a parallel universe, in which she failed to leave the party with Zaphod, as in Book One. Instead she went back for her bag, only returning in time to see his spaceship departing.

Having desperately regretted this fact for seventeen years, she's only too happy when an alien spaceship lands on her lawn and offers to take her to the planet Rupert. It turns out that the aliens,

known as Grebulons, have lost all sense of purpose after their ship was hit by a meteorite, and now idle away their time by monitoring Earth. Having seen Tricia's interview with astrologer Gail Andrews, they want her to re-triangulate their horoscopes to take into account Rupert's relative position.

Meanwhile, Ford Prefect arrives at the *Hitchhiker's Guide to the Galaxy* offices and immediately senses that something isn't right. He learns that The Guide is now run by the corporate behemoth that is InfiniDim Enterprises, and The Guide is to be re-marketed at affluent business travellers rather than impoverished hitchhikers. Knocking unconscious the new, rather odious editor-in-chief, Ford steals his Identi-i-Eeze card and gains access to The Guide's most closely guarded inner sanctum, where he re-programs the central computer. As alarms go off around the building, he manages to return the card but soon comes under rocket fire and jumps out of the window.

Landing on a ledge outside the mysterious thirteenth floor, Ford climbs inside and discovers a small black disc that turns out to be *The Hitchhiker's Guide to the Galaxy Mk 2*. This updated version of The Guide exists in an infinite number of dimensions, the ruthless logic being that it's more efficient to sell one guide multiple times than to go to the bother of actually making multiple copies. It wields a terrifying degree of power, and Ford finds it rather sinister.

At the same moment, it dawns on Ford that the large, slug-like thugs who've been chasing him around the building are Vogons. Terrified, he steals *The Hitchhiker's Guide to the Galaxy Mk 2* by posting it to himself, care of Arthur Dent, in the internal mail. Then, just before the Vogons smash the door down, he jumps out of the window again.

Arthur Dent, the unwitting recipient of this parcel, has been in a terrible state, having lost Fenchurch in a hyperspace travel malfunction. Unable to return to Earth, he has been aimlessly planet-hopping, paying his way by selling DNA in the form of spit, toenails and semen. Finally, he finds a degree of contentment when he crash-lands on the remote planet of Lamuella and becomes much revered as their Sandwich Maker.

Triple-decker sandwich that may or may not contain Perfectly Normal Beast.

His sense of peace is, however, soon shattered by the unexpected arrival of Trillian. To his considerable surprise, she informs Arthur that they have a daughter (no, they didn't: she was created from Arthur's DNA). Trillian then leaves Arthur and the girl, not inappropriately named Random, to get to know one another, a task that is not helped by her regular tantrums and mood-swings.

The arrival of the parcel sent by Ford only makes things worse. When Random opens it, disobeying Arthur's instructions, the enclosed black disc unfurls into a bird capable of mind-bending shape-shifting, thanks to its unique gifts for temporal reverse engineering and Unfiltered Perception. When Ford Prefect arrives, Random knocks him unconscious, steals his spaceship and heads to Earth. Not realizing the danger it poses, she takes with her The Guide Mk 2. In pursuit come Arthur and Ford, riding a bizarre creature named a Perfectly Normal Beast.

Meanwhile, in a Soho editing suite, Tricia is struggling with the footage she filmed on Rupert, which looks strangely unconvincing. Just when she's starting to wonder whether the whole Grebulon episode took place only in her imagination, she hears that a spaceship has landed in Regent's Park. Heading down to report on the story, her professional exterior is rather punctured when a girl emerges from the spaceship calling her "mother". This is particularly upsetting as she's never seen the girl before in her life.

Arthur and Ford arrive on Earth and see Trillian interviewing Random on television. However, Arthur senses that this is a different person to the one they know, even though she shares the name Tricia McMillan. Ford and Arthur head to one of her known haunts, a club owned by a gentleman named Stavro (as an in-joke, the address is number 42). Here they encounter Trillian and…

Trillian, or rather Tricia, whom Arthur has just seen on TV. Also present is Random, armed with a gun from the spaceship she stole from Ford. Somewhat hysterical, she is demanding to know why she doesn't seem to belong even on her own planet, and, more specifically, why her own mother doesn't recognize her.

Secure in the knowledge (gained in *Life, the Universe and Everything*) that he can't die until he has visited Stavromula Beta, where he will duck an assassin's bullet and an incarnation of Agrajag will once again die in his place, Arthur is attempting to calm everyone down. Moments later, however, Random's gun goes off; Arthur dives out of the way, but the club's proprietor is shot instead. When Arthur learns that this man's name is Stavro Mueller, and the name of the venue is Beta, things start to fall into place.

Far above the planet, the Vogon ship has returned to carry out the demolition order that, thanks to the plural nature of this part of the Galaxy, it previously failed to complete. As the Grebulons too snap out of their listless state and engage their gun turrets, Arthur at last gains a tremendous sense of serenity. Finally, it's all over…

…or is it?

Even by his infamously tardy standards, Adams had struggled to finish *Mostly Harmless*, and by this stage he was increasingly distracted by other projects. However, he did express an intention to write a sixth *Hitchhiker's* book, both in order to end the saga on a more upbeat note and on the grounds that six was "a better kind of number". When Adams died in 2001, this idea looked to have perished with him. However, the publication of *And Another*

Thing..., a sixth *Hitchhiker's* novel written by bestselling children's writer Eoin Colfer, ensures that, for at least some of the characters, there is a future beyond Stavro Mueller.

2

We've met before: the characters

From the Allitnils to Zem the mattress, *The Hitchhiker's Guide to the Galaxy* features a supporting cast of such extraordinary scope, it could put even *The Simpsons* to shame. Even Russell, Fenchurch's blow-dried brother, and still more minor characters such as airborne voyeur Enid Kapelsen or gardener Eric Bartlett are sketched in just enough detail to engender some emotional response. Extraterrestrials merit just as much attention, not only weird and wonderful but often

offering an indirect comment on human nature to boot. The Oglaroonians, for instance, represent the myopia required to deal with the sheer vastness of the Universe, confining their entire lives to a single nut tree. The Belcerebon people, afflicted with telepathy, are condemned to a life of incessant chitchat in order to prevent their every thought being broadcast to everyone within a five-mile radius. The list of bit-part roles is almost endless, and detailed examination of all the *Hitchhiker's* characters could fill this entire book. Here, though, are some of the more prominent.

Arthur Dent

Working in local radio and unable to quite get the hang of Thursdays, Arthur Dent is, at the start of the *Hitchhiker's* saga, ordinary in almost every respect. Extraordinary things soon happen to him, of course, yet his role in the ensuing cosmic adventure is as a kind of Everyman; we see the rest of the Universe through his eyes.

Lost in a world of fantasy and absurdity, not to mention rather sinister bureaucracy, he's somewhere between Lemuel Gulliver in Jonathan Swift's *Gulliver's Travels* and Josef K. in *The Trial* by Franz Kafka. There are parallels, too, with Alice from Lewis Carroll's *Alice in Wonderland* (conspiracy-theorist types may see significance in Carroll's use of the number 42; see p.63), and even Christian, the protagonist in John Bunyan's *The Pilgrim's Progress*. The fact that

Arthur's name

There has been much conjecture among hard-core fans about the origins of Arthur's name: specifically, was Adams aware of the Arthur Dent who wrote *The Plaine Man's Pathway to Heaven*? The author himself claimed that any link with this early-seventeenth-century Puritan tract was mere coincidence. On the other hand, biographer M.J. Simpson, who is *the* authority on all things *Hitchhiker's*, claims that Adams had in fact seen an original copy of this book less than a year before first writing the first script. Either way, the fact that in the first draft the character went under the entirely different name of Aleric B suggests that the issue may not be worth losing too much sleep over.

Bunyan's book even features a wicket gate (see p.15) may, for some, be almost too much to bear.

Though usually perceived as a hapless, helpless anti-hero, it's worth pointing out that Arthur does, at points, display more bravery than experienced space travellers like Ford and Zaphod (though, admittedly, that may not be saying much). He also suddenly develops a sex drive, and an exhibitionist streak, in *So Long, and Thanks for All the Fish*, when he and Fenchurch make the beast with two backs on the wing of a Boeing 747.

Most of the time, however, Arthur wants nothing more than comfort and cosiness, as symbolized by his dressing gown, now a ubiquitous part of the character's costume. (In an example of the

fluid relationship between the various formats of the *Hitchhiker's* story, the dressing gown was in fact not conceived until the TV series and only then incorporated into the novels.)

We're told that Arthur lives in the West Country, that sometimes quaint bastion of old-fashioned Englishness. Arthur is apparently the one role that Adams insisted be played by an English actor, and it's not hard to see why: his initial attempt to convey to Fenchurch how important they are to one another is as awkward and stilted as anything in *Brief Encounter*. Coincidentally, the scene even takes place in a pub next to a railway station.

Arthur's adherence to national stereotype, as well as his beta male personality, comes through in the fact that he likes cricket but

Martin Freeman's movie interpretation of the ape descendant Arthur Dent: a pathetic yet somehow endearing role likened by movie director Garth Jennings to that of Jack Lemmon in *The Apartment*.

has never been very good at it, and that he used to score own goals in childhood football matches. We also learn that he likes Hall and Woodhouse best bitter, the *Guardian* newspaper crossword and, in particular, a good cup of tea.

Famously, Adams based elements of Arthur on the actor Simon Jones, or at least on Jones's strengths as an actor, although he also admitted that the character has aspects of his own personality. Jones, who played the role in the original radio series, as well as on the album and on TV, now comes across as a rather uptight Arthur, his attitude towards events alternating between mildly grumpy and utterly indignant. In the film, in which he's played by Martin Freeman, he is less "Disgusted of Tunbridge Wells" and instead closer to Tim, Freeman's self-deprecating character in the original UK incarnation of the superb sitcom *The Office*. Well aware that, in his own words, he's rolled a three on the dice of life, he's still afraid to throw again: "I could roll a six. I could also roll a one."

Ford Prefect

Ford Prefect is an alien from the vicinity of Betelgeuse. As a boy he was nicknamed Ix, but he adopted his bizarre moniker – taken from the name of a line of now-forgotten Ford motor vehicles – upon coming to Earth, in the mistaken belief that cars were the planet's dominant life form. Having spent a decade and a half on the planet, he has more in common with Arthur than any other main character in the saga, at least when neither Trillian nor Fenchurch is about, and he becomes Arthur's most constant companion.

Ford is a researcher for *The Hitchhiker's Guide to the Galaxy* (see

The original Ford Prefect – rather more inconspicuous as a make of car than as an assumed name for an alien travel guide researcher.

below). As such, he teaches Arthur many useful lessons – perhaps the most important being the vital role played by towels in intergalactic travel. Yet although both resourceful and adventurous, he's a frequently infuriating travelling companion: reckless, irresponsible and, most damningly, lacking any understanding of sarcasm. More forgivably, he claims to have a doctor's note that excuses him from saving the Universe and will in preference elect, on almost every occasion, to get drunk and dance with girls.

It's also part of Ford's personal code of ethics never to pay his own (frequently gigantic) bar bills, often escaping the resulting tricky situations by agreeing to write a favourable review for The Guide. His expense account, meanwhile, is so notorious that he habitually enters the publisher's head office via the ventilation system rather than having to face awkward questions in the lobby.

In the original radio series and album, Ford was played by Geoffrey McGivern, who is said to have inspired some of the character's more spectacular pub-based antics. However, McGivern was apparently deemed too ordinary-looking to play the role on TV; though humanoid in appearance, the character requires a certain extraterrestrial eccentricity. In his place was cast David Dixon, clad in clashing clothes and blue-tinted contact lenses, who plays the part with the manic intensity – and something of the vocal delivery – of Richard E. Grant in *Withnail & I*. (Ford also shares that character's regular demands for booze and even masquerades as an out-of-work actor.)

A more contemporary, streetwise take on Ford's persona can be found in the film, where he's played by critically acclaimed American rapper and actor Mos Def. Cast, according to executive producer Robbie Stamp, for his Zen-like cool, Mos Def delivers a significantly more laid-back version of Ford than either McGivern or Dixon. Casting an African-American as a character described in the book as having ginger hair proved controversial in certain circles, but is surely a concern for only the most extreme of purists. The guy's an alien, for Bob's sake.

The Guide

However endearing one finds Arthur's bumbling incredulity, arguably the most important character in *The Hitchhiker's Guide to the Galaxy* is The Guide itself, an electronic device that has more in common with an iPod or Wikipedia than any traditional travel guide.

As well as fleshing out many important details of the story, its irreverent prose style provides a good deal of the humour. It's also The Guide that gives us the famous catchphrase "Don't Panic" (and another, in that the message is inscribed in "large friendly letters").

Rula Lenska, self-confessed "crazy Polish countess", has been a long-standing presence in the *Hitchhiker's* radio shows.

In its incarnation as a black bird, the more powerful and pernicious Guide Mk 2 also becomes an important plot device in *Mostly Harmless*, conspiring to destroy planet Earth.

The story goes that Adams and Simon Brett always knew they wanted a "Peter Jones-y" voice to play the role of The Book in the original radio series. Yet they apparently approached several actors, including Michael Horden and Michael Palin, before thinking it might be an idea to try Peter Jones himself. Certainly, to many fans, Peter Jones (no relation to Simon Jones, who played Arthur Dent) is now synonymous with the role, which he played not just on the original radio series but also for the album and TV. The Guide Mk 2 does not appear in the TV series or the film, but was voiced on radio by Rula Lenska, who also played the Lintilla clones.

The TV series is a particularly strong moment for The Guide, thanks to visuals that still pass muster in the post-*Matrix* world, and so must have appeared utterly groundbreaking in 1981. These visuals were not, as commonly believed, computer-generated, but instead created using entirely traditional cel animation techniques. The film incarnation of The Guide, which featured rather simpler graphics, was voiced by Stephen Fry, who succeeded in his stated aim of capturing Peter Jones's mix of authority and affability.

Zaphod Beeblebrox

Like his distant cousin Ford Prefect, Zaphod Beeblebrox is roughly humanoid in appearance, with two major exceptions: for reasons that vary between different formats of the story, Zaphod has a second head and a third arm.

When we first meet him, he bears the title "President of the Galaxy", a thoroughly meaningless position whose main purpose is to distract attention *away* from the true seat of power. In this respect he's perfect for the role, spending two of his ten presidential years in prison for fraud and generally behaving in the sort of extravagantly hedonistic style appropriate for a self-proclaimed "cool frood". He's soon stripped of his title anyway, after stealing the *Heart of Gold* spaceship for reasons that at the time escape him but which he later learns are related to finding the man who *really* runs the Universe (see p.11).

Apparently partially based on Johnny Simpson, one of Adams's Cambridge contemporaries, Zaphod's persona is essentially an amalgamation of the archetypal rock star, hippy and surfer. Perhaps his key characteristic is his desperate need to appear thoroughly relaxed at all times, with the result that he is in fact a rather manic character, with all the insecurity of the classic poser. He's also selfish, cowardly and wildly irresponsible, though he has enough charisma to somehow remain an appealing character. Despite a central role in the early stages of the story, however, Zaphod has all but disappeared by the later books.

Zaphod was played in the original radio series by Mark Wing-Davey, a Footlights graduate known for his long hair and bright blue dinner jackets. Wing-Davey reprised the role on the album and on TV. In this last format, however, the extra arm and, in particular, head became a major problem (one never anticipated by Adams, who had invented the extra body parts as a one-off radio gag). Despite reportedly costing more than Wing-Davey himself, the extra head spent most of its time lolling on the actor's shoulder in hopelessly inanimate fashion. The TV series also seems to have been

responsible for first hinting that the character has a *third* extra appendage, costume designer Dee Robson incorporating a double fly into Zaphod's trousers.

The idea of priapic duality is also alluded to in the film, in which Zaphod is played by Sam Rockwell, sporting long blond hair, extravagant shades and a flamboyant long coat apparently meant to echo the plumage of a peacock. There's something of Mike Myers (of both *Wayne's World* and *Austin Powers*) in his self-obsessed, rather adolescent Zaphod, whose belief in his own coolness remains unshakeable in his own head(s), if no one else's. The film attempted to solve the problem posed by the character's twin heads by positioning the extra noddle beneath the original, snapping up involuntarily at various points like Peter Sellers' saluting arm in *Doctor Strangelove*.

Marvin

Marvin is a robot whose brain, we're told, is the size of a planet. However, he spends his long life – he's 37 times older than the Universe itself when he finally dies – in a state of unremitting misery, having been fitted with a prototype of so-called Genuine People Personality technology. It gives him a headache merely to think down to the level of the other characters and he occasionally demonstrates his loathing for all organic life forms by means of an ironic hum. Though he has earned himself the soubriquet Paranoid Android, much of this "paranoia" seems entirely justified: the other characters won't think twice about leaving him to what looks like certain death to enable their own escape.

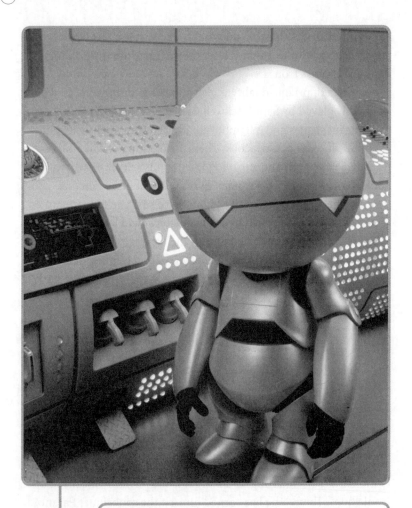

"Your plastic pal who's fun to be with": the sphere-headed movie version of Marvin. Compared to his TV incarnation (pictured opposite), the near-featureless face worked well to accentuate Marvin's down-trodden persona.

Robot disco

Long before Radiohead released the song "Paranoid Android", Marvin himself was putting out records, with two singles released by Polydor in 1981. First came "Marvin", in which a monotone Stephen Moore yearned to rust in peace in that "great junkyard in the sky" over a pop disco beat. It reached number 53 in the charts, the record-buying public apparently forgiving the inaccuracy of the line about being "the metal servant to the human race"; strictly, of course, Marvin's masters are aliens. It was backed by "Metal Man", a tune compared to "Space Oddity" by Wonko the Sane lookalike David Bowie. The follow-up, "Reasons to Be Miserable" (an allusion to "Reasons to Be Cheerful" by Ian Dury and the Blockheads), did less well, failing to make the top 75. Again the lyrics see Marvin wistfully imagining being broken up for spare parts and lamenting his demeaning workload: "How can a robot think with his elbows in the sink?" The B-side – in fact the record was billed, in suitably self-deprecating style, as a double B-side – was "Marvin I Love You", featuring a mysterious woman who's besotted with the robot, but whom, of course, he never gets to meet. Both singles live on via YouTube, often accompanied by images cut and pasted from both TV and film incarnations of the story.

Marvin's personality was supposedly based on the comedy writer Andrew Marshall, though, perhaps unsurprisingly, Marshall has been keen to play down the similarities. There are clear parallels to Garfield in the cartoon of the same name and the robot Bender in *Futurama*. However, there's something peculiarly English about Marvin's stoicism, making the most obvious precedent Eeyore the donkey in A.A. Milne's *Winnie the Pooh* books.

It has been suggested by Geoffrey Perkins, producer of the original radio series, that Marvin may be the series' most popular character – which could signal our collective respect for intellectual prowess but more likely says something about our love of remorselessly sardonic humour. When pressed, Adams himself named Marvin as his personal favourite.

Although he delivers one of the series' most enduring catchphrases in "Life? Don't talk to me about life", Marvin, like Zaphod, rather fades out as the story progresses. He apparently dies at the end of *So Long, and Thanks for All the Fish* and, despite fans' hopes for a reappearance, he remains entirely absent from *Mostly Harmless*. Marvin did, however, establish a life outside the series, releasing two singles in the 1980s (see p.39), as well as being honoured with his own "depreciation" society.

Perhaps because of his popularity, and because, as a robot, his appearance leaves so much to the imagination, Marvin has tended to be a particularly controversial character when it comes to screen adaptations. Stephen Moore, who played the role in the original radio series and album, was reportedly less than impressed by the costume proposed for the TV series. As a result, he elected to only supply the voice, with David Learner portraying the body inside a robot suit. The film version also split the role, with Alan Rickman

providing the voice and Warwick Davis inside the suit, this time white and rounded rather than grey and hard-edged. As a nod to the TV series, the original Marvin (or at least a "refurbished" version) can be spotted briefly on Vogsphere in the film.

Trillian

Despite the name's extraterrestrial sound, Trillian is simply an abbreviation of Tricia McMillan, the idea being that we assume she's an alien before realizing that she's actually from Earth. In fact, Arthur once tried to chat her up at a party, but she ended up with Zaphod instead, thanks to the ultimate chat-up line: the offer to show her his spaceship. She is therefore the only other human besides Arthur to have survived the demolition of Earth.

Adams doesn't seem to have been very comfortable writing female parts, and himself admitted that Trillian is a rather flat character, marginalized (or entirely absent) for much of the story. When she does take centre stage, however, she comes across as not only more intelligent than her companions, but also more practical and perceptive. This, after all, is a woman whose pre-media career was in mathematics and astrophysics.

Trillian's first moment of glory comes at the end of *Life, the Universe and Everything*, when she works out that Hactar has been behind the Krikkit robots all along. This impressive piece of deduction inspires even Marvin to admit that he despises her less than other life forms. The action-based nature of her role at this point stems from the fact that this whole novel is based on an unused script Adams had originally written for *Doctor Who*, and

Trillian essentially assumes the Doctor's role for the latter pages.

She takes centre stage again in *Mostly Harmless*, this time in duplicate, thanks to the convergence of parallel dimensions. Under the name Trillian Astra, she is a successful news reporter for a big sub-etha network, and also has a daughter called Random, conceived using Arthur's sperm from a DNA bank. But we also meet Tricia McMillan, a version of the same character who encountered Zaphod at the party but, crucially, went back to get her bag and thus missed her chance for a life of intergalactic high jinks. She's very confused when Random shows up in a flying saucer, addressing her as "mother" – and even more confused when she meets Trillian, her parallel self, in the final showdown.

Trillian was played in the original radio series by Susan Sheridan. In the TV series, the role went to Sandra Dickinson, whose frizzy blonde hair and squeaky American voice seem to jar with the novels' description of a character who is dark-haired and, at least before her TV career, certainly no bimbo. Trillian plays a particularly prominent role in the film, where she is portrayed by a turquoise-jumpsuit-sporting Zooey Deschanel.

Fenchurch

Though unnamed, Fenchurch is actually introduced on the very first page of the first book, as the girl sitting in a café in Rickmansworth, but she then disappears until *So Long, and Thanks for All the Fish*.

Arthur meets her upon his return to Earth, and immediately senses that they have something very significant in common. Eventually he discovers that, while the rest of the population has

Beetlejuice

Betelgeuse features in *Hitchhiker's* as (at least approximate) home to both Ford Prefect and his semi-cousin Zaphod Beeblebrox. And, unlike many locations cited by the ever-imaginative Adams, it does actually exist, a red supergiant star approximately 600 light years from Earth. Its name is believed to derive from the Arabic for "giant's shoulder", the etymology describing the star's position: it marks the left-hand shoulder of the "hunter" in the constellation Orion. Adams is by no means the only science-fiction writer to allude to Betelgeuse, which is presumably appealing in part because it is among the biggest known stars and in part because it has a slightly silly name. As well as being the birthplace to Tharg the Mighty, fictional editor of the *2000AD* comic, Betelgeuse shows up in Kurt Vonnegut's *Sirens of Titan* and the novels of Philip K. Dick. It seems safe to assume that Bela Tegeuse in Frank Herbert's novel *Dune* is an allusion to the star – and of course it was directly, if phonetically, celebrated in *Beetlejuice*, the Tim Burton comedy horror film of 1988.

dismissed it as a mass hallucination, Fenchurch is convinced that Earth really did get destroyed. As a result, everyone thinks she's bonkers, but Arthur simply falls even more in love with her – here, finally, is a fellow human to whom he can talk about his own adventures.

Some have seen in Fenchurch hints of Adams's romance with his future wife Jane, although biographer M.J. Simpson suggests the

character was based on the writer Sally Emerson, with whom Adams had a relationship (see p.129). The author himself stated that the main inspiration came from memories of adolescent love. Whatever the truth, Fenchurch is a little more three-dimensional, if perhaps less brainy, than Trillian. She also differs in that her relationship with Arthur is actually consummated – on the wing of an aeroplane to boot.

Her name is a nod to Oscar Wilde's *The Importance of Being Earnest*, in which a lead character was famously discovered inside a handbag at Victoria Station. Adams's creation, by contrast, was actually *conceived* at Fenchurch Street Station, apparently in the ticket queue. We learn that she is fairly tall, has dark hair and a pale face, and is prone to looking rather serious, though she's in possession of a fantastic smile. She also learns the cello and lives in a bizarrely converted stable in Islington, where entry can require the operation of a pulley system. Most remarkably, her feet don't touch the ground, but rather glide along just above it.

The job of bringing Fenchurch to life has largely fallen to Jane Horrocks, who plays her on the Quandary Phase radio series (see p.155) as an amiable, no-nonsense northerner.

Slartibartfast

Key to understanding Slartibartfast is the fact that when Adams wrote the part, he reportedly envisaged it being played by John Le Mesurier. The English actor, who would instead play the small role of the Wise Old Bird in the Secondary Phase radio series, is best known as the charming, well-educated and slightly vague Sergeant

Wilson in the classic World War II sitcom *Dad's Army* (bizarrely, another show with the catchphrase "Don't panic").

Arthur meets the elderly planet designer on Magrathea in the first novel, in which he is portrayed as dignified, trustworthy and wise, if a little lost in his own thoughts: Sergeant Wilson meets Gandalf, with a bit of Moses thrown in. He is a particular lover of

Arthur (Simon Jones) in the BBC TV series, alongside Richard Vernon as Slartibartfast – a wise Magrathean who is ignorant of early 1960s sitcoms.

fjords, and won an award for designing the coastline of Norway. We subsequently learn that he is part of the Campaign for Real Time (a gag that will make more sense to those familiar with real-life British organization CAMRA, the Campaign for Real Ale).

Slartibartfast reappears in *Life, the Universe and Everything*, in a substantially more purposeful, active role. Frankly, it doesn't suit him and even Adams himself acknowledged that the personality transplant may have been a mistake. Again, it was the unfortunate result of the author's using a rejected *Doctor Who* script as the basis for the third novel, Slartibartfast being assigned the Doctor's role before it's given over to Trillian.

Richard Vernon played the character, in suitably grandfatherly fashion, in the original radio series, as well as on the record and on TV. In the Tertiary Phase radio series, Slartibartfast was played by Richard Griffiths. Bill Nighy took on the role for the film, his lived-in, handsome features and voice – simultaneously authoritative and insouciant – making him something of a shoo-in.

Deep Thought

Deep Thought is a giant computer, built by pan-dimensional beings (who in this dimension look exactly like mice) as part of their attempt to find the Ultimate Answer to Life, the Universe and Everything. It is Deep Thought who, in answer to this question, delivers perhaps the best-known line in the whole story: "forty-two". It is also Deep Thought who designed Earth, as a still more powerful computer intended to make sense of this apparently meaningless answer.

Deep Thought's name, described by Adams as an obvious pun, is presumably taken from the anonymous source in America's Watergate scandal. The part was originally played on radio by Geoffrey McGivern, more prominently cast as Ford Prefect. The role was then taken on by acclaimed voice actor Valentine Dyall for the album and TV series, and in the film by Helen Mirren. This, for once, was a role in which she really *couldn't* be dubbed thinking man's crumpet. Instead, the film's Deep Thought sits somewhere between Rodin's *The Thinker* and a bored, block-headed Buddha.

Prosetnic Vogon Jeltz

The Vogons are the baddies of the *Hitchhiker's* story, all the more unpleasant for the fact that they aren't exactly evil as such, but simply stubborn, cold-hearted and absolute sticklers for laborious paperwork. They are grotesquely ugly, unshapely brutes with a lumbering gait and dark-green, sluggish skin.

Prostetnic Vogon Jeltz is in charge of the Vogon ship that attempts to destroy Earth in *The Hitchhiker's Guide to the Galaxy* and returns to finish the job at the end of *Mostly Harmless*. Terrifyingly, he is said to appear ugly even to other Vogons. He is also a keen poet, using his verse as a means of torture, it being well known that Vogon poetry is the third worst in the Galaxy.

In the original radio series, Jeltz was played by Bill Wallis, who also played Mr Prosser – an appropriate casting decision since that character is, to an extent, Jeltz's Earth-bound alter ego. Toby Longworth took the role in subsequent radio series, with Martin Benson cast in the TV series and Richard Griffiths in the film. In

This etching of John Bull by James Gillray is a virtual prototype for the bloated, vulgar Vogons of the *Hitchhiker's* movie.

this format, the Vogons really come into their own, their flattened faces, hunched backs and hopelessly overhanging bellies partly inspired by the work of eighteenth-century satirical cartoonist James Gillray.

Eddie

Eddie is the Sirius Cybernetics Shipboard Computer that controls the *Heart of Gold* spaceship. Though capable of working out the occupants' personality problems to ten decimal places, he is apparently unable to solve the flaws in his own oppressively cheerful character, bombarding his passengers with banal greetings. He is even known to break into a kind of mechanical croon at the most inopportune moments, presumably in a misguided attempt to restore calm.

If Marvin is Eeyore from *Winnie the Pooh*, Eddie is the ever-bouncy Tigger – via the plastic platitudes of American corporate hospitality. Eddie does have a back-up personality, a kind of mollycoddling matron, but if anything it's even less tolerable. In either incarnation, suffice to say that most readers no doubt empathize with Zaphod's threat to re-program Eddie's data banks with a large axe.

The role was played in the original radio series by David Tate, with some help from a ring modulator and an electro-mechanical typewriter. Tate also provided the voice for the TV series and album, while in the film the voice is provided by Thomas Lennon.

Benjy and Frankie

As the physical manifestation of hugely powerful pan-dimensional beings, mice play a vital, though fairly brief, role in *The Hitchhiker's Guide to the Galaxy*. Mice were the most intelligent creatures on Earth – a "rodent genius" concept explored in Daniel Keyes' story "Flowers for Algernon". And it was they who, in their quest to find the Ultimate Question, first ordered the construction of the supercomputer known as Earth – and who ordered the replacement version, after that planet's demolition at the hands of the Vogons.

Benjy and Frankie are the two mice Trillian brought with her from Earth, never for a moment realizing that they were the planet's most intelligent life form. Things turn nasty on Magrathea, when the creatures realize that instead of getting Slartibartfast and chums to rebuild the Earth computer and waiting another ten million years for it to complete its program, they can simply take the necessary information from Arthur's brain. Unfortunately, they need to remove it first, and they aren't going to let Arthur's horrified

objections stand in their way. When Arthur escapes, Frankie and Benjy decide that, to have any chance on the 5-D lecture circuit, they'll simply have to make up their own question to fit the answer 42. They ultimately settle on "How many roads must a man walk down?"

The versatile David Tate added Benjy to his numerous roles in the original radio series, with Frankie played by respected voice artist Peter Hawkins (who also, incidentally, voiced the Daleks in *Doctor Who*). In the TV series, the characters are represented by real mice, voiced by Tate and Stephen Moore. In the film version, in which they are again played by real mice, the voices are provided by director Garth Jennings and his sister Zoe Kubaisi.

Random

Random is Trillian's daughter, conceived using Arthur's sperm from a DNA bank and born on a spaceship – hence her full name, Random Frequent Flyer Dent. Somewhat older than her ten years thanks to the complications of repeated time travel, she largely adheres to adolescent cliché, her default moods either sullen or stroppy. A childhood spent travelling the Universe with her news reporter mother only exacerbates the emotional problems posed by puberty, as Arthur discovers when Random arrives on the planet of Lamuella in *Mostly Harmless*. She might not be the only teenager to complain that life is boring, but she may be the only one to do so on the grounds that gravity is activated *all the time*.

Understandably upset that she doesn't have a home, even in planetary terms, Random travels to Earth in the company of the

rather malevolent *Hitchhiker's Guide to the Galaxy Mk 2*. Even here, however, she is unable to find a sense of belonging. Matters are only complicated by the presence of Tricia, a version of her mother from a parallel dimension.

Random was played in the radio series by Samantha Béart.

Sperm whale

Although making only the briefest of appearances, as a missile transformed by the Infinite Improbability Drive, the sperm whale from the original radio series (and the first novel) seems to have captured many hearts. Adams said he

received numerous letters from people upset by the creature's brief but emotive internal monologue as it plummets to its death on the planet below. The character was voiced in the original radio series by Stephen Moore, who also took the role for the TV series. Comedian Bill Bailey provided the voice in the film version.

Humma Kavula

In *The Restaurant at the End of the Universe*, we're told in passing of the Jatravartid people of Viltvodle Six, who believe that the entire Universe was sneezed out of the nose of a creature called the Great Green Arkleseizure. Their days are spent waiting, in awe, for the Coming of the Great White Handkerchief.

Being Humma Kavula: John Malkovich as the nasal missionary in the *Hitchhiker's* movie.

It was apparently at Adams's own instigation that this idea was considerably expanded for the *Hitchhiker's* film. Here, the *Heart of Gold* lands on Viltvodle Six and our protagonists meet Humma Kavula, the high priest of this rather bizarre religion. He's played by John Malkovich as a kind of demented Elton John, but with two major physical modifications. First, he has no eyeballs, though he wears glasses that disguise the sunken sockets; and second, his "normal" body stops at the torso, his numerous legs instead mechanical and telescopic.

3

The Hitchhiker's universe

Many of the themes in *The Hitchhiker's Guide to the Galaxy* – towels, tea, and the like – are undoubtedly meant to be briefly amusing, nothing more. Even these are worthy of a little explanation, particularly, for instance, for the *Hitchhiker's* novice coming to the novels in non-sequential order. There are also, however, rather deeper aspects of science and philosophy in the story, discussed ad infinitum by Adams's more obsessive fans (and he certainly has his fair share of those). So, bearing in mind the

ever-present danger that analysis can kill what is still, first and foremost, a work of comedy, here are a few of the key concepts, themes and recurring motifs.

God

God – or rather gods – crop up regularly in *The Hitchhiker's Guide to the Galaxy*. At the very start of the saga, we hear of Oolon Colluphid's literary trilogy *Where God Went Wrong, Some More of*

God taking time out from creation to have a little bit of a dance.

God's Greatest Mistakes and *Who Is This God Person Anyway?* And the theme continues right through to *Mostly Harmless*, with Old Thrashbarg ranting and raving about "Almighty Bob".

Along the way, we find the site of God's last message to his Creation transformed into a naff tourist attraction, the message itself thoroughly underwhelming. In a grand mockery of eschatology, the Great Prophet Zarquon manages to spectacularly mis-time his own second coming, arriving at the Milliways restaurant just in time for the end of the Universe. We meet "Rain God" Rob McKenna, a lorry driver who brings rain wherever he goes. And then there's Humma Kavula and the handkerchief-worshipping religion dedicated to the "Great Green Arkleseizure".

It's fair to say, then, that God doesn't emerge from *Hitchhiker's* in a very positive light. But like Zarquon, He comes across more as a bungler than a malicious tyrant; and Jesus is portrayed sympathetically as getting nailed to a tree "for saying how great it would be to be nice to people for a change". In many ways, then, it's organized religion, rather than God Himself, that is targeted – although in the first novel God is "proven" not to exist at all, thanks to the Babel fish (see below). Adams's interest in evolutionary theory is evident as early as Fit the Sixth, when he (and co-writer John Lloyd) present the Haggunenons of Vicissitus Three, who evolve several times over a single lunch. This curiosity only increased with passing years, particularly after the *Last Chance to See* trips of the late 1980s (see p.133) and his friendship with Professor Richard Dawkins, known as "Darwin's rottweiler" for his fierce championing of natural selection over creationism. Adams seems to have shared many of Dawkins' views, in 1998 agreeing to an interview with *American Atheist* magazine, in which he made it

abundantly clear that he was no mere agnostic but rather a "radical atheist". However, as someone who had been a Christian until the age of eighteen, and described himself as agnostic as late as 1984 – the year *So Long, and Thanks for All the Fish* was published – it seems that Adams's radical atheism was a relatively late development.

Towels

The Hitchhiker's Guide to the Galaxy describes the towel as "about the most massively useful thing an interstellar hitchhiker can have". To some extent, of course, its uses are practical. As well as providing warmth and shelter, it can also be used as a weapon, a sail, a distress signal – even, on occasion, to dry oneself. But The Guide also says that much of the towel's value is psychological, hence the phrase "really knows where his towel is" to convey a certain togetherness as a person.

Many hitchhikers modify their towels by weaving items such as computer equipment into the fabric. Ford Prefect, however, favours a relatively unadorned towel, one corner soaked with nutrients. This idea is espoused even more enthusiastically by Roosta, whose towel is saturated with protein, vitamins, wheatgerm, Bar-B-Q sauce and even anti-depressants.

Other than its dietary augmentations, Ford's only customizations to his Marks & Spencer towel have been to thread a few pieces of wire and a writing implement into the hem, and to reinforce the stitching. This last modification is one for which he is particularly grateful when, in *Mostly Harmless*, he finds himself hanging by his

towel from an airborne robot. The item's manifold uses are also further evident when, later in that book, he and Arthur use one, matador-style, to catch a Perfectly Normal Beast.

Quite why Adams decided to elevate the humble towel to the level of combined survival kit and security blanket is a matter of conjecture. Science-fiction writer Mark W. Tiedemann, for instance, suggests that towels replicate the loop structure of the Universe. A more prosaic explanation comes from Adams himself, who explained that he had repeatedly lost his towel while on holiday in Greece, and decided that it was symptomatic of the disorganization in his life in general.

Whatever its origins, the humble towel has become one of the most iconic of *Hitchhiker's* accessories, even being produced as a promotional item. It is a testament to the esteem in which the *Hitchhiker's* towel is held that it is now honoured with its own Wiki page (towel.org.uk). And every year on 25 May, a hard core of fans carry a towel in tribute to the late Douglas Adams.

Babel fish

The language problems associated with conversing with aliens are usually conveniently ignored by sci-fi writers. Adams, however, addressed the issue head-on, solving it at a stroke through a simple but ingenious device called the Babel fish, which Ford gives Arthur as soon as he leaves Earth. In fact it's not a device at all, but a naturally occurring life form; inserted into one's ear, this small, yellow, leech-like creature feeds on brainwave energy and then excretes it in a filtered form, so instantly translating any incoming language into one understandable by its host.

So useful is the Babel fish that it is even cited by The Guide as evidence of the non-existence of God. The somewhat warped

The Babel fish, Adams's rather neat attempt to address an issue ignored by most sci-fi writers, whose aliens speak perfect (if strangely accented) English.

argument here is that the fish is too useful to have evolved by chance, which could be seen to prove that God *does* exist – but since His existence relies on faith, and proof negates faith, the existence of proof (said fish) implies the non-existence of God. On hearing this, God "promptly vanishes in a puff of logic".

The fish is named, presumably, after the Biblical story of the Tower of Babel, built by a united, monolingual humanity. When God realized that the tower was being built in order to celebrate the glory of man, rather than a divine presence, He scattered the people across the Earth, dividing them by different languages as they went. Adams seems to have regarded these schisms as a good thing: in *Hitchhiker's*, we learn that in breaking down language barriers, the Babel fish has caused more bloodshed than any creature in history.

Of course, the Babel fish lives on beyond the *Hitchhiker's* story as the name of an online translation service.

The ultimate answer

Perhaps the most famous concept in *The Hitchhiker's Guide to the Galaxy* is the idea that there is a simple answer to the meaning of life: 42. This, as any sane person can see, is a non sequitur, funny precisely because of its lack of meaning. Fans, however, have spent the last three decades desperately trying to "solve" this puzzle, apparently oblivious to the fact that discussion renders the joke *less* funny, rather than more.

Some, for instance, have found significance in the fact that 42 in binary form comes out as 101010. Others have focused on the part of the story set on pre-historic Earth, where Arthur tries to spell

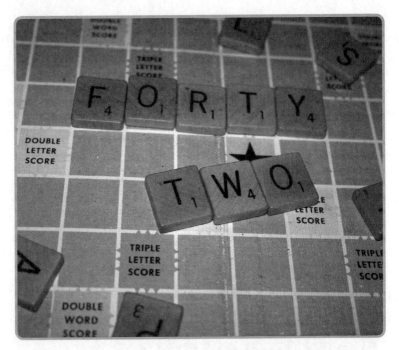

out the Ultimate Question using scrabble letters. The resulting question, "What do you get if you multiply six by nine?", gives the answer 54, not 42. Yet some have pointed out that six multiplied by nine does in fact equal 42 if carried out in the numeral system known as base 13. (Adams wryly responded that he didn't write jokes in base 13.)

Writer and academic Adam Roberts, meanwhile, has detected parallels in Kierkegaard's *Either/Or*, in which the Danish philosopher – incidentally another proto-existentialist (see below) – pictures a bookkeeper ruining a merchant house through confusing the numbers six and seven.

Still others have detected literary, scientific and even religious significance in the number 42. Lewis Carroll used it in both *Through the Looking Glass* and *The Hunting of the Snark* (and the latter *was* an influence in naming each *Hitchhiker's* radio episode a "fit"). The number 42 also crops up in several religions, including, apparently, a Tibetan mystical cult. And perhaps most significantly, 42 is the atomic number of molybdenum, a chemical that many regard as crucial in creating life on Earth.

Adams put rather a wet blanket on this often inspired conjecture by announcing he'd chosen the number simply because it was dull – as he put it, a number "you could take home and show to your parents". He also stated that he'd remembered John Cleese, something of a hero to him, declaring 42 to be the most ordinary number. Post-*Hitchhiker's*, it is certainly no longer that, referenced by everything from UK TV sitcom *The Kumars at No. 42* to the terrifyingly slick funk-pop act Level 42.

Existentialism

In a universe in which an entire planet can get potted as part of a cosmic game of billiards, life can seem disorientating, even futile. One solution for those looking for meaning – beyond the number 42 – is that expressed by Slartibartfast, in what writer Marguerite Krause suggests may be the core message of the whole *Hitchhiker's* saga: "Perhaps I'm old and tired, but I always think that the chances of finding out what is really going on are so absurdly remote that the only thing to do is say hang the sense of it and just keep yourself occupied."

It's worth remembering that philosophers such as Majikthise and Vroomfondel are mocked in the *Hitchhiker's* series just as mercilessly as representatives of religion. But even so, Slartibartfast's words could be read as evidence of a quasi-existential outlook, abandoning the hope of objective truths and settling instead for an "authentic" individual existence (relating back to questions of free will – see below).

A similar sentiment is expressed in Arthur's decision to settle down as the Sandwich Maker, accepting the pointlessness of existence but nevertheless content. In this, Arthur parallels the Greek mythological figure of Sisyphus, as interpreted by philosopher Albert Camus – condemned to forever repeat the same meaningless task yet nonetheless happy.

Existentialist concepts of angst and dread are perhaps most obvious when Arthur loses Fenchurch, as well as his home planet, in *Mostly Harmless*. His wretched, aimless wanderings would not be out of place in the works of existentialist poster boy Jean-Paul Sartre.

Zen

Western interest in Zen Buddhism had been growing since the Beat writers of the 1950s and spilled over into the well-intentioned, if frequently half-baked hippie philosophy of the following decade. In 1974, just three years before the first *Hitchhiker's* episode made the airwaves, Robert M. Pirsig published his prodigiously selling *Zen and the Art of Motorcycle Maintenance* – itself parodied in the *Hitchhiker's* TV series as *Zen and the Art of Going to the Lavatory*.

Fate, free will and precognition

In the first and second *Hitchhiker's* novels, Zaphod Beeblebrox is acting in a manner not even he understands: stealing the *Heart of Gold*, demanding a meeting with Zarniwoop and so on. His behaviour turns out to be the result of a plan he dreamt up with Zarniwoop, all memory of which has been erased – but which he nonetheless cannot escape. A similar theme crops up in *Life, the Universe and Everything*, with Agrajag telling Arthur that he can't die until he's been to Stavromula Beta. This is Adams's take on the age-old question of predetermination versus free will, a preoccupation from Aristotle's era right up to *Minority Report*, both the Philip K. Dick novel and Steven Spielberg film. Indeed, an intergalactic version of that story's "Precrime" department might have prevented Agrajag's death at the end of *Mostly Harmless* (and, of course, on every other occasion). The issue of free will also relates to time travel, particularly the "grandfather paradox" explored on p.109 of this book. Assuming it were possible to travel back in time, do humans possess sufficient free will to change the course of history?

No grandparents were harmed during the testing of this hypothesis...

It is perhaps unsurprising, then, that despite its backdrop of spaceships and robots, it is possible to see parallels between *Hitchhiker's* and Zen Buddhism (which, arguably not a religion at all, may not have been tarnished by the highly sceptical attitude towards God detailed above).

The Man in the Shack, the true ruler of the Universe, has something of the Zen master about him, refusing to assume that

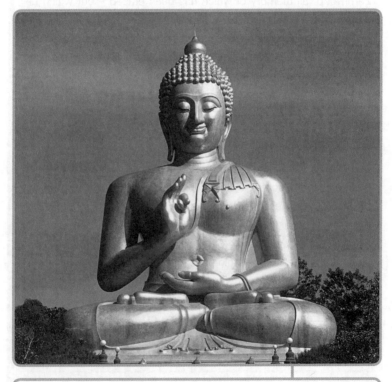

Life is suffering. Just ask Agrajag.

rain is wet, and talking to a table for a week simply to see what happens. His simple yet mysterious statements are reminiscent of the riddle-like Zen koans, demolishing traditional notions of logic as effectively as the infamous question "What is the sound of one hand clapping?"

Writer Marie-Catherine Caillava suggests that the idea of 42 as the Ultimate Answer could itself be regarded as a koan. She also detects Zen in the Total Perspective Vortex (see p.110), which breaks down pre-conceived notions of our importance in the Universe. Elements of Buddhist teaching can be located in the "not thinking" Arthur requires for flying, where any contemplation of what he's actually doing will bring him down with a bump. And the Buddhist idea of reincarnation shines through in the character of Agrajag, whom Arthur has killed repeatedly (if often unknowingly).

We even get the interstellar version of Shaolin, in the form of Pralite monks. Perhaps understandably, many leave the order just before vowing to spend the rest of their lives inside small metal boxes. Instead, they roam the Universe running Mind-Surfing resorts and presumably being celebrated by the intergalactic equivalent of the Wu-Tang Clan.

Bureaucracy

Unlike normal sci-fi baddies, we're specifically told that the Vogons are not actually evil. They are disgustingly vile, certainly, but their most negative quality is to be so beholden to red tape that they wouldn't save their own grannies without orders signed in triplicate. It is thanks to precisely this questionable personality trait that

Vogons have come to constitute the backbone of the Galactic Civil Service, and as such demolish Earth in order to make way for a hyperspace bypass.

The Vogons' unthinking adherence to fixed rules is particularly clear in the movie version. When the protagonists visit Vogsphere, any original thought is punished by a smack in the face from one of a number of paddles that shoot up from the ground. In perhaps the ultimate symbol of Vogon bureaucracy, they are then forced to rescue Trillian by queuing up and finding and completing precisely the correct piece of paperwork. This idea, explained director Garth Jennings, was conceived as a deliberate contrast to the action-hero antics one would expect from films such as *Star Wars*.

Back on Earth, in a satire of the inscrutable nature of official paperwork, Arthur learns that the documents concerning the demolition of his house have been "on display" in a locked filing cabinet inside a disused lavatory, itself in a dark, stairless cellar. When he questions why it is necessary to build the bypass for which his house must be demolished, Mr Prosser simply replies: "It's a bypass. You've got to build bypasses." This, it seems, is justification enough.

There's also an extended dig at a certain stratum in the hierarchy of office authority in the story of the Golgafrinchan B Ark and its cargo of personnel officers and advertising executives. Continuing to trot out their middle-management mantras even on pre-historic Earth, they attempt to discover fire by organizing a focus group. Meanwhile, their main problem in developing the wheel is working out what colour it should be.

The myopic and often menacing corporate forces that so plague Arthur are reminiscent of those suffered by characters in the work

of author Franz Kafka or even in the more recent book and film *Fight Club*. Both, incidentally, also contain elements of existentialist philosophy – see above.

Capitalism

For all his mockery of over-zealous pen-pushers, perhaps an even more significant theme in *Hitchhiker's* is Adams's attitude to the larger corporate structures that employ them. He has a pop at custom-designed luxury goods through Magrathea, a planet dedicated to building other planets at extortionate prices. And there's even a dig at the concept of money itself, when Adams points out that the pushing around of small green pieces of paper hasn't managed to change the fact that most people on Earth are unhappy most of the time.

The almost ubiquitous Sirius Cybernetics Corporation provides an ongoing vehicle for Adams's mockery of capitalist big business. The giant sign displaying the company motto, "share and enjoy", is now semi-submerged, with the unfortunate result that its meaning has changed considerably. In the local language, it now reads: "Go stick your head in a pig."

The other prominent company in the saga, equally ripe for ridicule, is the one that publishes *The Hitchhiker's Guide to the Galaxy* itself. Initially it's Megadodo Publications, none too promising a moniker given that the dodo is pretty much the archetypal extinct species, but one which looks like branding genius when compared to the name of its successor: InfiniDim Enterprises. The thoroughly nasty nature of this company is evident in its

transformation of the *Hitchhiker's* offices from a hedonist's playground into a sterile and sinister corporate hellhole, and its manufacture of the terrifying *Hitchhiker's Guide to the Galaxy Mk 2*.

Adams even gives us his own version of economic theory in the Shoe Event Horizon, most fully developed in the radio version. This concept states that since a depressed person will tend to hang his head, a declining civilization will attempt to cheer itself up by buying new shoes. As this phenomenon picks up momentum, more and more shoe shops will appear. However, the quality of the footwear they sell will decrease as they struggle to keep up with demand – hence people need to buy new shoes even more often. Eventually it becomes financially impossible to open any other type of shop and the entire economy collapses.

Though this could be seen as Adams's pithiest send-up of capitalism, it's worth pointing out that Adams is an equal opportunities satirist, often mocking opposing viewpoints with equal gusto. Sometimes, in fact, it's not even clear quite who he's targeting. Political columnist and fantasy author Vox Day, for instance, has seen the Shoe Event Horizon as a dig not at capitalism, but rather at the Marxist notion of capitalist crisis, which is pretty much the antithesis.

Politics

The negative portrayals of politicians in *The Hitchhiker's Guide to the Galaxy* are surely not unrelated to the socio-economic climate in which Adams originally wrote the story. Under the prime ministership of James "Crisis? What crisis?" Callaghan, Britain was crippled by trade union strikes in the late 1970s. The crisis's nadir, notoriously dubbed the Winter of Discontent, fell squarely between the broadcast of the original *Hitchhiker's* radio series (1978) and the publication of the first novel (1979).

It's a long way, however, from Jim Callaghan's consensus politics to the megalomania of Zaphod Beeblebrox, Adams's President of the Galaxy. Rightly or wrongly, Zaphod would probably regard John F. Kennedy or even Barack Obama as his nearest Earth-based equivalent. Sam Rockwell, who played the role in the film version, said his Zaphod was in part influenced by Bill Clinton.

If Zaphod in a sense represents all world leaders, then it's a none too flattering portrayal. He is reckless, selfish and cowardly – in fact, it's for precisely these "qualities" that he got the job. For in Adams's

Universe, the President of the Galaxy is nothing but a puppet, the logic being that anyone who wants to rule is ipso facto unsuited to the task. (Remarkably, Adams conceived this argument *before* the presidency of George W. Bush.)

The majority of the Galaxy's population, however, don't seem to know that the Man in the Shack really rules the Universe, and hence presumably believe that Zaphod really is in charge. Strangely, they don't seem to mind. Perhaps the explanation is the same as that Ford offers of a democratic world run by lizards. The people hate the lizards but nonetheless keep voting them back into power – "because if they didn't vote for a lizard, the wrong lizard might get in".

All in all, there are enough jokes at the expense of politicians and government for Vox Day to dub *Hitchhiker's* an "overtly anti-government collection of subversion". And as he has pointed out, there's a certain irony in the fact that it was funded and distributed by the BBC. Again, however, Adams throws us a counterweight. Just before anyone writes him off as a radical lefty, it should be borne in mind that the absurd threat of a national philosophers strike by Vroomfondel and Majikthise in the first book pretty much demolishes trade unions with a single blow.

The insignificance of Earth

Space, as The Guide tells us, is big, and any individual planet is pathetically insignificant in comparison. Earth, however, seems to come in for a particular bashing, as is clear from Ford Prefect's description of the planet in The Guide itself. Despite Ford's fifteen

The end of the world

The Earth in *The Hitchhiker's Guide to the Galaxy* isn't just insignificant – it's also destroyed, both in the first novel and then again, when saved by parallel universe shenanigans, at the end of *Mostly Harmless*. If this sounds a little downbeat, it's nothing compared to Adams's original pitch to radio producer Simon Brett: *The Ends of the Earth* would have seen the planet being destroyed in a different way every single week.

Given that he had long been producing such jolly storylines – a "world blows up" sketch on TV sketch show *Out of the Trees*, an "end of the Universe" sketch on *The Ringo Starr Show* and so on – one could detect in Adams an unhealthy obsession with apocalypse.

While doomsday scenarios have long been used in fiction and film to introduce suspense, Adams's work is unusual in that the demolition of the Earth is presented in such perfunctory fashion. And whereas the destruction of the Earth usually provides a story's climax – or, even more often, is somehow averted at the last minute – it takes place right at the start of *Hitchhiker's*, in the very first episode of the radio series. In this sense, Adams's work has less in common with *The War of the Worlds* or *Day of the Triffids* than with the film *Titan A.E.* or Dan Simmons's novel *Hyperion*, in which the Earth is destroyed early in the tale – and, in the latter case, entirely by mistake.

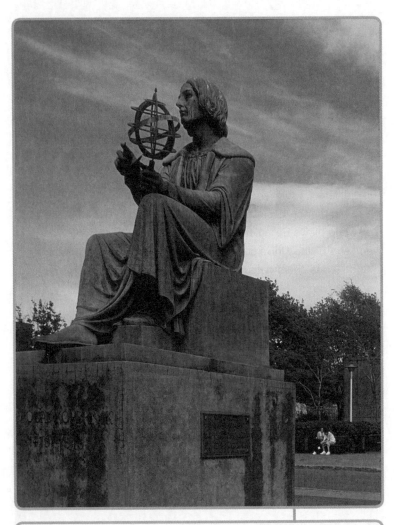

A bronze statue of astronomer Nicholas Copernicus (1473–1543), the father of heliocentric cosmology, at the Montréal Planetarium in Canada.

years of research, the subeditors don't think we deserve more than two words: "mostly harmless".

It's the culmination of an argument that's been going on ever since 1543, when mathematician and astronomer Nicholas Copernicus (pictured opposite) made the enormously controversial claim that Earth orbited the Sun, not the other way round. It resurfaced in the eighteenth century, when Voltaire's *Micromégas* mocked the Earth-centric views of our philosophers. Even today, we struggle with the idea that we really are just another planet. Or, as Adams puts it in the opening lines of the first novel, an "utterly insignificant little blue-green planet" orbiting a "small unregarded sun" located "far out in the uncharted backwaters of the unfashionable end of the Western Spiral Arm of the Galaxy".

This situation becomes even harder for Arthur to accept when he learns that Earth is not just utterly forgettable, it's also strictly functional. There is nothing mysterious, let alone miraculous, about its origins: it was simply built by the Magratheans as a supercomputer, at the request of pan-dimensional beings who look like mice. Even something of such apparently natural magnificence as the Norwegian coastline is merely the result of the fact that Slartibartfast, who was designated as that country's designer, happened to like fjords.

The ultimate insult is that Earth is summarily demolished simply because it obstructs the path of a hyperspace bypass – or, as we later learn, for the equally offhand reason that psychiatrists wanted to prevent the discovery of the meaning of life.

Humans as the planet's third most intelligent life form

Arthur not only has to come to terms with the idea that Earth is a thoroughly inconsequential place. He is also forced to acknowledge that, even on that trivial scale, humans are of rather less significance than he'd previously assumed. We are in fact only the planet's third most intelligent life form.

Though humans dismissed their attempts to warn us as a form of light entertainment, the dolphins had long foreseen the attempted destruction of Earth. Furthermore, they actually prevented its demolition, replacing it with a planet from a parallel dimension before departing for good. And mice are still more intelligent and powerful, a manifestation of pan-dimensional beings of quite staggering potency. Even the wise old Slartibartfast is at their beck and call.

The intelligence of animals is a recurring theme, and one also reflected in Adams's non-*Hitchhiker's* projects, particularly *Last Chance to See*, in which Adams and zoologist David Carwardine searched for near-extinct species (see p.133). By all accounts the project had a profound effect on Adams, feeding his love of Darwinism and inspiring his attempt, for instance, to climb Mount Kilimanjaro in a rhino suit.

Adams's assessment of the relative intelligence of humans and animals doesn't just cast positive light on the animals, however; it also suggests that humans are, by contrast, a bit dim. In *So Long, and Thanks for All the Fish* we meet John Watson, the only man on the planet to understand the disappearance of the dolphins, having

studied the species in great detail. His opinion of humanity, however, is rather lower, particularly when he discovers a set of instructions inside a packet of toothpicks. Refusing to partake in a civilization that needs to be told how to remove its dental detritus, he renames himself Wonko the Sane and demonstrates his rejection of society by designating everything beyond his walls "the asylum".

Even extraterrestrial beings seem to regard humans with embarrassment, our insistence on resurrecting painful memories of the Krikkit Wars (see p.14) being regarded as particularly vulgar. And while humanity's close links with apes are referred to on several occasions, it seems that humans are not descended from primates at all, but rather from Golgafrinchan telephone sanitizers and marketing analysts.

Poetry

Like towels and tea, poetry is an apparently everyday concept that Adams imbues with a rather different meaning. It is most closely associated with the Vogons, who write it not in an attempt to capture some intangible sense of beauty but simply to throw into sharp relief the grotesqueness of their appearance.

"O freddled gruntbuggly", begins one Vogon work, in what appears to the non-Babel-fish-equipped as amphigouri or nonsense verse. To Arthur and Ford, however, strapped into special Poetry Appreciation chairs, the Vogon captain's poetry recital is a form of genuine torture – one with which anyone who has sat through a group creative writing class will empathize.

A scene from the *Hitchhiker's* movie, in which Arthur (Martin Freeman, right) and Ford (Mos Def) are tortured by the surrealism of Prostetnic Vogon Jeltz's underlying metaphors.

Vogon poetry is one of the most enduring ideas in *Hitchhiker's*, and one that will appeal to fans of Edward Lear and Lewis Caroll, or even – significantly, given Adams's Beatles obsession – John Lennon's *A Spaniard in the Works* and *In His Own Write*. It is even now possible to create your very own personal Vogon verse, via the BBC website's Vogon Poetry Generator (tinyurl.com/vogonpoetry). The one created in the course of researching this book included a line about a "psychotronic facial growth that looks like a cheese".

Like many of Adams's light-hearted and apparently fantastical ideas, however, the concept of poetry as an instrument of torture

recently took a rather chilling step closer to reality. In 2008 it was alleged that the US military had been using pop songs, played over and over again at high volumes, as part of their interrogation process.

Terrifyingly, Vogon verse is only the *third* worst in the Universe, the dubious honour of second place going to the Azgoths of Kria. Recital of a single poem by their Grunthos the Flatulent was enough to kill four members of his audience, a fifth surviving only by biting off one of his own limbs as a means of distraction.

In the original radio series, the worst poet of all time was Paul Neil Milne Johnstone, one of Adams's former schoolmates who also went on to study at Cambridge. However, less than keen on this public humiliation, he requested that his name be removed, and hence he is replaced by Paula Nancy Millstone Jennings (or a deliberately indecipherable tape re-edit on the album version).

Alcohol

The Hitchhiker's Guide to the Galaxy has this to say on the subject of drunkenness: "Go to it, and good luck." In many ways, it's a theme continued through the whole *Hitchhiker's* saga. The story actually begins with Arthur feeling hungover, then being taken to the pub by Ford Prefect and handed three pints of bitter – muscle relaxant, he's told, required when passing through a matter transference beam.

The alcohol theme continues as the story moves into outer space, Ford and Zaphod being particularly enthusiastic in its consumption. At Milliways, Ford is so drunk he collides with a waiter before promptly sliding underneath the table; fortunately the restaurant

has a machine for sobering up diners as they leave. Meanwhile, Zaphod's logic in consuming multiple consecutive drinks – the second to check the first is OK, the third to find out why the second hasn't reported back, and so on – has seen "Beeblebrox's gambit" pass into urban lore.

Elsewhere, we encounter a flying building that plays host to the longest party in history, sustained by regular booze raids on cities below (the whole concept itself conceived by drunken astro-engineers). We learn that 85 percent of known worlds in the Galaxy have a drink phonetically reminiscent of a gin and tonic: among them jynnan tonnyx, gee-N'N-T'N-ix, jinond-o-nicks, chinanto/mnigs and tzjin-anthony-ks. There are also regular mentions of Ol' Janx Spirit, with accompanying songs and drinking games, including one in which contestants have to pour the liquor into their opponent's glass through telepsychic power alone.

No drink, however, is treated with the sheer awe that surrounds the notorious Pan Galactic Gargle Blaster. Invented by Zaphod Beeblebrox, this is a cocktail so extraordinarily potent

that consumption – at least in the film version of the story – results in an involuntary scream. The recipe is detailed in The Guide, and there have even been attempts to create a "real life" version – though Geoffrey Perkins, who produced the original radio series, has stated that such a feat would be impossible under Earth's atmospheric conditions.

Tea

Wistfully imagined by Arthur, tea serves as a reminder of the character's humanity (and even specific nationality, it having been an established icon of Englishness since the days of the Empire). His regular requests for the beverage say much about Arthur's character, particularly in contrast to the prodigious quantities of alcohol consumed by Zaphod and Ford.

The drink carries connotations of warmth, comfort and relaxation, exactly those for which Arthur so desperately yearns as he stumbles around an absurd and frequently hostile Universe. Sadly, his search is in vain: the computer Hactar conjures a silver teapot, for instance, but it is merely an illusion. Even the *Heart of Gold*, for all its technology, can produce only a hopeless approximation of tea via its Nutri-Matic machine.

Perhaps the most high-profile appearance of the drink as a plot device comes when Arthur decides to inform the Nutri-Matic machine how to make a *proper* cup of tea. The enormity of his request demands so much of the shipboard computer that it has no circuits left with which to evade a Vogon attack. When they are saved by Zaphod's great-grandfather, they find that the Nutri-Matic

Drinks Synthesizer has produced a silver teapot and three bone-china cups and saucers.

Tea was even involved in the creation of the Infinite Improbability Drive, thanks to its role as a producer of Brownian Motion. Apparently it's largely a case of hooking up a Bambleweeny 57 Sub-Meson Brain to an atomic vector plotter and then placing the whole thing in a cup of tea.

Incidentally, if anyone is hungry for still more theories relating to the number 42, there's a light-hearted, tea-related solution to the number's meaning on a current *Hitchhiker's* forum: "Forty Two = For Tea Two = Tea For Two". So there you go.

Cricket

Despite its popularity in India, Australia and other countries with the questionable fortune to have once been part of the British Empire, cricket remains a quintessentially English pastime. The gentle thwack of leather on willow might not actually soundtrack the lives of the majority of the population but, like red busses, wonky teeth and Beefeaters, it's part of the England so loved by Hollywood.

All this makes the sport ripe for ridicule, particularly as Adams was writing long before the sexed-up Twenty20 game was introduced. The already limited activity tends to be played out between just three players, the bowler, wicket keeper and batsman, who will often play nothing but defensive strokes for so long that spectators fall asleep. In all likelihood, they will be awoken only by occasional screams of "Owzat!", shouted with the collective gusto of

Insensitive humans insist on referencing the horrific Krikkit Wars in the name of sport.

men who last touched the ball three hours previously and are dying to do something; the umpire may or may not respond by raising a single forefinger. And – final proof of the sport's inherent absurdity – there exists a position called "silly mid on".

Arthur Dent's interest in the sport signifies much the same character traits as his love of tea. But Adams uses cricket as more than mere personality signifier. Rather, it forms the central conceit of *Life, the Universe and Everything* (and the Tertiary Phase radio series). Here, the game of cricket is simply a lingering memory of the most violent wars in history.

The Krikkit robots responsible for this bloodshed exhibit numerous parallels to the game we know, including white shin-pads

that serve as jet packs and grenades that look like cricket balls. The key they are attempting so violently to reassemble is even shaped like a wicket, with three pillars and two cross-pieces. And then there is the game of Brockian Ultra-Cricket, which essentially amounts to two teams bashing the hell out of one another with miscellaneous sporting equipment, then retiring to apologize from a safe distance.

Cricket's appeal as a metaphor for life is well established, and Adams was by no means the first author to feature the sport. Even in Victorian times, for instance, it appeared in Charles Dickens's *The Pickwick Papers* and *Tom Brown's Schooldays* by Thomas Hughes. And at the end of the nineteenth century it featured in Sir Henry Newbolt's poem "Vitaï Lampada", its infamous refrain "Play up! Play up! And play the game!" proving as stirring on the battlefield as on the school cricket pitch. Since then, cricket has appeared in L.P. Hartley's *The Go Between* and the war poems of Siegfried Sassoon, as well as recent works by Thomas Pynchon (*Against the Day*) and Joseph O'Neill (*Netherland*). Most significantly in this context, however, it is also referenced in the work of two other writers, both keen practitioners of the sport and regarded as influences on Adams: A.A. Milne and P.G. Wodehouse.

Western pop culture

A considerable part of the appeal of the *Hitchhiker's* story comes from the fact that it comprises so many everyday scenarios and observances, simply blown up to cosmic scale. We all know of the ubiquity of McDonald's on Earth, for instance, but Adams takes it a stage further. When Trillian visits the Grebulons on the planet

Rupert, they feed her the best food they can offer: McDonald's hamburgers, reheated in a microwave.

That the brand's appeal has seduced even alien populations could be part of Adams's indictment of capitalism – see above – but it can also be read as a comment on the all-pervasive nature of Western culture. The Grebulons also buy lava lamps and brown corduroy beanbags via mail order, and watch American TV shows like *M*A*S*H* and *Cagney and Lacey*.

Elsewhere, Ford Prefect relaxes on a spaceship by watching the Western *The Magnificent Seven* and even says he only returned to Earth because he wanted to see the second half of the Bogart–Bergman classic *Casablanca*. Tony Bennett's signature song "I Left My Heart in San Francisco" is parodied in the *Hitchhiker's* showtune "I Left My Leg in Jaglan Beta". And then of course, there's Elvis Presley, living contentedly in outer space where he runs the Domain of the King Bar & Grill. He wasn't abducted by aliens, we're told, but rather went of his own accord.

Petty annoyances

In Adams's view of outer space, civilization has achieved a level of technological sophistication that humans can only dream of. For all their scientific advances, however, the population are often plagued by the same petty annoyances that we all experience in our daily lives.

Yes, there is danger from missiles, Frogstar Fighters, trigger-happy intergalactic cops and Vogon poets, but almost as problematic are the minor nuisances. We all know that foreign coins

can be confusing and awkward, for instance, but Adams gives us a single unit of currency that is thousands of miles in diameter. The Grebulons have enough technology to monitor activity on Earth in enormous detail, but their main concern is how to recalibrate their horoscopes in relation to the position of Rupert. And of course, there's the spaceship unable to take off until it has received its delivery of lemon-soaked paper napkins, an apparently simple task that has taken 900 years.

The fact that the Sirius Cybernetics Corporation complaints division occupies a landmass the size of several planets will not surprise those who have had dealings with the company's Earth-bound equivalents. Neither does the perverse notion of improving the quality of air inside office buildings by sealing all the windows shut seem unrecognizable. The explanation that the new Breath-O-Smart systems will negate the need for fresh air seems strangely familiar – as does their inevitably going wrong on a particularly humid day.

Sex

With the exception of the film version, in which the relationship between Arthur and Trillian is inevitably amplified, the *Hitchhiker's* story for the most part lacks all but the merest hints of sex, love or romance. We know that Zaphod and Trillian are in some kind of a relationship, but the details are kept fairly vague. Otherwise, the only erotic charge present in the first three books comes from Ford Prefect's fantasies of Eccentrica Gallumbits, the Triple-Breasted Whore of Eroticon Six. Arthur's libido seems to have deserted him

Though the relationship never quite convinced in the movie version, there was more of a spark between between Zaphod (Mark Wing-Davey) and Trillian (Sandra Dickinson) in the TV series.

before the saga even began, when he failed to chat up Trillian at the party back on Earth.

All this changes dramatically, however, in *So Long, and Thanks for All the Fish*, when Adams steps outside the narrative and asks whether Arthur "does not, to put it in a nutshell, fuck?" The answer, of course, is that he does – because by this stage he's met Fenchurch,

the saga's only prominent female character besides Trillian. But Adams also takes the opportunity to imply that just because Arthur's carnal exploits have not previously been detailed, there's no reason to assume that he passed the lonely nights on Krikkit, or on pre-historic Earth, in total celibacy.

Although we're never exposed to the presumably mind-boggling details, we're told that *The Hitchhiker's Guide to the Galaxy* itself dedicates many pages to sex. One entry on the subject suggests as further reading "chapters seven, nine, ten, eleven, fourteen, sixteen, seventeen, nineteen, twenty-one to eighty-four inclusive, and in fact most of the rest of the Guide". However, The Guide is not always reliable on the subject. Its account of the unspeakably sexy Fuolornis Fire Dragons, and their effect on the ever-randy people of Brequinda in the Foth of Avalars, is hopelessly out of date, much to the disappointment of visiting hitchhikers.

4

The science

The few scientists who appear in *The Hitchhiker's Guide to the Galaxy* are not spared the mockery dished out to practitioners of most other professions. One particular group, for instance, dedicate their time to thoroughly pointless experiments involving a robot and a herring sandwich. Yet Adams was, of course, very far from being sceptical of scientific endeavour as a whole.

Science fiction and science fact have long enjoyed a symbiotic relationship, and several concepts in *Hitchhiker's* are at least half-rooted in real-life discourse. Unfortunately, many involve quantum theory, in which physics steers dangerously close to metaphysics, in the process mangling the lay reader's brain as surely as a Pan Galactic Gargle Blaster. Here, then, is an attempt to explain some of the thinking behind concepts such as time travel and parallel universes, without once mentioning Schrödinger's cat. (If you

haven't yet become acquainted with that hypothetical feline, simultaneously dead and alive inside a sealed box, you'd be well advised to keep it that way.) The following pages also document how some of Adams's more inspired creations – the "Dish of the Day", sub-etha networks and the like – have proved impressively prescient of later developments in the realms of science and technology.

The birth of the Universe

The best explanation of the Universe's origins in the *Hitchhiker's* saga comes from an inebriated Ford Prefect – although he promptly ruins everything by announcing that he was not detailing the Universe's origins at all, but simply describing a good way to relax. Still, Ford constructs a decent, if rather basic, descriptive model: simply fill a bath with fine sand, film it all trickling down the plughole, and then reverse the film. That, he says, is the birth of the Universe.

Ford is essentially describing the Big Bang theory, the idea that the Universe exploded from an infinitely dense singularity approximately 15 billion years ago. In *Hitchhiker's*, the theory is referred to indirectly via the "Big Bang Burger Bar", and in Eccentrica Gallumbits' description of Zaphod as "the Best Bang since the Big One".

Most scientists seem to regard the Big Bang as the best explanation we've got for the birth of our Universe. The tricky question, and not just in terms of a measurement of Zaphod's sexual potency, is: what was there before the Big Bang? One theory states that the Big Bang wasn't the beginning of everything at all, merely

the beginning of *our* Universe. Another, supported by theoretical physicist Michio Kaku, says that the Big Bang could have been preceded by an unstable, ten-dimensional universe; the Big Bang represented that universe splitting into the four dimensions of our current existence. Still others say that we can't hope to answer pesky questions like this until we have developed a Theory of Everything – see **the Ultimate Answer**.

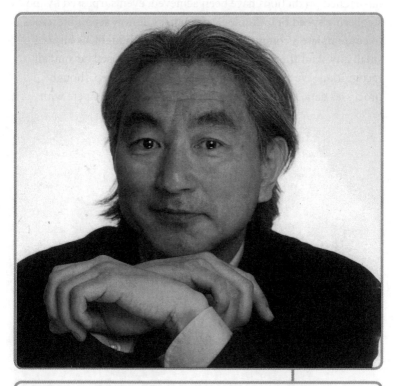

Theoretical physicist Michio Kaku contemplates a ten-dimensional universe.

Computers

The computer population of *Hitchhiker's* ranges from the irritating (Eddie) to the downright malevolent (Hactar). Its most prominent figures, however, are Deep Thought and its successor Earth – both, incidentally, portrayed in a rather more positive light.

As with many aspects of *Hitchhiker's*, Adams's most fantastical, far-fetched predictions have been achieved, even surpassed by the staggering speed of technological progress. It now seems ludicrous to contemplate a computer that is, like Deep Thought, as big as a small city. And the power of computers has increased beyond all recognition. We are not told the speed at which Deep Thought processes data, but it's debatable whether it could compete with

IBM's Roadrunner computer, which made computing history in 2008 when it achieved a processing speed of more than a thousand trillion operations a second.

Even if Deep Thought were able to triumph over Roadrunner in a game of cyber Top Trumps, its period of triumph would be limited due to Moore's Law, which effectively states that computer processing speed doubles every two years, thus increasing exponentially. Adams even refers indirectly to computer obsolescence, in that Deep Thought can only calculate the Ultimate Answer; working out the Ultimate Question requires a more powerful successor.

Incidentally, Deep Thought itself has become a reality in one very literal sense, in the form of a chess computer named in its honour. Though that computer lost to grandmaster Garry Kasparov in 1989, Kasparov was subsequently defeated by its successor – not planet Earth, but another chess computer called Deep Blue. Ironically, the Earth too is in a sense fulfilling its function as a supercomputer, following the rise of the Internet (see **sub-etha networks**). Unlike the Earth designed by Deep Thought, however, our version seems to be largely dedicated to pornography.

Dish of the Day

One of the greatest bit-part characters in *Hitchhiker's* is the Dish of the Day, a large dairy animal that actually wants to be eaten – so much so that it will recommend various parts of its anatomy to diners. Arthur is horrified by the concept, though Zaphod points out that eating an animal that wants to be eaten is surely better than

eating one that doesn't. The animal heartily agrees, disapproving of Arthur's preference for a green salad; as it explains, it knows many vegetables that, by contrast, don't want to be eaten at all.

On one level, the Dish of the Day – and the morals of consuming said creature in relation to a green salad – is just a quick joke at the expense of the vegetarian lobby. As usual, however, there are serious issues alongside the humour, most notably in the parallels with genetically modified food. The Dish of the Day was created only through careful breeding – of the kind that has been going on for hundreds of years and has, for example, bred the mothering instinct out of chickens to increase their laying rate – but GM has vastly increased our ability to manipulate nature in such ways.

As science-fiction author A.M. Dellamonica has pointed out, if Adams was alluding to GM food, he was predicting, rather than commenting on, a societal trend. The Flavr Savr tomato was not approved by the US Food and Drug Administration until 1994, a decade and a half after Adams created the Dish of the Day. But, yet again, Adams's fiction was very close to the mark: Dellamonica notes that Arthur's refusal to consume his Dish of the Day steak with the same gusto as Ford or Zaphod is very much echoed in twenty-first-century scepticism regarding transgenic food.

Though talking cows are a way off, science writer Michael Hanlon has noted that the Dish of the Day throws up ethical dilemmas that are not so far removed from our own reality, particularly given NASA's experiments with growing meat in a Petri dish. If, for instance, it became possible to breed animals that didn't feel pain, would vegetarians feel comfortable eating them?

The end of the Universe

Though we never get to see the actual end of all Creation, Adams does offer some idea of what to expect via the extended sequence in Milliways, the "Restaurant at the End of the Universe". Max Quordlepleen, the ultimate showbiz host, describes the last remaining red-hot suns being destroyed by photon storms, followed by an incredibly bright light before all of Infinity collapses into a void.

This, essentially, is the reverse of the Big Bang theory (see **the birth of the Universe**), a point Zaphod makes explicit by describing the Milliways climax as "nothing but a gnab gib". Known by scientists as the Big Crunch hypothesis, this is certainly accepted as one possible (although unlikely) way the Universe could end, perhaps in a few tens of billions of years. The science basically says that the expansion of the Universe would slow down and eventually be stopped by the immense gravitational pull of all the matter and dark matter. Everything would then implode into the infinitely dense singularity in which it existed prior to the Big Bang.

In Adams's scenario, this moment is followed by a state of affairs "that wasn't merely a vacuum, it was simply nothing". But there are those who suspect that there may be a more cyclical process at work, just as the Time Turbines pull Milliways back into existence, ready for the lunch sitting. According to this view, the contraction of the Universe would be swiftly followed by another Big Bang, the whole Universe constantly yo-yoing between the Bang and the Crunch. Though no entirely respectable scientist has put it in *quite* these terms, it's basically the existence of Agrajag (see p.15) blown up to cosmic scale.

The Big Crunch, and the associated Big Bounce, is only one theory of the end of the Universe, however. Another possibility is the Big Freeze, whereby the Universe simply continues to expand ad infinitum. Stars burn out and the temperature of the Universe drops, leaving a cold, dark wasteland of dead stars that exists for all eternity. There is also a third theory, dubbed Steady State, that says the Universe will continue to expand but is nevertheless in a state of equilibrium, because new matter is being continuously created to populate the expanding Universe. In other words, no Big Freeze, no Big Crunch, and everyone lives happily ever after. Unfortunately for us, however, this last scenario is considered highly unlikely by the majority of scientists.

A vision of the future?

The Guide

Though its appearance has changed somewhat between different formats of the story, *The Hitchhiker's Guide to the Galaxy* remains fundamentally an electronic guidebook with the words "Don't Panic" printed on the front. Of course, what might have seemed futuristic in the late 1970s has now become ubiquitous, even old-fashioned. In 1984's *So Long, and Thanks for All the Fish*, Adams compares The Guide to a small laptop, but for a machine that is meant to represent cutting-edge technology, even that description seems outmoded in an age when even a mobile phone can take photos and send emails.

To give him his due, however, Adams was well aware of subsequent technological developments, particularly those that enabled mobile Internet access. Though smartphones occurred too late for the novels or original radio scripts, he certainly realized their importance to his "Earth edition" of the *Hitchhiker's Guide*, h2g2 (see p.138). Indeed, h2g2 Ltd actually launched a WAP version in 1999, with the aim of offering location-specific information on cinema or bus timetables.

Though WAP may now be old news, The Guide is still reminiscent of several items that constitute everyday pocket or handbag content (most of them sadly beyond the reach of someone on a budget of just 30 Altairian dollars a day). Described in the first novel as looking like a large pocket calculator with a hundred or so tiny buttons, The Guide apparently appears to be something like a BlackBerry, except with a slightly larger screen. In terms of function, it combines elements of the iPhone – or iPod, in that it speaks its entries – with those of eBook readers such as the Sony

Reader or Amazon's Kindle. Indeed, Randall Munroe's *XKCD* comic made explicit the link with the latter product, depicting the Kindle as simply *The Hitchhiker's Guide to the Galaxy* with a fresh coat of paint.

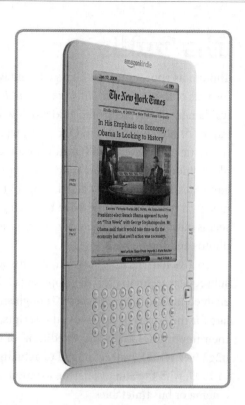

The Amazon Kindle – perhaps the Hitchhiker's Guide of our near future. Adams would surely have been a fan.

Infinite Improbability Drive

It is thanks to the Infinite Improbability Drive that the *Heart of Gold* is the most powerful spaceship ever built. From transforming its occupants into woollen dolls to turning entire planets into banana fruitcake, it can undertake any conceivable action, however seemingly improbable. The only condition is that someone on board must know precisely how improbable that action is.

Science writer Michael Hanlon has been impressed by Adams's emphasis on the power of improbability, pointing out that highly unlikely things happen all the time without contradicting the laws of physics. Indeed our whole Universe may owe its existence to some highly unlikely quantum shenanigans. Hanlon also notes that probability is today being utilized perhaps more than ever before, be it in synthesizing new drugs or monitoring terrorist threat.

From a scientific viewpoint, there are two key ideas involved in Adams's description of the Infinite Improbability Drive: the Theory of Indeterminacy and the concept of Brownian Motion. Both are real enough. The former is a cornerstone of quantum physics, describing the incompleteness of the physical state. Brownian Motion, meanwhile, is a concept relating to the zigzag "random walk" of particles in a gas or liquid, in this case a cup of tea.

The Drive performs many tasks, at one point turning a pair of incoming missiles into a sperm whale (see p.52) and a bowl of petunias. Its primary function, however, is as a method of crossing vast interstellar distances. This too is at least partly based on genuine scientific theory, Heisenberg's Uncertainty Principle stating that the more precisely we can measure the velocity of a subatomic particle, the less accurately we can know its position. If an electron doesn't have a definite location but rather an infinite number of *possible* locations, then the *Heart of Gold* could – theoretically at least – pass through every place in existence before "collapsing the wave function" and deciding where to stop. It would thus achieve spontaneous space travel.

Science hasn't yet made this a reality but, then again, it's not something one wants to rush. Adams himself makes this quite clear through the tale of the ominously monikered Starship *Titanic*,

constructed so that any malfunction was infinitely improbable. Unfortunately, this represented a rather fundamental misunderstanding of probability: even an infinitely improbable event will happen some time, given a long enough window of opportunity, and may even happen right away if you're extraordinarily unlucky. Twisting this logic for comic effect, Adams declares that the infinitely improbable is in fact "very likely to happen almost immediately". As a result, his Starship *Titanic* suffers Total Existence Failure mere moments into its maiden voyage.

Machines

From robots – Marvin, of course, but also the Krikkiters and others – to talking doors and elevators, the *Hitchhiker's* universe is one run by electronic machines (among them, of course, **computers** – see above). And again, in many ways, Adams's vision has been borne out in practice, in-car satellite navigation systems being just one example, even sharing the anthropomorphic properties of Marvin or Eddie. Lifts don't yet attempt to persuade their occupants into going down rather than up, but it's surely not too far off.

Digitization is clearly not without benefits. We are told, for instance, that *The Ultra-Complete Maximegalon Dictionary* requires a fleet of lorries for its transportation, and is therefore markedly less practical than the *Hitchhiker's Guide*. And Adams himself was certainly no Luddite, his fascination with gadgets, particularly Apple Mac computers, suggesting that at least one part of him was thoroughly in favour of the digital revolution.

At the same time, however, machines are portrayed with a

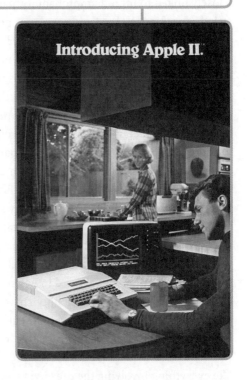

An ad from 1977 for the then cutting-edge Apple II computer. Adams was a big fan of Apple machines, and they no doubt influenced his own futuristic visions of intergalactic technology.

Introducing Apple II.

certain ambivalence in *Hitchhiker's*. Like the button on the *Heart of Gold*, the sole function of which seems to be the illumination of a panel reading "Please do not press this button again", they can be ill-designed, frustrating and pointless. They can also be malevolent, as with *The Hitchhiker's Guide to the Galaxy Mk 2*, which threatened to spark a *Terminator*-style rise of the machines, although the story is not allowed to develop that far. Unlikely though it sounds, Arthur even becomes the dressing-gown-clad equivalent of John Connor, the *Terminator* franchise's anti-machine warrior. His argument with a Nutri-Matic drink dispenser has unwittingly made him a hero on the planet of Brontitall, whose population have exiled their robots and built a statue of Arthur in tribute.

Parallel universes

Closely linked to infinite improbability, parallel universes – though strictly speaking, as The Guide explains, neither "parallel" nor "universes" – are a prominent theme in *Hitchhiker's*. In the first novel, we encounter the idea of a replacement Earth. In *So Long, and Thanks for All the Fish*, Arthur learns that the dolphins saved Earth from destruction by replacing it at the last minute with a planet from another dimension. And in *Mostly Harmless*, we discover the planet of NowWhat, occupying exactly the same location as planet Earth but in a hellish parallel dimension; "right planet, wrong universe", as Arthur gloomily puts it.

Though parallel universes might feel like the stuff of science fiction, they're actually regarded by many scientists as perfectly possible. One reason for this is simply that space is so enormous; the odds are that somewhere out there is a planet identical to ours (and, on it, someone very nearly identical to you). This is essentially the well-worn argument, alluded to when Arthur and Ford first encounter the Infinite Improbability Drive, that even a monkey could write Shakespeare, given a typewriter and sufficient time. Somewhere in the cosmos it's probably already happened.

There's also a quantum interpretation for parallel universes that, like everything involving the dreaded Q word, is rather harder to get one's head around. Simply, this states that whenever an event has multiple possible outcomes, *all* of these outcomes will occur: new universes are constantly being created. In *Mostly Harmless*, for instance, Tricia McMillan fails to leave the party with Zaphod, but another version of herself *does* leave the party and goes on to lead an entirely independent life gallivanting around the Galaxy.

Universes

As if parallel universes weren't confusing enough already, they also throw up some pretty awkward questions in terms of semantics. For if the Universe by definition encompasses all of existence, how can there can be a parallel version? Some have responded by referring to the counterparts in different terms: rather than parallel universes, some suggest "alternative realities", "interpenetrating dimensions", "parallel worlds" or "alternative timelines". Others, adherents to the so-called "many universes interpretation", have instead coined new umbrella terms for the Whole Sort of General Mish Mash, including "multiverse", "meta-universe" and even "omniverse". This last term found a strong champion outside the scientific community in the form of the late cosmic jazz pioneer Sun Ra, whose Arkestra for a while actually incorporated the term into their ever-changing group moniker. Sadly, scientists have thus far been unable to conclusively prove whether or not the bandleader was, as he claimed, born on Saturn.

According to this view, the answer to the "grandfather paradox" – see **time travel** – is that in one universe you kill your grandfather, and in another you don't.

One other type of parallel existence in *Hitchhiker's* is that experienced by Zaphod on Frogstar World B – not a real world at all, but rather a virtual reality: an electronically synthesized universe controlled from Zarniwoop's briefcase. Like the characters in Plato's

Allegory of the Cave, Zaphod is unable to distinguish reality from the shadows – in this case, shadows of the digital variety, like the simulacra beloved of theorist Jean Baudrillard. Anyone who thinks this is merely the stuff of films such as *The Truman Show* or *The Matrix* has perhaps not encountered Second Life, a virtual world whose appeal is all too real.

Theorist Jean Baudrillard has suggested in his work that simulacra are not merely copies of reality, but can be labelled "the hyperreal", in that they become real through the fact that they are perceived as real. A comforting thought from Zaphod's point of view.

Sub-etha networks

When Ford Prefect hitches a ride on a passing spaceship, he does so by means of an electronic sub-etha "thumb". When Trillian visits Arthur on Lamuella, she informs him that she is now working for a major sub-etha broadcasting network. And it is via the sub-etha net that field researchers submit their material to *The Hitchhiker's Guide to the Galaxy* itself.

Unlike many of Adams's ideas, the sub-etha network requires no hypothetical quantum physics to evaluate its chances of one day becoming a reality. It is, of course, here already, in the form of the Internet. Though its use in military and academic fields pre-dates Adams's initial radio script by some years, the World Wide Web as we know it didn't arrive until at least a decade later, thanks to the invention of HTML, not to mention the growth in home computing. (Adams was a predictably enthusiastic early adopter, first going online in 1983.)

Just as the sub-etha network became a reality in the guise of the Internet, Adams actually attempted to launch an Earth-based *Hitchhiker's Guide*, in the form of online encyclopedia h2g2.com (pictured overleaf; also see p.138). The collaborative nature of this site, open to contributors all over the world, parallels that of The Guide, whose entries are as likely to come from passing strangers as from established researchers such as Ford Prefect.

Of course, this editorial stance has become standard practice with the growth of "wiki" sites, of which by far the best known is Wikipedia, launched in 2001. As with Wikipedia, The Guide's content can be biased towards the interests of its particular demographic, and neither is it always reliable. (One apparently

minor typo has led many trusting interplanetary hitchhikers to their death at the hands of the Ravenous Bugblatter Beasts, which unfortunately make a good meal *of,* rather than *for,* visiting tourists.) Also like Wikipedia, however, it has clear advantages over its book-based equivalent. Not only does The Guide have more entries and greater portability than the *Encyclopaedia Galactica,* but as every *Hitchhiker's* fan knows, it is also slightly cheaper and has "Don't Panic" inscribed on the cover.

Recent phenomena such as blogging and social networking sites like MySpace and Facebook are also reminiscent of The Guide's egalitarian editorial policy. And the concept of open-source software, developed in a transparent, collaborative fashion via peer review rather than behind closed doors by copyright holders, goes one step beyond Adams's wildest predictions.

Teleportation

When Arthur, Ford, Zaphod, Trillian and Marvin find themselves on a stolen spaceship heading into the heart of a sun, they escape via a teleport. Indeed, it's the same mode of transport that allowed Arthur and Ford to escape from Earth right at the start of the *Hitchhiker's* story.

Though it may sound just as unlikely as travel via the Infinite Improbability Drive, teleportation – or matter transference – is in fact far closer to reality. The basis for this is a seemingly impossible but readily observable phenomenon known as quantum entanglement, which appears to contradict Einstein by seemingly operating faster than the speed of light. (It is not known how its speed compares with the Hingefreel spaceship, powered by the one thing faster than light: bad news.)

Much like time travel, however, teleportation throws up some tricky questions. Would it really be *you* that arrived at the other end, or simply a facsimile? Does the original subject simply vanish (and would this constitute an act of murder?), or remain in the original location like a faxed piece of paper? The answers to such conundrums are as yet unknown beyond the cast of *Star Trek*.

Time travel

Though less prominent than in some science-fiction tales – H.G. Wells's *The Time Machine* (1895) remaining the classic example – time travel still plays an important role in *Hitchhiker's*. It is the only means, for instance, of reaching the Restaurant at the End of the

Time travel grammar

Far from killing your grandfather or becoming your own mother, Adams writes in *The Restaurant at the End of the Universe* that the most challenging problem associated with time travel is in fact one of syntax. Apparently, the only solution in such circumstances is to consult the *Time Traveller's Handbook of 1001 Tense Formations* by Dr Dan Streetmentioner. Among the grammatical constructions contained within are "wioll haven be", in place of "which is"; "willing watchen" for "whilst watching"; and, as the correct substitution for "can meet and dine with", the spectacularly verbose "mayan meetan con with dinan on-when". We would go on, but Dr Streetmentioner's book stops dead at the Future Semi-Conditionally Modified Subinverted Plagal Past Subjunctive Intentional. So rare was it for a reader to get beyond the section, it was deemed unnecessary to actually print the subsequent pages.

Universe (except for Marvin, of course, who gets there by simply being very patient indeed).

Thankfully for those of us without a robot's longevity, scientists have suggested it would not be inconceivable to reach Milliways the short way. Certainly some believe that we could achieve a sort of time travel via the very method unwittingly practised by Arthur Dent, who in *So Long, and Thanks for All the Fish* returns from eight years in space only to discover that a mere six months have passed on Earth. In reality, however, this time discrepancy would actually

work in reverse: that is, more time would have passed on Earth than in space, the logic being that the faster one moves through space, or the further one is from a massive object such as Earth, the slower one moves through time. Arthur's cover story that he's had a "face drop" would not, therefore, be necessary.

If a brief holiday from Earth feels like a bit of a cheat as a means of time travel – and let's face it, it's not going to get you to Milliways – then rest assured that many other methods have also been deemed worthy of scientific consideration. Mathematical logician Kurt Goedel, best known for his Incompleteness Theorem, suggested that twists in the fabric of space time could allow for time travel. There is also talk, for instance, of entering a wormhole in one era and exiting in another.

Moving any of this from the theoretical realm to the practical has, as usual, proved a little tricky. Yet Adams seemed less concerned by the science of time travel than by associated philosophical questions, such as a situation in which you travel back in time and kill your grandfather (in a strictly hypothetical sense, it must be stressed). This, of course would mean that you yourself were never conceived – so how could you have travelled back in the first place? Adams offers his own take on this "grandfather paradox", except that in *Hitchhiker's*, the danger is not killing but *becoming* one's own father or mother; it might be dubbed the "Marty McFly paradox" in honour of cult movie *Back to the Future*. Adams, however, says that becoming one's own parent is nothing a broadminded family can't handle.

Adams even offers his own time travel paradox, in the story of the great poet Lallafa, who was offered an endorsement deal by manufacturers of correcting fluid who travelled back in time for the

purpose. So lucrative was the deal that Lallafa never actually got round to writing the poems in the first place. It was this event, we're told, that led to the formation of the Campaign for Real Time. Lacking such a real-life pressure group, some quantum physicists get round this sort of paradox by suggesting that if one travelled back in time, every change one made would result in the creation of a parallel universe – see **parallel universes**.

Total Perspective Vortex

No removal of fingernails, no electrodes to the genitals – the Total Perspective Vortex does nothing but reveal to its victim their size in relation to the whole of the Universe. And yet, it is the cruellest torture method in the whole *Hitchhiker's* saga, worse even than Vogon poetry in that only Zaphod Beeblebrox has ever survived it (and only then because he was in an electronically synthesized universe).

Invented by a character named Trin Tragula in an attempt to silence his nagging wife, the Total Perspective Vortex relies on channelling the whole of Creation through one small piece of fairy cake. Adams's logic here was that every piece of matter in the Universe is in some way affected by every other piece of matter, and thus the whole thing can be extrapolated from any individual component.

Michael Hanlon has confirmed that this idea has at least one foot in passable scientific theory; it does seem to chime, for instance, with the "cosmic web" idea that the whole Universe is bound together by an invisible cobweb of dark matter. Perhaps

Werner Heisenberg's "Uncertainty Principle" states that to know the precise value of one of a pair of physical properties requires that you know less about the other.

unsurprisingly, however, Hanlon points out that extrapolating the entire Universe from a piece of fairy cake might in practice not be so easy. Again, the relevant arguments concern Werner Heisenberg and the multiplicity of possible electron locations (see **Infinite Improbability Drive**).

The Ultimate Answer

It may have been conceived, let us never forget, as a joke, but the number 42 has a tendency to have theories thrust upon it. Some of the more creative interpretations have been dealt with in the previous chapter, but there is also a scientific approach to this most enthusiastically investigated number.

Certainly, the concept of distilling Infinity into numerical form has become markedly less ridiculous in the years since Adams conceived of the idea. In 1999, Martin Rees, the UK's Astronomer Royal, declared that the Universe could be boiled down to six numbers, including the strength of gravity and the speed at which the Universe is expanding. Each has a value that, for whatever reason, falls within the terrifyingly narrow conditions required for life.

Admittedly, none of Rees's figures was 42. Yet that number did enjoy specific, if short-lived, scientific endorsement, as the exact value of the Hubble Constant, a measure of the rate of expansion of the Universe. This was truly "a delicious moment", as Adams's friend and collaborator John Lloyd recalls. The joy was tempered somewhat, however, by the discovery that Hubble's Constant wasn't constant at all, and hence promptly changed to a completely different number.

Of course, Adams conceived the notion of the Ultimate Answer well before either of these events, rendering them of passing interest only (though he was apparently deeply tickled by the Hubble episode). Instead, he was presumably poking fun at the broader desire for a single unifying theory to explain our existence. It's this same concept, indeed, that he mocked in *Mostly Harmless* as the

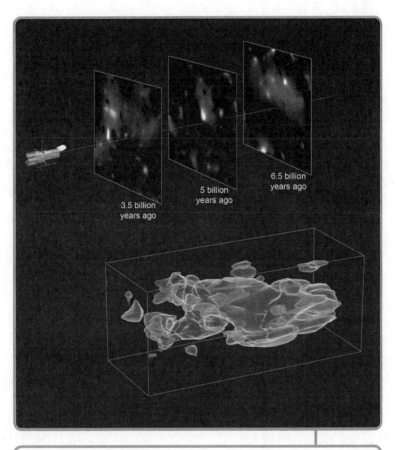

Hubble mapping the Cosmic Web of "Clumpy" Dark Matter.

Whole Sort of General Mish Mash, which "doesn't actually exist but is just the sum total of all the different ways there would be of looking at it if it did".

113

Absurd though it may sound, however, the idea of the Ultimate Answer is not too far removed from a genuine drive in contemporary physics – that towards a Grand Unified Theory, or the even more ambitious Theory of Everything. This latter is, in essence, an attempt to reconcile the fundamental forces of gravity, electromagnetism, and weak and strong nuclear forces. Each makes sense on its own terms but the otherwise elegant theories cannot yet be encompassed within a single theoretical framework. In technical terms, "big stuff" (stars, black holes) doesn't seem to work like "small stuff" (electrons).

While some scientists don't believe in a unifying Theory of Everything, others are pinning their hopes on superstrings, M-branes and mind-meltingly complex ten-dimensional Calabi-Yau shapes. Whether the number 42 plays any particularly significant role within these Calabi-Yau shapes, of course, remains to be seen.

Phase Two

5

Adams ... mostly harmless

For any *Hitchhiker's* fan, there is a temptation to understand Douglas Adams himself through the characters he invented. Was he the bewildered Arthur? The hedonistic Zaphod? The perennially depressed Marvin? The answer, according to close friend and sometime collaborator John Lloyd, is that the personality traits of all three – and no doubt other characters too – nestled within Adams's enormous frame. There are even specific parallels between Adams's life and various *Hitchhiker's*

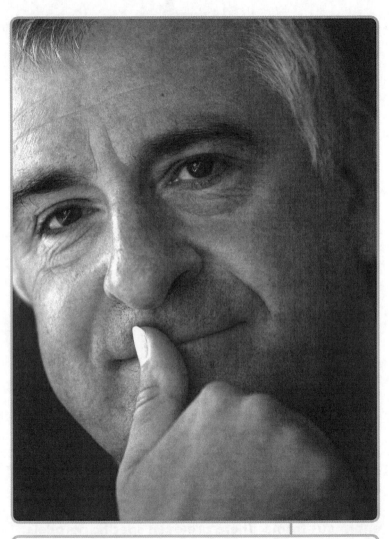

The man known as "Bop Ad", after his notoriously illegible signature.

situations. The section where Trillian dumps Zaphod could have been inspired by Adams's real-life break-up with Sally Emerson; Arthur's claim to have returned from California, rather than outer space, was written when Adams had just returned from a year in LA; and so on.

The nearest Adams came to a fictional alter ego, however, seems to have come in the form of a rather more inconsequential character than Arthur or Zaphod. More than one observer has pointed out the similarities between Adams and the captain of the Golgafrinchan B Ark, whom he resembled in at least one major regard: in times of stress, he is reported to have taken up to five baths a day. History does not record whether or not he owned a rubber duck.

Early years

Although he gave a large number of interviews over the years, the precise details of Adams's life are not always easy to ascertain. At times he seems to have applied his prodigious imaginative skills to elements of his own biography, and he certainly had a raconteur's preference for a good yarn over slavish adherence to the facts. But perhaps this disregard for the strict truth is understandable: after all, there are only so many times any of us could bear to be asked the significance of the number 42, or the origins of *The Hitchhiker's Guide to the Galaxy* as a concept, before indulging in a little narrative decoration, if only for our own amusement.

We do know, however, that the man who would become known

as the Big D – after the Big Z, nickname for his subsequent creation Zaphod Beeblebrox – was born on 11 March 1952. As official biographer Nick Webb puts it, young Douglas was an unusually late developer in all but size: Adams later claimed he didn't learn to speak until he was almost four, but he was already well on the way to his 6'5" eventual elevation.

Though born in Cambridge, Adams went to Brentwood school in Essex, which offered such traditional English educational tools as a house system, rugby and even that character-building form of institutionalized enslavement, "fagging". Douglas arrived as a day pupil in 1959, becoming a boarder from the age of eleven. In his time at the school, he distinguished himself primarily by being very tall – so much so that when he moved to the main school, and thus from short to long trousers, he had to wait four weeks for a bespoke pair to be made. Perhaps not unconnected to this, he was also rather clumsy, on one occasion managing to break his nose on his own knee.

The young Adams wanted to be a nuclear physicist when he grew up – but, already uniting the two apparently incongruous fields that would one day shape his professional career, he also displayed a tangible literary bent. He had two letters printed in the *Eagle* comic, and he was famously awarded ten out of ten in a creative writing class by a Mr Halford – supposedly the only time the teacher gave such a score.

Adams left Brentwood in 1970, the sixties still very much swinging despite the notional change of decade. In tune with the *Zeitgeist*, he took a gap year to hitchhike around Europe, raising the money through a series of bizarre odd jobs including hospital porter and chicken shed cleaner. According to legend, it was while on this

trip that Adams first conceived of a *Hitchhiker's Guide to the Galaxy*, having been inspired by his trusty *Hitchhiker's Guide to Europe* (and a few too many beers) while lying in a field in Innsbruck. Biographer M.J. Simpson, however, claims that the "road to Damascus" moment occurred not in Austria, 1971, but in Greece, 1973. We may never know the truth; Adams himself admitted as early as 1985 that he'd already told the story so many times that he could no longer remember the actual details.

University days

Whether or not he had idly stumbled upon the title that would change his life, Adams was certainly not conscious of the fact when he arrived at Cambridge University in 1971. He read English literature, reportedly writing just three essays in the course of his entire degree. Those who have studied English literature may, of course, regard such an output as assiduous, but this fact is usually taken instead as evidence that Adams's goal was not academic. He wanted to join Footlights.

As it turned out, Adams didn't find the university's legendary comedy group as easy to infiltrate as he had hoped. Instead, he first joined the Cambridge University Light Entertainment Society and formed a successful writing trio with Will Adams and Martin Smith, the latter subsequently immortalized in *The Hitchhiker's Guide to the Galaxy* as "bloody Martin Smith from Croydon". Eventually, however, he did make it into Footlights, assisted by Simon Jones – who would go on to play a (rather larger) role in *Hitchhiker's*, as Arthur Dent in the radio and TV series.

For fans, it's worth mentioning that Martin Smith and Simon Jones were not the only Cambridge contemporaries of Adams's to subsequently play some kind of role in the ensuing *Hitchhiker's* story. Johnny Simpson and Andrew Marshall, upon whom Zaphod Beeblebrox and Marvin would respectively be based, were friends, Adams sharing a room with the latter in his third year. Also in his circle were John Lloyd, with whom Adams would write not only *The Meaning of Liff* but also episodes five and six of the *Hitchhiker's* radio series; Geoffrey McGivern, who would play Ford Prefect in the radio series; and Jon Canter, who coined the line that would later become Marvin's catchphrase: "Life? Don't talk to me about life."

Hitchhiker's was still a long way away, however. Adams's comedic aspirations at this point were largely confined to a strong desire to emulate Monty Python, whose approach to comedy seemed every bit as revolutionary as The Beatles' approach to rock'n'roll. (Both acts would remain among Adams's lifelong passions; and like them, he too would simultaneously mock and epitomize a certain notion of Englishness through his work.) It was perhaps his infatuation with the Pythons, particularly fellow Cambridge man John Cleese, that made Adams determined to make his name as a writer-performer. However, his lack of physical co-ordination and his propensity to "corpsing", or onstage giggling, meant he took rather more easily to writing lines than delivering them.

Footlights

It's no surprise Adams was desperate to join Footlights whilst at Cambridge, ostensibly studying for an English degree. John Cleese and fellow Pythons Eric Idle and Graham Chapman may have been his specific inspiration, but the alumni list is surely unmatched by any undergraduate comedy group in the world. Peter Cook, David Frost, Stephen Fry, Clive Anderson, Hugh Laurie, Jonathan Miller, Griff Rhys Jones, Clive James and all three Goodies are just some of its better-known graduates. Nor are its glory days over: recent Footlights successes include Sacha Baron Cohen – aka Ali G and Borat – and both David Mitchell (pictured) and Robert Webb of British sitcom *Peep Show*. Come to think of it, Mitchell's character Mark Corrogan, alternately pompous and diffident but forever reactionary, would make a pretty good Arthur Dent. Meanwhile Robert Webb's Jeremy, a wannabe musician who puts just a little too much effort into being cool, is somewhere between Ford and Zaphod...

Hard graft

Upon graduating from Cambridge in 1974 with a rather underwhelming 2:2, Adams found himself in the sort of professional wilderness which many graduates – particularly those looking to work in the media – will recognize. He tried writing sketches for Radio 4's political satire show *Week Ending*, but with only limited success, his idiosyncratic, wildly expansive humour not easily shoe-horned into pre-existing formats.

Things started looking up when Graham Chapman, a fellow Footlights graduate who had gone on to huge success with Monty

The *Monty Python's Flying Circus* team; from left to right, Michael Palin, Graham Chapman, John Cleese, Eric Idle, Terry Jones.

Python, saw some of Adams's sketches and invited him for a drink. Thus begun a writing partnership that lasted well over a year – a major break for the 22-year-old Adams. His subsequent contributions to *Monty Python's Flying Circus* were relatively limited, but still sufficient for him to become one of only two non-Pythons to receive a writing credit on the TV series. (Adams also showed up in a couple of cameos, including ... drumroll ... programme 42.)

Unfortunately for Adams, the *Flying Circus* TV show would shortly come to a halt. Though Chapman and Adams embarked on various solo projects, success proved elusive. Their TV sketch show, *Out of the Trees*, saw only a single episode broadcast, while *The Ringo Starr Show* didn't even reach pilot stage.

So while certain sections of the population were having their lives transformed by punk, 1976 was for Adams rather a low point. The partnership with Chapman had come to little. He had been writing with John Lloyd, but that too had got nowhere. Lloyd, in the early days of a stellar career that would include *Spitting Image*, *Not the Nine O'Clock News* and *Blackadder*, could fall back on a decent job as a radio producer. Adams, on the other hand, was thoroughly broke, a situation not helped by the fact that, as with many in the world of comedy, his emotional make-up was rather volatile. Hugely genial and enthusiastic when things were going well, he also had a tendency to become gloomy when the chips were down – and this, sadly, was such a stint. Adams moved back to his mother's house in Dorset and even talked about getting a "proper job" in Hong Kong.

But Adams never went to Hong Kong. In February 1977, he met radio producer Simon Brett and pitched three original shows, one of which was a sci-fi comedy entitled *The Ends of the Earth*. Brett liked

the idea, and the next month the BBC approved a pilot – although by then it was going by the name of *The Hitchhiker's Guide to the Galaxy*.

It would, however, be six months before the BBC committed to a full series, and a full year before it was broadcast; and, of course, no one at the time could have known that *Hitchhiker's* would become a runaway success. So while he was waiting for the green light on *Hitchhiker's*, Adams sent the script, as a writing sample, to the team responsible for cult TV series *Doctor Who*. This was perfectly sound many-irons-in-the-fire logic, but it backfired: almost at the same time as he got the go-ahead on *Hitchhiker's*, *Doctor Who* producer Graham Williams commissioned a four-part script entitled *The Pirate Planet*. Like the proverbial busses, that elusive script-writing job for which Adams had waited so long had suddenly arrived in duplicate.

Holed up in his mother's Dorset house, Adams churned out scripts for the Dalek-battling Tardis-traveller whilst manically writing the first series of *Hitchhiker's*, powered only by tea, Bovril sandwiches and his beloved baths. Later in his career, Adams's inability to finish, or even start, books became infamous. At this point, however, he was not going to miss two such good opportunities, even though his workload had jumped from negligible to near-impossible faster than a Hingefreel spaceship.

At almost the same time, a third opportunity presented itself: he became a producer for *Week Ending*. But though his was undoubtedly a highly original mind, Adams was far too chimerical for a producer role. His absent-minded attitude towards money, for instance, would be illustrated later when his accountant stole something like £375,000 from him before he cottoned on. (The

story has a rather macabre postscript, in that the accountant committed suicide shortly afterwards.)

Adams, who at this stage had precious little money to steal, left the producer job after just six months, having been offered a role as script editor on *Doctor Who*. That position too would be relatively short-lived, however, for it was while working on *Doctor Who* that *Hitchhiker's* simply exploded. Not only did the radio series (broadcast from March 1978) find an immediate audience, but spin-off projects arrived in such quick succession that the precise chronology can be difficult to disentangle. As well as trying to write both the second series of the *Hitchhiker's* radio show (broadcast from January 1980) and the first *Hitchhiker's* novel (published October 1979), he signed a contract for the TV pilot (screened from January 1981). There were also stage and album versions in both 1979 and 1980. All this was on top of *Doctor Who*, for which Adams not only was script editor but had undertaken writing duties too, including the well-received *City of Death* and an uncompleted story called *Shada*.

Glory days

By September 1980, *Hitchhiker's* had spawned its own convention, Hitchercon 1, at which Adams was Guest of Honour. The second radio series was broadcast in the UK, promoted on the front cover of the UK's main TV and radio magazine, *Radio Times*. The *Restaurant at the End of the Universe* was published, and as well as a rave reception in the UK, it made it onto the bestseller lists in the US (where the BBC radio show would subsequently be broadcast

nationwide). Translation rights were sold all over the world. The TV show was screened at the start of 1981, and there were even rumblings of a feature film. Specific details of all these projects are to be found in the following chapters, but it's worth noting their near-simultaneous genesis, if only to reaffirm the speed and scale of the initial *Hitchhiker's* phenomenon.

Inevitably the sudden success had an effect on Adams himself. He splashed out on a series of fancy cars including an MG and a string of Porsches (he went through them at quite a rate, in part thanks to a tendency to get so enthusiastically involved in conversation that he somewhat neglected the road). And, in turn, this new lifestyle influenced Adams's writing: journalist Nicholas Wroe observes that "it is possible to track the movement of Adams's life even between the first and second series of the radio show. In the first there were a lot of jokes about pubs and being without any money. The second had more jokes about expensive restaurants and accountants."

The newly wealthy Adams was generously hospitable, known for celebrating anything worth celebrating with an enormous meal, perhaps accompanied by a jeroboam of champagne. Equally, he was known to forget that not everyone could afford the high life to which he'd soon became accustomed, and could be rather tactless in this regard. There was nothing malicious in it; rather, it was just Adams as head-in-the-clouds romantic. Another example of Adams's occasional insensitivity, this time creative rather than financial, concerns the first *Hitchhiker's* novel. Adams asked Lloyd to co-write the book, since he'd co-written two episodes of the radio series on which it was based, but then decided he'd rather do the book solo. This was understandable enough. What was less

Douglas Adams with all the books he might have written had he ever got the hang of publishers' deadlines.

understandable was his decision to inform Lloyd, one of his best friends, via letter. Their friendship was thankfully strong enough to withstand the hurt and anger, but feelings ran high for a while. Nor was this an isolated incident – another occasion saw Michael Bywater, another old friend, fully expecting to be given the job of writing the *Starship Titanic* novel, only to see it handed to Terry Jones.

There are no doubt two sides to these stories, repeated here only to illustrate Adams's distinct lack of pragmatism. His exuberant, impulsive nature came to the fore too in his relationship with Sally Emerson, which took place around this time. Adams met Emerson,

a fellow writer, while promoting *The Restaurant at the End of the Universe* and, though she was married, the pair soon embarked on a passionate affair. It was a whirlwind romance, and sadly short-lived: Emerson moved in with Adams in September 1981, but she'd left again by Christmas. Adams was devastated, one reason he struggled with third novel *Life, the Universe and Everything*, which he submitted a full year late – although it still bears the dedication "For Sally".

In truth, the evidence suggests that Adams would have missed the deadline for that third novel regardless of the break-up. His procrastination in this regard is notorious (and yet another reason why he'd never have made a good radio producer). Geoffrey Perkins

Sally Emerson.

was forced to move in with Adams even during the *Hitchhiker's* radio series, house arrest being the only means of guaranteeing a finished script. For the novels, it would become customary to lock Adams in a hotel room until he had completed a manuscript – Sonny Mehta (Pan's editorial director) on sentry duty for *So Long, and Thanks for All the* Fish, and Heinemann editor Sue Freestone taking on the job for *Mostly Harmless*. Not for nothing would Adams famously declare "I love deadlines. I love the whooshing noise they make as they go by."

One result of the Sally Emerson debacle was that Adams had finally become ensconced in the London borough of Islington, having been persuaded to move out of the flat he shared with Jon Canter in Highbury New Park. Islington, an enclave of monied boho chic, would remain Adams's home for almost two decades, and it was here that he would host his notoriously extravagant parties. A typical scenario would see members of Pink Floyd or Procul Harum performing to an audience of equally A-list names from other areas of the arts, from Salman Rushdie to Lenny Henry. If Adams had a stint as Marvin before his career took off, this was the author as Zaphod – or perhaps the late King Antwelm of Saquo-Pilia Hensha from *Mostly Harmless*, who left his vast fortune to finance an annual feast.

Life beyond *Hitchhiker's*

Despite his new nest, Adams was spending a lot of time in California, attempting – not for the last time – to get a film version of *Hitchhiker's* off the ground. It was on one of these American trips

that he and John Lloyd, having overcome the animosity surrounding the *Hitchhiker's* novel, wrote *The Meaning of Liff*, a spoof dictionary of concepts familiar to all yet previously neglected by the lexicon. Though it may sound a fatuous concept, it's truly a minor masterpiece and was a deserving bestseller when published in 1983. A sequel, *The Deeper Meaning of Liff*, appeared in 1990. In a sense, however, the main significance of *The Meaning of Liff* in terms of Adams's career trajectory is that it represented a first move away from the *Hitchhiker's* universe with which he'd become synonymous. True, there would be a fourth *Hitchhiker's* novel, *So Long, and Thanks for All the Fish*, in 1984. Yet it was written under duress, even by Adams's standards, and imbued with a palpable sense that its author had fallen out of love with his subject.

That book out of the way, Adams embarked on a new project, *Dirk Gently's Holistic Detective Agency*, for which he received over $2 million for the US rights alone (and remember, this was 1985). Not surprisingly given that sort of advance, Adams made all the right noises about getting started straight away. Legend has it, however, that when the deadline appeared, he had written precisely one sentence. Adams's dilatory approach to deadlines had only worsened by the time of the follow-up, *The Long Dark Tea-Time of the Soul*.

Still Adams continued to spread his wings. One country that gets a brief mention in *Dirk Gently* is Madagascar, Adams having just visited the island with WWF zoologist Mark Carwardine for an article in the *Observer* magazine. The trip, which had been in search of an extremely rare species of lemur, was such a success that he and Carwardine decided to extend the concept to include near-extinct

species around the world. Their expeditions of 1988 and 1989 would be collected in *Last Chance to See*, both a BBC Radio 4 series and, once Adams had undergone the by now obligatory coercion, a book. It is arguably his best piece of writing, and certainly gave a major boost to Adams's interest in ecology and evolution. Twenty years later, *Last Chance to See* was revived, with a new series featuring Adams's friend Stephen Fry as well as Carwardine.

Last Chance to See also represented a significant stage in the evolution of Adams himself. Having already distanced himself from *Hitchhiker's*, this was a further step, away from novels and script-writing altogether. Instead, he was taking on a broader role, one for which terms like "philosopher" or "intellectual" are perhaps too pompous, yet – along with "media personality" – are not entirely inappropriate. He was particularly obsessed by information technology, which was making the futuristic fantasies of *Hitchhiker's* come true before his eyes. Adams was an early advocate of Apple Macintosh computers, claiming to be the first person in the UK to own one, and he remained an evangelistic fan. Having missed the *Dirk Gently* deadline, for instance, he attempted to make up for lost time by typesetting the whole book on his personal Mac.

He had actually discovered Apple Macs while making the *Hitchhiker's* computer game, released in 1984 – one recent *Hitchhiker's* project that he *had* enjoyed. Adams's second computer game, *Bureaucracy*, appeared in 1987, and he even contributed to *Labyrinth*, the computer game offshoot of the David Bowie fantasy film. He would subsequently join the Apple Macintosh-related think tank Vivarium and, in 1990, presented a "fantasy documentary" on the future of multimedia technology entitled *Hyperland*. In 1995, he

was even briefly appointed to the UK government's Library and Information Commission, where he was again fighting for IT and digital technology.

Back in the saddle

Adams clearly relished his new role as IT pioneer. There was, however, the inconvenient matter of one more *Hitchhiker's* book. When *Mostly Harmless* eventually emerged in 1992, it seemed to represent the culmination of a general trend: not only was Adams

Adams, photographed in 1988 … with a stuffed cat.

finding it harder and harder to write, but the books themselves were also – perhaps in consequence – increasingly bleak in tone. His mood was not helped by the fact that his stepfather had died the previous year. But in any case, it must have felt strange going back to *Hitchhiker's* after such a protracted break, particularly given his globe-trotting adventures in the interim period. (On the other hand, as Neil Gaiman points out in *Don't Panic*, the influence of *Last Chance to See* can be detected in Adams's elaborate description of the Perfectly Normal Beasts.)

Mostly Harmless sold well in both the UK and the US, and in the year of its publication Adams was honoured with an episode of the *South Bank Show*, the respected, if easily parodied, arts TV programme presented by Melvyn Bragg. Also around this time, the TV series was finally released on video (previously delayed by contractual wranglings over the film rights, which Adams had finally bought back at considerable expense). Yet *Mostly Harmless* was the last book Adams would finish and in a sense also represented his last intensive stint in the limelight. He talked about writing another book, including a sixth *Hitchhiker's* novel, but it will by now be no surprise to hear that he didn't make any great inroads in this department, since no editor handcuffed him to his Apple Mac.

One reason for Adams's lower profile during the 1990s was a happy change in his domestic circumstances. In 1991 he had finally married Jane Belson, an Oxford-educated barrister who had become his girlfriend after Sally Emerson. Their daughter Polly was born in 1994. In a detail that, like the episode number of his *Monty Python* cameo, clearly represents cosmic synergy rather than mere coincidence, Adams had become a father at the age of 42. Dave

Gilmour's birthday present was an invitation to perform live with Pink Floyd, Adams being a keen musician who had amassed what was believed to be the world's largest collection of left-handed guitars. The performance took place in October of that year, at Earl's Court in London.

There were other, professional, reasons why Adams might have become partially obscured from fans' view as the 1990s wore on. For one thing, he was occupied with the *Hitchhiker's Guide to the Galaxy* film, which would sporadically rise up, zombie-like, before returning to development hell. Another reason was that Adams, perhaps inspired by the mice Frankie and Benjy, had carved himself a lucrative niche in the lecture circuit. He was taken on by an American agent in the early 1990s, developing a strong following first in the colleges and universities, and then, with appropriately increased fees, amongst corporate IT clients. He relished the implied acceptance by the scientific community and the opportunity, after all this time, to perform as well as write.

However, perhaps the main reason for Adams taking a step away from the limelight around this time was The Digital Village. This was a multimedia company (or, as Adams preferred, "multiple media company") originally conceived in 1994 and launched two years later. That Adams's official position was "Chief Fantasist" might seem to convey a rather naïve idealism, yet there were undoubtedly impressive names involved – not least Adams's fellow partners, Richard Creasey and Robbie Stamp, who together had been pushing new media at Central TV.

Yet despite initial aims of operating right across the board from online publishing to feature films, almost all TDV's efforts soon became concentrated on an all-consuming computer game called

Music

Adams said himself that, alongside Monty Python, The Beatles were his greatest influence. Yet his love of music didn't stop at the Fab Four: Pink Floyd were another passion, the band's "Set the Controls for the Heart of the Sun" inspiring the Disaster Area stuntship sequence in *The Restaurant at the End of the Universe*. Milliways itself was apparently inspired by "Grand Hotel", a song by British rock act Procul Harum (of "A Whiter Shade of Pale" fame). As a writer, Adams was known to play a single record obsessively whilst working on a particular book: Kate Bush during the first novel, Paul Simon during *The Restaurant at the End of the Universe*, Dire Straits for *So Long, and Thanks for All the Fish*, and Bach and Mozart respectively for the two Dirk Gently novels. As his fame grew, he was able to befriend many of his heroes, some of them performing at the Partially Plugged gigs he hosted in his Islington home.

Adams, perhaps practising for his Earl's Court appearance?

Starship Titanic (see p.219). A ground-breakingly ambitious project undertaken with insufficient resources, the game would not appear until 1998, by which time TDV had practically imploded under the strain. In many ways, *Starship Titanic* represented a quite remarkable achievement, particularly given time and budgetary constraints, and it even won an industry award. Only in comparison to its passenger liner namesake, however, could it be judged an actual success.

The spin-off novel – written by Monty Python's Terry Jones but based on Adams's plot, hence the absurd title *Douglas Adams's Starship Titanic: a Novel by Terry Jones* – fared no better. Its relatively poor sales seemed to confirm that Adams no longer shifted units in the quantities his name had once guaranteed. According to M.J. Simpson, some of the dates on Adams's *Starship Titanic* promotional tour struggled to attract an audience that extended into double figures.

The only good thing about releasing *Starship Titanic* was that it finally freed up The Digital Village to focus on a project that, with the wisdom of hindsight, seems both more suitable and more achievable. There had been talk for some time about an "Earth" edition of *Hitchhiker's*, or *The Hitchhiker's Guide to the Internet*. It finally arrived in 1999, under the truncated title of h2g2, the whole company re-branding itself h2g2 Ltd. In many ways, the site was prescient (see p.105). Yet like The Digital Village it struggled in the rather crucial regard of what Americans call monetization and disappeared in 2001 when the dot.com bubble burst. Two months later, however, it re-emerged as a subsection of the BBC website, returning *Hitchhiker's* to the BBC after nearly a quarter of a century.

By this stage, however, Adams (together with Jane and Polly)

had moved to Santa Barbara, California, in part to be able to pursue the *Hitchhiker's* film in LA. It was not to come to pass in his lifetime, however. Two years later, on 11 May 2001, Adams had a fatal heart attack while exercising in a private gym. Right to the end, as wags affectionately noted, the frood knew where his towel was.

If this seems a rather abrupt ending to Adams's story – well, it

Adams in 2000, the year before his untimely death.

was. He was just 49, his death not only cruelly premature but entirely unexpected. The tributes, from Stephen Fry's brief, touching online message to David Gilmour's rendition of *Wish You Were Here* at the memorial service, were a reminder of the sheer number of people Adams had touched through his work. But that was not his only legacy. The week he died, he was honoured with an asteroid named Arthurdent. Four years later, the International Astronomical Union's Minor Planet Center announced that a celestial object would be named Douglasadams after the man himself.

6

The radio series

The Hitchhiker's Guide to the Galaxy was first
conceived for the airwaves, and to many purists
the radio incarnation remains definitive. Certainly,
the radio series shares with the novels a distinct
advantage over the stage, TV and film adaptations,
in that images exist only in the mind's eye. Adams's
surreal flights of fancy are thus untempered by
budgetary constraints. But while it keeps the
question of appearance gloriously subjective –
every listener can have a slightly different idea of
what Marvin looks like, for instance – the radio
version remains unequivocally definitive in terms of
sound. Surely no one familiar with the shows will

be able to read the novels without envisaging The Guide's lines in the ever so slightly sardonic voice of Peter Jones.

An instant hit

That the first episode of *The Hitchhiker's Guide to the Galaxy* was broadcast at 10.30pm on a Wednesday evening, with no pre-publicity whatsoever, gives some idea of its predicted prospects. According to *Hitchhiker's* mythology, that episode, on 8 March 1978, attracted an audience so small that it didn't even register on the BBC's monitoring service, giving an official audience of precisely zero.

Yet soon up to thirty fan letters were arriving at the BBC every day, and, unusually for a new radio show, there were (positive) reviews in two UK Sunday newspapers. By the time the final episode of the first series was broadcast in mid-April, word of mouth had made the show a bona fide cult success. The whole series had been repeated twice by the end of the year, and within two years it had spawned not just a second series but also a novel, an album and a stage production, with a second novel and TV adaptation arriving not long afterwards.

Though in retrospect the success of *Hitchhiker's* may seem to have been inevitable, in many ways it's surprising the show got made at all. Adams had attempted science-fiction comedy before, but had always fallen at the first hurdle since sci-fi, according to prevailing wisdom, was simply too 1950s.

With hindsight, we know this notion was about to be exploded

with all the force of a supernova bomb. Adams pitched the idea that would become *Hitchhiker's* in early 1977; before the decade was out, *Close Encounters of the Third Kind*, *Star Wars*, *Alien* and *Star Trek: The Motion Picture* had all been released in cinemas. With this wave of sci-fi still around the corner, however, the fact that *Hitchhiker's* got off the ground is largely thanks to BBC Light Entertainment producer Simon Brett, who commissioned the pilot in February of that year. It was recorded in June, in the BBC's Paris Studio – confusingly located in London. Adams managed to get his first choices for the roles of Arthur (Simon Jones) and Ford Prefect (Geoffrey McGivern), while it was reportedly Brett's secretary who suggested Peter Jones as The Book.

As it turned out, Brett was shortly to leave the BBC for a job in TV, yet his role in these early stages was absolutely crucial. Not only did he commission the pilot, but he then had to present it to the BBC old guard, who were rather bewildered by the whole thing. One story has Brett's superiors turning to him, having sat in stony-faced silence through the entire pilot, and asking: "Simon, is it funny?" Apparently Brett's reputation was such that his answer in the affirmative was good enough for them. Accordingly, word came through in late August that five more episodes had been commissioned.

In part because Adams had been almost simultaneously commissioned to write a story for *Doctor Who*, the second *Hitchhiker's* episode was not recorded until November, by which time Brett had moved on. The producer chair was instead occupied by Geoffrey Perkins. At this point Perkins was a very junior producer, but he would go on to become the BBC's Head of Comedy. He is also credited with conceiving one of the most

wonderfully daft ideas in British comedy: the utterly inscrutable Mornington Crescent game on Radio 4's *I'm Sorry I Haven't a Clue*.

Despite being an Oxford University graduate in a remarkably Cambridge-dominated group, Perkins proved an ideal producer, every bit as important in getting the show made as Simon Brett had been in getting it commissioned in the first place. Although Arthur, Ford and The Book had already been cast, Perkins was involved in choosing actors for subsequent roles, for instance suggesting Stephen Moore as Marvin.

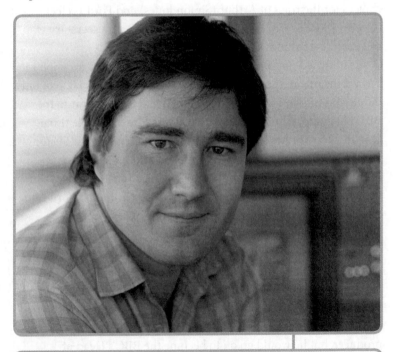

Geoffrey Perkins.

Perkins was also heavily involved in the narrative aspects of the show, striving to impose some sense of order on Adams's wildly picaresque tale. It was Perkins who reportedly argued for the continued inclusion of both Marvin and Zaphod, Adams having conceived them as only short-lived roles. Though such a decision obviously changed the course of the ensuing story quite considerably, it is impossible (and irrelevant) to quantify the respective contributions of Adams and Perkins. What is important is their shared, fearlessly improvisatory approach – clear from day one, when each happily admitted to the other that he didn't have a clue what he was doing.

In fact, one gets the distinct impression that *no one* involved in that first series knew quite what was going on, least of all some of the actors. Adams, a passionate music fan, was determined that the show should employ the production values of landmark albums by The Beatles and Pink Floyd, requiring a level of post-production detail that was without precedent in radio comedy. Stephen Moore's voice, for instance, was put through a harmonizer to create a suitably robotic pitch and tone, while the sound of Marvin's walk was created via elaborate tape loops (which, in this pre-digital era, meant actual loops of tape running around the studio).

These groundbreaking sonics were in substantial part thanks to the legendary BBC Radiophonic Workshop, as represented by Paddy Kingsland, Dick Mills and Harry Parker. Synthesizers, filters, envelope shapers, tape delays and echo chambers were just a few of the items called into service on *Hitchhiker's*. Yet Geoffrey Perkins has pointed out that many sounds were remarkably simple in origin, and considerable credit also goes to the technical team, led by Alick Hale-Munro. The sound of the demolition of the Earth, for instance,

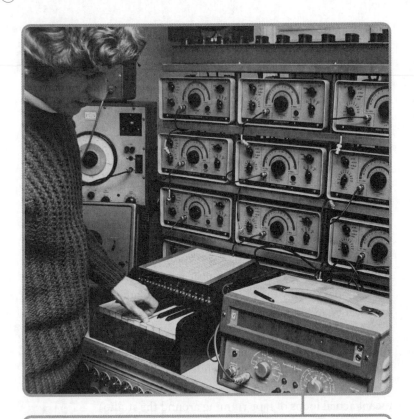

Sound engineer Brian Hodgson of the BBC's Radiophonic Workshop, producing sound effects for *Doctor Who* in 1969.

was apparently just a combination of bog-standard sound effects such as thunderclaps and explosions. Equally, the voice of Zarquon was achieved by placing pieces of sticky tape around the head of a tape recorder, making the sound wobble as the capstan rotated.

Either way, this working method meant that actors were often

The BBC Radiophonic Workshop

The Hitchhiker's Guide to the Galaxy was only one of innumerable projects undertaken by the BBC Radiophonic Workshop in its four-decade existence. *Quatermass and the Pit* and *Doctor Who* are among their best-known triumphs, but from their formation in 1958 the Beeb's in-house sound laboratory worked on everything from schools programmes to local radio jingles. Though they augmented their early tape manipulations with synthesizers, samplers and MIDI as they became available, their tirelessly experimental approach to sound design also found room for such everyday objects as bottles, lampshades and cutlery. Forced to close in 1997, the Workshop's reputation is nonetheless stronger than ever, the likes of Daphne Oram, Desmond Briscoe, John Baker, David Cain, Dick Mills and Delia Derbyshire celebrated via compilations and reissues, as well as in academic and artistic circles. They have proved a major influence on electronic artists such as Aphex Twin, Add N to (X), Stereolab and Broadcast, while music journalist Rob Young has even suggested that they may be the nearest the UK has come to a Stockhausen or John Cage. Unlike those stalwarts of experimental classical music, however, their work was beamed into the nation's living rooms on a regular basis. Now that's a good use of the licence fee...

The original radio cast (from left to right, David Tate, Alan Ford, Geoffrey McGivern, Mark Wing-Davey, Simon Jones) share a chuckle, while Adams (third from right) makes a last-minute tweak.

required to deliver their lines out of sequence, other voices added later along with an enormous array of special effects. And in order to achieve the required voice separation, any actor whose voice needed to be manipulated had to be recorded in isolation – often achieved in this less than high-tech environment by shutting them inside a cupboard.

Cupboards notwithstanding, *Hitchhiker's* was in many ways recorded more like a drama than a comedy, which would traditionally have been recorded live, in front of an audience. The

Radio music

It wasn't just the sound effects that were such a strength of the radio show – *The Hitchhiker's Guide to the Galaxy* also featured some truly superb music. There are snatches, for instance, of prog guitar legend Robert Fripp, über-producer Brian Eno and jazz icon Louis Armstrong – alright, it's the banal "What a Wonderful World", but then, as the closing notes of the first series, it's hardly meant sincerely. We are also treated to such leading lights of experimental classical music as György Ligeti, Karlheinz Stockhausen and Terry Riley. The theme tune, "Journey of the Sorcerer" by The Eagles, may not be to all tastes, likewise the Bee Gees' "Staying Alive", from the disco attended by Zaphod and Roosta. Yet since the latter has had every eighth beat removed and is also played backwards, it is both unrecognizable as, and arguably superior to, the original.

lack of studio audience for *Hitchhiker's* was another thing that the BBC's powers that be weren't sure about, and another battle won early on by Simon Brett. Quite apart from the fact that laughter would have ruined the meticulously assembled soundscape, the producer pointed out that it would have been impossible for an audience to sit through the laborious production process. He wasn't wrong: Geoffrey Perkins would soon spend an entire day creating the sound effects for the first three minutes of one episode.

Adams, in enthusiastic mode, was more involved with the production process than would be considered usual for a writer – in

fact, in the nicest possible way, he seems to have made himself a bit of a nuisance. Together with the distraction of *Doctor Who* and the fact that, due to ruthless self-editing, *Hitchhiker's* scripts had a worrying tendency to *decrease* in length at the end of a writing

The *Hitchhiker's* gang during a recording session for the radio series. (From left to right, Douglas Adams, Geoffrey Perkins, David Tate, Geoffrey McGivern, Mark Wing-Davey, Simon Jones and Alan Ford.)

session, it's no surprise that he soon found himself unable to meet the deadlines.

As a result, episodes five and six were co-written with his friend John Lloyd, who had also been attempting to collide sci-fi and comedy in his novel *Gigax*. He and Adams plundered the half-finished book for ideas, a tremendous help at the time (and a tremendous bone of contention when it came to the novel adaptation – see Chapter Seven).

These co-written episodes were recorded in February 1978. Extra cast members included David Jason (later to star in the sitcom *Only Fools and Horses* and the detective series *A Touch of Frost*) as the Captain of the B Ark and, as Max Quordlepleen, Roy Hudd, on his way to becoming a true veteran of British entertainment.

Beyond the first series

Given the immediate success enjoyed by the first radio series, it's no surprise that the BBC commissioned a *Hitchhiker's* Christmas special, broadcast on Christmas Eve 1978. The original idea had been to have Marvin arriving in Bethlehem and being cured of his depression by some shepherds, like a robotic version of James Stewart in *It's a Wonderful Life*. Perhaps wisely, however, this idea was abandoned, and instead the programme – subsequently known as Fit the Seventh – is simply a bridge into the second series. Despite Perkins having moved in with Adams in an attempt to secure a finished script, Adams still found himself writing lines on the day of recording, typing them onto carbon paper so they could be immediately distributed to the actors.

This was the start of a worrying trend, although one which Geoffrey Perkins thought he had more than allowed for on the second series proper, through some judiciously early deadlines. Indeed, recording for the first episode began as early as May 1979, with the series not set to begin transmission until the following January. Despite Perkins's efforts, however, the show that would become known as Fit the Ninth (i.e. the second episode of the series, not counting the Christmas special) was not recorded until November.

Even this could have been OK, since with one episode broadcast per week, they still had until March to finish the final shows of the series. But then word came that Radio 4 controller David Hatch had made a deal with the *Radio Times* magazine: they would dedicate their front cover to *Hitchhiker's*, but only on the condition that the entire series be broadcast in a single week. At a stroke, the second radio series became an even more adrenalized, ad hoc experience than the first. And of course the success of the first series brought its own pressures, as they now had their own high standards to live up to.

At times, Adams was literally writing lines in one corner of the studio whilst actors recorded on the other side of the room – not exactly ideal circumstances for careful redrafting. Fit the Eleventh and Fit the Twelfth, the final episodes, were recorded in January, the latter so close to the transmission date that the role of Man in the Shack was still uncast as the *Radio Times* went to print and was thus credited to Ron Hate, an anagram of A.N. Other. It was then decided that the role was to be played by Jonathan Pryce, but even this changed at the last minute: Adams had yet to write the part

Plot differences

Much like the electronic guidebook from which it takes its name, *The Hitchhiker's Guide to the Galaxy* can be unreliable, and is particularly untrustworthy as it morphs from one incarnation to another. Changes between the first two radio shows and first two novels include:

- In Fit the First, Arthur persuades Mr Prosser to let him nip to the pub with Ford. In the first novel, it's Ford who does the persuading.
- Lady Cynthia, a "crud-faced old bat", makes an unpopular speech about the bypass in the same episode. She is absent from the novel.
- Frankie and Benjy offer to buy the Ultimate Question from Arthur in Fit the Fourth. In the novel they are more aggressive, intending to forcibly remove his brain.
- The protagonists find themselves in Milliways in Fit the Fifth, as a result of an exploding computer in the previous episode. Though the protagonists do visit Milliways – located on the ruins of Frogstar World B, rather than Magrathea – in the second novel, it's Eddie who sends them there.
- In Fit the Fifth, the protagonists leave Milliways in a spaceship that turns out to belong to the Haggunenon admiral. In *The Restaurant at the End of the Universe*, the stolen spaceship belongs to rockstar Hotblack Desiato.
- The planet Brontitall on which the protagonists arrive in Fit the Tenth does not appear in the second novel. Instead, a somewhat shorter version of that section of the story is effectively relocated to Frogstar World B.

when Pryce arrived at the studio, so he ended up playing Zarniwoop instead.

Mixing on this final episode was finished just twenty minutes prior to transmission – ludicrously close to the wire, particularly as the tape then had to be driven three miles down the road before it could be broadcast.

In such circumstances, it's hardly surprising that the second series isn't quite up to the standards of the first, though it still has much to recommend it. The sound effects are superb, including the Total Perspective Vortex (Geoffrey Perkins thumping the strings of a piano), Gargravarr's voice (flanger and tape echo) and the firing of rockets (someone blowing a raspberry into the microphone).

Certainly Paddy Kingsland excelled himself on this series, reportedly working so hard that on the final day he had to go home because he was hallucinating. Kingsland also composed original music for the series, whereas the first series had simply used pre-existing music that Adams had recommended. The series introduced actress (and subsequent *Celebrity Big Brother* George Galloway stroker) Rula Lenska, playing the Lintilla clones and the Stewardess, and theatre maverick Ken Campbell as Poodoo. It says something about the mania of the recording process that the name of the latter's character apparently reduced the entire cast into helpless giggles for a good half hour.

Further phases

Though Adams stated that he left the final episode deliberately open-ended so as to allow for a third series, it was not to be during

his lifetime, thanks to the various reasons detailed in Chapter Five. The prospect of a third series did raise its head in 1993, when Adams suggested as producer Dirk Maggs, responsible for the Radio 4 dramatization of *Superman*, but this project never got off the ground.

Maggs and Above the Title Productions would eventually manage to get *Life, the Universe and Everything* adapted for radio, although not until after Adams's death. Broadcast from September 2004, this so-called Tertiary Phase still starred Simon Jones, Geoffrey McGivern, Mark Wing-Davey, Susan Sheridan and Stephen Moore, but with William Franklyn as The Book and Richard Griffiths as Slartibartfast. Joanna Lumley appeared as Sydney Opera House Woman, but perhaps the most notable cast addition was that of the late Adams himself, posthumously playing Agrajag thanks to carefully re-edited extracts from an audiobook reading. This, of course, was particularly appropriate given the character's theme of reincarnation.

The Quandary and Quintessential Phases followed in 2005, again directed and co-produced by Dirk Maggs, who adapted the scripts from the fourth and fifth novels respectively – although following them rather less slavishly than he had with the Tertiary Phase. As well as Jane Horrocks as Fenchurch, the Quandary Phase saw Rula Lenska reappear, this time playing the Bird, while Sandra Dickinson from the TV version played Trillian. Other notable cast appearances included Geoffrey Perkins as Head of Light Entertainment Radio, Stephen Fry as Murray Bost Hanson, and astronomer Sir Patrick Moore as himself. The series even boasted two major American stars: New York comedy legend Jackie Mason as East River Creature, and Hollywood's Christian Slater as Wonko the Sane.

Hot on its heels, the Quintessential Phase again featured many of

the original cast members: Simon Jones, Geoffrey McGivern, Mark Wing-Davey and Stephen Moore all reprised their roles, while the two versions of Tricia McMillan were played, appropriately, by Susan Sheridan and Sandra Dickinson. Griff Rhys Jones, another member of the extended *Hitchhiker's* family, put in a brief appearance as Old Thrashbarg. Continuing the parallel universe theme of the fifth novel, the series concludes with a coda of possible endings.

7

The books

Sufficient time has surely passed since the publication of *The Hitchhiker's Guide to the Galaxy* for it to qualify indisputably as a classic. In 2003, a quarter of a century after it first appeared, the book was included in the BBC's Big Read survey, an attempt to find the UK's favourite novel. Championed by comedian Sanjeev Bhaskar, it ended up as the nation's all-time number four, beaten only by *Lord of the Rings*, *Pride and Prejudice* and Philip Pullman's *His Dark Materials*. This popularity is borne out by the sales figures: along with its sequels, *Hitchhiker's* has now sold 16 million copies worldwide and, remarkably for a novel frequently described as quintessentially English, has been translated into 35 languages. All of which makes the BBC's decision to turn down the

novel back in 1978, on the grounds that books of radio shows didn't sell, seem rather embarrassing.

The first novel

Adams found himself an agent as soon as he graduated from Cambridge, choosing Jill Foster presumably because she also represented several members of Monty Python. Phoning her first thing every morning, the aspiring writer had plenty of enthusiasm but, initially at least, precious little actual work. With the near-instantaneous success of the *Hitchhiker's* radio show, however, Adams was suddenly hot property (at least, to everyone except the BBC). Several publishers approached Adams looking for a spin-off novel, with Pan's commissioning editor Nick Webb winning the bidding war. The deal was signed in August 1978 for an advance of £3000.

It wasn't only Douglas Adams's name on the contract, however: he was to write the novel with John Lloyd, who had helped him out with the final two episodes of the first radio series. When Adams subsequently changed his mind, electing to make a go of it alone, it caused quite a rift between the two men – one that was only partially healed when Lloyd received his half of the advance. Unfortunately, by this time the pair had already booked a writing holiday in Corfu, where the atmosphere must have been about as warm as the weather – and, this being autumn, blankets were reportedly required for sitting outside, even during the day. One good thing did come out of their time on the island, however: the word games with which they passed the time would evolve into *The Meaning of Liff* (see p.244).

As well as affecting Adams's personal life, the John Lloyd issue may also have been responsible for the rather sudden ending of *The Hitchhiker's Guide to the Galaxy*. It has been suggested that Adams restricted himself to material from the first four radio shows so as not to use anything from the episodes he'd co-written with Lloyd. Adams, however, blamed his publisher for the rather rude truncation. By his account, the novel was only two-thirds finished, but since his deadline had already been extended numerous times, Pan eventually insisted on publishing the manuscript in unfinished form.

As well as the troubled relationship with writing schedules that would characterize his career, the first *Hitchhiker's* novel was also an early introduction to Adams's love of private jokes. The name of the worst poet in the Universe may have been changed, in all but the very first editions, to Paula Nancy Millstone Jennings, but it had originally been a dig at a former classmate. Similarly, "bloody Martin Smith of Croydon" was a Cambridge contemporary. And the telephone number of an Islington flat where Arthur once attended a party was the actual

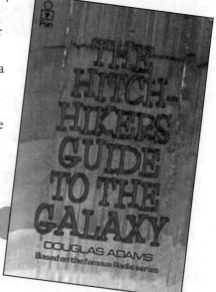

The first novel's original Hipgnosis paperback jacket was a multicoloured, almost psychedelic affair with, unsurprisingly, "Don't Panic" emblazoned on the back.

phone number of Adams's friends Jonny Brock and Clare Gorst, to whom the first novel is dedicated.

The novel was eventually published in October 1979, with a cover by Hipgnosis, a team primarily known for designing record sleeves for the likes of Paul McCartney, Led Zeppelin, Genesis, Yes and Peter Gabriel. They were even responsible for the prism that adorned the cover of Adams's beloved *The Dark Side of the Moon* by Pink Floyd.

To mark the publication, Adams attended a book signing at London sci-fi bookstore Forbidden Planet, that has become a key part of *Hitchhiker's* folklore. There were, reportedly, so many people milling about on the streets when Adams arrived that he initially thought he had stumbled into a march or a demonstration – then he realized it was the queue of people waiting to buy his book. The story goes that the next day the book was number one in the *Sunday Times* bestseller list.

FORBIDDEN PLANET PRESENTS ONE OF THE MOST EXTRAORDINARY VENTURES IN THE ENTIRE HISTORY OF CATERING

THE HITCH-HIKER'S GUIDE

THE RESTAURANT AT THE END OF THE UNIVERSE

TO THE GALAXY

MAIN COURSE

DOUGLAS ADAMS

THIS WHOLE JU - JU FLOP SITUATION WILL LAST FROM

2·00-4·00p.m. ON SATURDAY 6th. DECEMBER 1980

(THE MANAGEMENT REGRET THAT THEY ARE STILL AWAITING THEIR CONSIGNMENT OF SMALL, LEMON-SOAKED PAPER NAPKINS).

WARNING: REMEMBER – THE DIFFERENCE BETWEEN WHAT YOU EAT AND WHAT YOU EXCRETE MAY BE SURGICALLY REMOVED – THEREFORE IT IS VITAL TO GET A RECEIPT!

"PARENTS OF YOUNG, ORGANIC LIFE-FORMS ARE WARNED THAT TOWELS CAN BE DANGEROUS IF EATEN IN LARGE QUANTITIES."

London's Newest Science Fiction and Comic Book Shop! 23 Denmark St., London WC2 - Just off Charing X Rd.

OPENING TIMES 10am-6pm; THURSDAY 10am-7pm TEL: 01 836 4179

SHARE AND ENJOY

A flyer for the Forbidden Planet store signing of December 1980.

M.J. Simpson, however, has pointed out that no book could appear in the *Sunday Times* bestseller list the day after publication – and furthermore, industrial action meant that *The Sunday Times* simply wasn't published at all that October. In fact, it seems likely that the crowds have also been exaggerated a little. Biographers can't even agree on the date of this legendary event, Simpson putting it on 13 October, while Nick Webb (who, as Adams's commissioning editor at the time, might be expected to know) claims it was 10 October.

If the story is apocryphal – or at least wildly inaccurate – the basic details remain true enough. The novel's initial print run had been just 60,000, already mildly ambitious for a debut novel, but it went straight onto the bestseller lists. Within three months it would sell a quarter of a million copies.

The following year, *The Hitchhiker's Guide to the Galaxy* came out in the US, Crown and Pocket publishing hardback and paperback versions respectively. The book was marketed at a hip student crowd, with Adams's Python connections being played up, and 3000 copies being given away free to readers of *Rolling Stone* magazine. Though the book didn't quite achieve the runaway success it enjoyed on the other side of the Atlantic, the US certainly helped push overall sales past a million in 1983, winning Adams his first Golden Pan award in the process.

Doing it all again

Given Adams's claim that he hadn't had time to finish the first novel, one might expect him to have started early on *The Restaurant at the End of the Universe*. On the contrary, however, the book was

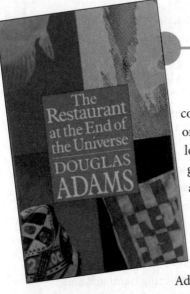

One of a set of *Hitchhiker's* covers that fitted together to form four possible images.

completed well past deadline, and only then because Adams was locked in a rented house by girlfriend Jacqui Graham – who also happened to be Pan's Press Officer.

Tearing her hair out on both professional and personal grounds, Graham imposed upon Adams a monk-like existence that would from then on become standard practice in extracting from the author anything approaching a finished manuscript. Every subsequent book apart from *The Meaning of Liff* would be delivered past deadline, by an ever greater margin as the years went on. On this occasion, however, Adams did have some legitimate distractions, including the TV adaptation of *Hitchhiker's*, and he also seems to have struggled somewhat with the raised expectations that accompanied his sudden success.

Knowing that he wanted the novel to conclude on pre-historic Earth but not entirely sure how to get there, Adams borrowed from the radio show far more irreverently than he had for the first novel. Some parts were unused, other parts added, and the order was significantly changed. He ended up writing *The Restaurant at the End of the Universe* in something close to reverse order.

Adams also drew on material previously conceived for other projects. The idea of a spaceship of mummies, as on the Golgafrinchan B Ark, had appeared in his ill-fated script for *The Ringo Starr Show*, while he had used the gag of a planet jettisoning the useless third of its population in an aborted *Doctor Who* story. Even specific details such as telephone sanitizers pre-dated the novel, Adams having written a kind of Alistair MacLean spoof in which an impregnable stronghold is stormed not by crack commandos but by humble folk simply hoping to clean the handsets.

The Restaurant at the End of the Universe was published in October 1980 and, although dissatisfied with it at the time, Adams would later declare it his favourite of the *Hitchhiker's* novels. Many fans would agree with him. Not only was it a great success in the UK – this time the Forbidden Planet signing really *was* mobbed – but, significantly, it also made it onto the bestseller lists in the US.

Never again...

In a soon-to-be-familiar pattern, Adams followed the publication of *The Restaurant at the End of the Universe* by swearing he would never write another *Hitchhiker's* novel. In July 1981, however, he signed a contract for *Life, the Universe and Everything*, a rather tempting advance having been negotiated by new agent Ed Victor.

Unlike the first two novels, *Life, the Universe and Everything* was not based on the *Hitchhiker's* radio scripts, but rather on an unused story about deadly cricket-playing robots from Adams's *Doctor Who* days. This should have been an advantage, the first two books

having suffered to an extent from being based on inevitably episodic scripts. Here, finally, was a chance to conceive a non-serial story within a deliberate, over-arching plot. Ironically, however, this strength of plot became the book's major flaw, overwhelming characters to whom saving the Universe simply did not come naturally in the way it would for Dr Who.

Though Adams struggled with the opening, reportedly penning twenty drafts of the first chapter before abandoning it entirely apart from a single sentence, he did come up with some strong ideas. Wowbagger the Infinitely Prolonged is an appealingly unpleasant minor character, dealing with the burden of immortality by insulting the population of the Universe in alphabetical order. The Starship *Titanic* only gets a brief mention, but its substantial potential would be further explored later in Adams's career (admittedly with mixed results) – see p.219. And Agrajag, the demented bat-like creature whom Arthur has killed, often accidentally, on numerous occasions, is superb – both in isolation and as a reference back to the bowl of petunias gag in the first novel.

Halfway through the book, however, Adams's gigantic

In the beginning was *The Hitch-Hiker's Guide to the Galaxy*. Then came *The Restaurant at the End of the Universe*. For further information, read on...

DOUGLAS ADAMS

The iconic cover of the third book in the series. For those too young to remember, that's what ringpulls on drinks cans used to look like.

heartstrings suffered a major blow. Whilst promoting *The Restaurant at the End of the Universe*, he had begun a passionate affair with (married) writer Sally Emerson. She even moved in with him, and for a while this proximity to another, rather more productive, writer seems to have improved Adams's own productivity, as well as his love life. Emerson also served as a much-needed testing ground for new material, a role previously played by Geoffrey Perkins and John Lloyd on the original radio show, and by friends Mary Allen and Jon Canter during the first novel.

At the end of 1981, however, Emerson left Adams; as he put it, "she went off with this bloke on the, to me, spurious grounds that he was her husband". Adams was disconsolate, later stating that *Life, the Universe and Everything* was written under circumstances in which he didn't feel up to building a bookcase, let alone writing a book. When the book appeared, a full year late, it still bore the dedication "For Sally".

The break-up may be one reason why the novel took a somewhat darker tone than the first two instalments (a darkness that would only increase as the saga continued). The book also marks a ramping up of swearing in Adams's writing, from a cheeky "bullshit" in the first novel to a Rory Award for "Most Gratuitous Use of the Word 'Fuck' in a Serious Screenplay", although the term was altered to "Belgium" in US editions.

However much his personal life may have been marred by heartbreak, the publication of *Life, the Universe and Everything* saw Adams's career leaping from strength to strength. The book was number one on the *Sunday Times* bestseller list for a remarkable seven weeks. He toured Australia for the first time, and, when the

hardback was published in the US, found himself with all three novels simultaneously in the *New York Times* bestseller list. Apparently, he was the first British author to achieve such a feat since James Bond creator Ian Fleming.

The fourth in the "trilogy"

After *Life, the Universe and Everything*, Adams again swore there would not be another sequel – and again, in November 1983, he promptly signed a deal for said sequel. The advances he was now commanding, reportedly £100,000 from Pan and, although figures vary, something roughly in the region of $500,000 from US publisher Pocket Books, were no doubt hard to resist. Yet Adams also craved the security of the *Hitchhiker's* universe after a frustrating year in the US, trying unsuccessfully to get a film adaptation off the ground.

Though Adams had struggled with writing the three novels up to this point, in many ways he'd had it easy: the first two were based on the radio version, the third on a *Doctor Who* script. *So Long, and Thanks for All the Fish*, then, was the first novel Adams had attempted to write from scratch, and he found it harder than ever, later issuing his oft-quoted remark that writing meant "staring at a blank piece of paper until your forehead bleeds". Ironically, the size of the advance negotiated by Ed Victor seems to have made it even harder, the author plagued by self-doubt as to whether he could live up to such great expectations.

As usual, Adams embarked on some elaborate displacement activities, including ten weeks at Huntsham Court hotel in Devon.

Influences on *Hitchhiker's*

The extent to which Adams was influenced by science-fiction literature has been the subject of much debate among fans and critics alike. It is generally accepted that he had only limited interest in the genre as a whole, but was a fan of Kurt Vonnegut and, in particular, Robert Sheckley – although he told Neil Gaiman that he didn't read the latter until critics started comparing their work. Though not as wholeheartedly comedic as Adams, both these writers shared an absurdist streak, whereas most other sci-fi, as Adams himself pointed out, simply isn't very funny. Probably more important than science fiction, then, were the influences on Adams's humour: Monty Python was one, but there were literary precedents too, from the satire of Jonathan Swift to A.A. Milne's gently witty Winnie the Pooh stories, described by Adams as more of an influence on his work than Lewis Carroll. Most important, however, was P.G. Wodehouse, whose affectionate mockery of pre-war, stiff-upper-lip England is echoed in Adams's treatment of Arthur.

He became firm friends with Mogens and Andrea Bolwig, who ran the place, and between them they got through a good deal of champagne. None of this, however, was a great help in writing the novel. With an extensive marketing campaign already in place and the book no nearer completion, Sonny Mehta, Pan's editorial director, resorted to the only method that guaranteed a finished

manuscript. He booked a suite at London's Berkeley Hotel and moved in with Adams, allowing him out only to go swimming in the hotel pool or running in nearby Hyde Park. Under these conditions, with Mehta watching over him and editing pages on the spot, the novel was finished in just a fortnight.

Unsurprisingly given the pressure he was under, Adams again revisited old material. The theme of the couple being repeatedly interrupted in a railway station had first appeared in a graduate-era show, *The Unpleasantness at Brodie's Place*. Nick Webb says Adams also recycled certain ideas from his love letters to Sally Emerson. Then there is the famous biscuit story, whereby Arthur is (silently) indignant when a man sharing his table steals half a packet of his biscuits, until he realizes that his biscuits are untouched – he had been eating the *other* man's biscuits all along. This too is a tale that Adams had told on several previous occasions.

Whether or not the biscuits anecdote emerged from personal experience, Adams was certainly following the well-known adage that one should write about what one knows, even drawing upon his own street as the inspiration for Fenchurch's home. In fact, the description seems to have been based on his own flat and that of neighbours Rick Paxton and Heidi Lochler – a converted stable, hence the rather mysterious reference to a "stable event" in the

book's dedication. (As well as his future wife Jane, the dedication also mentions "a number of unstable events" with Mogens and Andy, a nod to Adams's time at Huntsham Court, and, as "stable through all events", his sometime abductor Sonny Mehta.)

Its high romance quota means that *So Long, and Thanks for All the Fish* is a very different book from the three that preceded it. In many ways, it barely feels like a *Hitchhiker's* novel at all. Despite – or because of – this, it was well received by some critics, apparently seduced by the book's gentler pace. And indeed it is certainly not without its merits, including God's final message to his creation and a decent bit-part character in Wonko the Sane. The novel is also noteworthy in that it reflects Adams's growing interest in ecology and changing attitude towards computers – while Eddie had been irksome and Hactar downright malicious, Arthur's Apple Mac is very useful indeed, reuniting him with his beloved Fenchurch.

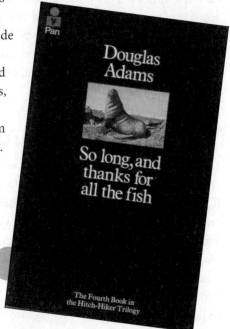

Leaving sci-fi iconography behind in favour of a slightly more "serious" look, this cover reflected a shift in the *Hitchhiker's* series that was not to everybody's taste.

However, though it was a bestseller in both the UK and the US, many fans felt let down by the book, particularly in its neglect of Zaphod and Trillian and lack of intergalactic adventure. It is the shortest of the novels by some margin and there are times when the authorial tone seems uncomfortably glib. The epilogue, for instance, is essentially an extended non sequitur, coming to a sudden dead end with "There was a point to this story, but it has temporarily escaped the chronicler's mind."

Most notoriously, Adams also steps outside the narrative, offering readers the chance to avoid the romance between Arthur and Fenchurch by skipping to the last chapter. Of course, such editorial intrusions are nothing new, dating back to the very first episode of the radio show, when we're told that Ford Prefect "will enter our story in 35 seconds and say 'Hello Arthur'". Yet Adams's tone here is palpably different, described by Neil Gaiman in his book *Don't Panic* as "patronising and unfair".

The final instalment

Following the publication of *So Long, and Thanks for All the Fish*, "the fourth book in the *Hitchhiker's* trilogy", it looked for a while as if Adams's customary protestations about not penning another sequel might actually be true. Yet after various non-*Hitchhiker's* activities, he did eventually start in earnest on the fifth novel, *Mostly Harmless*. This was largely because Adams was once again locked in a hotel room, this time by Sue Freestone, editor at new publishers William Heinemann, and his friend Michael Bywater. (His inability to hit deadlines, by now notorious, was a main theme of a

The influence of *Hitchhiker's*

So pervasive has *Hitchhiker's* been that its precise influence is not always easy to pinpoint. American Mark Leyner is one author who has been compared to Adams for his bleakly absurdist, postmodern style, as has comic sci-fi and fantasy writer Terry Pratchett – although the latter's first novels in fact just pre-date *Hitchhiker's*. Outside literature, it would be possible to detect Adams's influence in BBC sitcom *Red Dwarf*. Broadcast from 1988, it was a kind of anti-*Star Trek* whose characters faced time travel and virtual realities with a familiar mix of cowardice and incompetence. More recently, both US sitcom *3rd Rock from the Sun* and Matt Groening's *Futurama* cartoon have borrowed from science fiction to offer a humorous slant on human foibles, the latter even containing the odd *Hitchhiker's*-style quantum physics gag. In film terms, Adams's influence – direct or otherwise – could be detected, for instance, in 1996's B-movie pastiche *Mars Attacks*, directed by Tim Burton. The following year's *Men in Black*, starring Tommy Lee Jones and Will Smith, took tongue-in-cheek science fiction even further into the mainstream, albeit in a rather more action-based fashion than Arthur Dent could ever have managed. Ironically, the success of that film actually helped persuade studios that there was a market for the *Hitchhiker's* movie – although it would take almost another decade for it to come to fruition.

docufiction episode of UK arts programme the *South Bank Show*, made around this time.)

Though Adams had originally intended *Mostly Harmless* to be centred on Arthur's daughter, Random, she in fact doesn't arrive until quite a way through the story. Instead, the book's main protagonist is once again Arthur Dent, although given the theme of parallel universes, some have questioned whether it's the same Arthur we know from the other four novels. Trillian, absent from *So Long, and Thanks for All the Fish*, also returns – twice, in keeping with the parallel universe theme. The other major presence in the book, although again it doesn't come into its own until relatively late, is that of *The Hitchhiker's Guide to the Galaxy Mk 2*. This pernicious creature is eventually responsible for the apparent destruction of the Earth in every dimension.

As such a synopsis suggests, the light tone of the first novel has all but disappeared; the events of *Mostly Harmless* play out against an altogether more desolate canvas. The thoroughly nasty InfiniDim Enterprises, for instance, has transformed The Guide's office from a drunken party zone into a malevolent corporation run by

By the time of this design, Adams was a household name, a fact underlined by the size of his name as it appears on the cover.

slimy, smooth-faced men and patrolled by thugs with rocket launchers. Meanwhile, Arthur says things like "Ford, I've had a *fucking* bad night", a line which it is hard to imagine spoken by the character from the original novel, whose mouth contained nothing more toxic than Nutri-Matic tea substitute.

Zaphod and Marvin are absent, as are Fenchurch and Slartibartfast. Though we do get Arthur, Ford and two versions of Trillian, it takes rather a long time for them all to meet up, and all are in some way frustrated – Arthur because he's lost Fenchurch and his planet, Tricia because she never left with Zaphod, Ford because of InfiniDim. If the characters are less than happy, so was their creator, who seems to have found this book, the last he ever finished, harder than ever. There are stories of Adams lying on the floor, on at least one occasion sincerely declaring himself unable to complete the book, while Bywater and Freestone tried to coax him into writing by suggesting plot scenarios.

Testament to the loyalty of his fans, "the fifth book in the increasingly inaccurately named trilogy" sold well when it appeared in late 1992 – four whole years after Adams had signed the deal with Heinemann, and thus something of a record even for him. The book was dedicated to Adams's stepfather Ron Thrift, who had died the previous year. Despite its troubled gestation, Adams himself seemed happier with the novel, even suggesting that he'd like it to be thought of as the fourth *Hitchhiker's* novel. *So Long, and Thanks for All the Fish*, it was implied, would best be quietly forgotten.

Thereafter, Adams did speak on various occasions of a sixth *Hitchhiker's* novel, and at one point *The Salmon of Doubt* was to have been that book. On the other hand, *The Salmon of Doubt* was to have been just about everything – over the years, the title was

attached to vague plans for *Hitchhiker's*, *Dirk Gently* and other unrelated novels. A book of that name did eventually appear posthumously, containing a half-finished Dirk Gently story plus miscellaneous other stories, articles and interviews. It looked as though the *Hitchhiker's* saga really had perished, along with the Earth. However, the publication of *And Another Thing...* by Eoin Colfer has, of course, made that sixth *Hitchhiker's* novel a reality – though, naturally, it still counts as a trilogy.

Stage productions

Including amateur versions, there have been well over a hundred stage adaptations of *The Hitchhiker's Guide to the Galaxy*, performed as far from Douglas Adams's beloved Islington as Germany, Bermuda and Australia. Particularly noteworthy, however, are the two professional productions directed by Ken Campbell, a genuine eccentric who until his death in 2008 epitomized experimental fringe theatre in Britain.

Campbell, who would later play Poodoo in Fit the Twelfth (see p.154), was introduced to the original *Hitchhiker's* radio series by a friend. A lover of the surreal with a devilish sense of humour, he perhaps saw Adams as a kindred spirit – although the prospect of a

ready-made audience, as suggested by the rave response to the radio show, certainly didn't hurt either. So, before *The Hitchhiker's Guide to the Galaxy* even became a novel, let alone a TV series, album, comic book or film, Campbell approached Adams for the stage rights. The writer readily agreed, apparently believing that a stage version was close to impossible.

h2g2 hits the ICA

Happily, Adams was proved well and truly incorrect by Campbell's production, which opened at London's Institute of Contemporary Arts in May 1979. With the sort of lateral thinking that characterizes the best low-budget theatre, the performance kicked off in the foyer. Then, when the Earth blew up, the show quite literally took its audience on a journey – one step on from a promenade performance, they were actually placed on some kind of hovercraft and pushed from scene to scene by stagehands.

The actors themselves were spread around the walls on various ledges. Chris Langham, of the *Not the Nine O'Clock News* sketch show, played Arthur Dent (and would subsequently return to *Hitchhiker's* in the role of Prak in the Tertiary Phase). Richard Hope played Ford, while Zaphod's twin heads were depicted by Mitch Davies and Simon Williams, within the same costume. Presumably as a way to help balance an overwhelmingly male cast, the role of The Book was split between two female ushers – one of whom, Cindy Oswin, would play Trillian on the *Hitchhiker's* album.

The ICA performance proved an enormous success, right down to its infamous Pan Galactic Gargle Blasters. Served at the bar, the

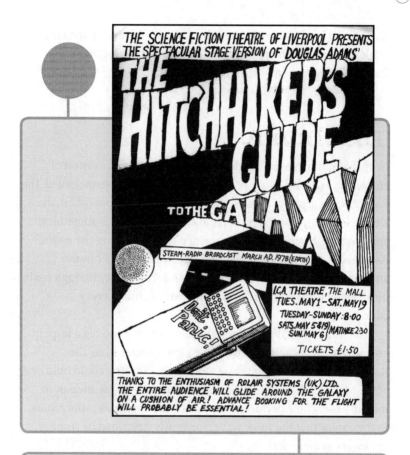

A flyer for the Theatre of Liverpool production of *The Hitchhiker's Guide to the Galaxy*, staged at the ICA in May 1979.

blue, steaming drinks could reportedly send you straight from sober to hungover, entirely bypassing the intermediate state of actual inebriation. The only downside of the whole production was that

the "airpod" technology limited the audience to just eighty a night. With only nine performances, tickets sold out so fast that even Simon Jones apparently struggled to get in.

The Rainbow

In such circumstances, the decision to stage another version of *Hitchhiker's* the following year, this time in a larger venue called The Rainbow, makes a lot of sense. The novel had been published, the album released, and a second radio series broadcast – something approaching *Hitchhiker*-mania seemed to be sweeping the nation. As a result, the Rainbow stage version attracted rather more attention than its cultish predecessor. Unfortunately, although again directed by Ken Campbell, it was inferior in almost every conceivable respect.

The fundamental problem was that it was just too big a leap: in an entirely different league from the eighty-seater ICA, The Rainbow, known as a gig venue more than a theatre, could hold 3000. Many of the show's problems stemmed from an attempt to magnify the whole performance to rock extravaganza proportions, to the extent that the show was erroneously described by some reviewers as a musical.

The grandiose scale was perhaps best symbolized by the inexplicable decision to feature Rick Wakeman in the role of a Mekon alien. Best known for his time with prog behemoths Yes, the keyboard player was here seen descending from the heavens aboard a flying saucer. To paraphrase Adams, more serious crimes against music have been spotted in the sky, but not by reliable witnesses.

Ken Campbell

It is not easy to define the achievements of writer, theatre director and actor Ken Campbell (1941–2008), director of both the ICA and Rainbow stage adaptations of *The Hitchhiker's Guide to the Galaxy*. Indeed, Campbell's refusal to be pigeonholed was an intrinsic part of his appeal. His career ran the gamut from *The Ken Campbell Roadshow*, which saw performers hammering nails into their noses and stuffing ferrets down their trousers, to irrepressible monologues about trepanning and teleportation. Perhaps his most notorious stage adaptation was a hallucinogenic, sexually charged, time-travel extravaganza called *The Warp*, boasting a truly marathon duration of 22 hours. But he was forever up to mischief offstage too, memorably

setting up a fictitious, Dickens-dedicated rival to the Royal Shakespeare Company and sending out fake invitations to the great and good of the thespian world, supposedly from director Trevor Nunn. Having set up the Science Fiction Theatre of Liverpool in 1976, he was the best possible choice for a *Hitchhiker's* stage adaptation – Rainbow catastrophe notwithstanding.

David Bett (Arthur Dent, right) and Kim Durham (Ford Prefect) being threatened by Vogons at the Rainbow Theatre in 1980.

Other elements of the show also took on prog-rock proportions. The opening night's performance lasted over three hours, more than twice the length of the ICA version, with a live five-piece band who apparently played for over half an hour during the Milliways sequence alone. Meanwhile, ambitious attempts to introduce lasers, then something of a novelty in theatre, fell flat. *Hitchhiker's* is simply not about special effects, and this attempt to compete with *Star*

Wars was not only doomed but also sacrificed the series' main strength – the nuance and wit of Adams's writing. The irony was that Adams himself had been significantly more involved with this production than with the ICA version.

There were other problems too. The performers were woefully under-rehearsed, a situation not helped by the decision that the actors playing Arthur and Ford should swap roles just a week before the show opened. And, as Ken Campbell pointed out, there was no hovercraft.

Rick Wakeman during the 1970s, the decade that saw him morph from David Bowie and Black Sabbath session man to fully blown prog superstar.

Whatever the reason, the Rainbow production often attracted embarrassingly small audiences – reports vary between 50 and 700 a night, but either way, that's not a lot in a 3000-capacity venue. It closed early, lost a lot of money, and is almost universally remembered as a fiasco.

Theatr Clwyd

The dismal failure of the Rainbow production does not, however, leave the ICA version as the only successful early stage adaptation. Sandwiched between the two Ken Campbell shows was a version performed by Welsh company Theatr Clwyd, which toured Wales in January and February 1980 and has been revived on various occasions thereafter. Director Jonathan Petherbridge divided the script into easily digestible chunks: two episodes a night were performed during the week, with a three-hour "omnibus edition" on Friday and Saturday for the seriously committed.

This version was a great success, in part because it shared with the ICA production the sort of low-key, informal feel that The Rainbow had spectacularly failed to capture. And thanks to relatively conservative staging – in other words, no hovercraft – it was this version, rather than the ICA incarnation, that helped establish a definitive *Hitchhiker's* stage script. Unusually, however, it followed the Haggunenon version of the story (see p.153), thus requiring that most underused of stage props: a chair that could morph into the Ravenous Bugblatter Beast of Traal. This ambitious demand was met by creating an inflatable version of the Beast,

Rocky Horror

Philip Tinsley, co-producer of the Rainbow stage adaptation of *The Hitchhiker's Guide to the Galaxy*, stated in 1980 that the show was "the first since *Rocky Horror* to appeal directly to young people". Indeed, Richard O'Brien's wonderfully demented stage production and film spin-off – another cult success that crossed into the mainstream – provide one of the few precedents for *Hitchhiker's*. O'Brien was playing with science-fiction convention in a more debauched fashion than Adams, and he threw in a good deal more sex and horror too. Yet both stories depict naïve, rather helpless humans cast adrift in a strange, preternatural environment. *Rocky Horror*'s Brad certainly bears comparison with Arthur, while Janet is somewhere between Trillian and Fenchurch, not that Adams gives us many female roles to choose from. Zaphod's flamboyant hedonism even has echoes of Frank-N-Furter, although the President of the Imperial Galactic Government has yet to appear in stockings and suspenders (in public, anyway). Rayner Bourton, who appeared as the newscaster in the *Hitchhiker's* TV series, provided a direct link between the two franchises, having actually played Rocky in the original Royal Court Theatre production of *The Rocky Horror Show*.

remarkable by all accounts, which was subsequently borrowed by other productions.

Hereafter, ongoing attempts to get the *Hitchhiker's* film version off the ground effectively scuppered all professional versions, due to rights issues. Amateur versions were unaffected, however, and have to date included a one-man show and a musical. The stage incarnation is also significant as the first appearance of the Dish of the Day, written by Adams specifically for theatre before being incorporated into *The Restaurant at the End of the Universe*.

9

Television

Largely due to inevitably lower budgets, British science-fiction television is all too often dismissed as inferior to its transatlantic counterpart. And against its cinematic sibling, TV science fiction – British or otherwise – can find itself neglected altogether, unable to offer visual spectacle on anything like the same scale. When *The Hitchhiker's Guide to the Galaxy* was broadcast, from 5 January 1981, it was competing not just against *Star Trek* but also against the first two *Star Wars* films. In subsequent years, it would at times almost seem to be competing too against Douglas Adams himself, who would frequently distance himself from the series despite having written the script.

As a result, the *Hitchhiker's* TV show doesn't share the reputation enjoyed by the radio series or novels, a state of affairs that seems

more than a little unfair. True, the clothes and hairstyles date this version more obviously than the original radio series or novels. But it is the TV actors who have, for good or bad, permanently defined their characters' appearance in the minds of many *Hitchhiker's* fans. The graphics remain genuinely impressive today despite the staggering advances in computer technology since they were produced. And, most importantly, more than a quarter of a century later, it's still funny.

Assembling the team

In an echo of Simon Brett's role on the *Hitchhiker's* radio show, John Lloyd – who had, of course, co-written two episodes of that radio series – was vital in getting the TV adaptation off the ground. But, having convinced the BBC's John Howard Davies of the idea's potential, Lloyd was promptly called off to work on *Not the Nine O'Clock News*, and would be barely involved in the series. In his place, the BBC put forward producer and director Alan Bell. Having initially believed that *Hitchhiker's* was unfilmable, Bell had been convinced to take on the project by Davies, who apparently declared the script one of the best he'd ever read.

Adams, however, was less than enamoured of the director, and his recollections of their working relationship would become less tactful with every subsequent year. In truth, it wouldn't have taken a Hawalius seer to predict that they might not have made perfect soul mates: Bell was far more of a pragmatist than the ever-fanciful Adams, representing such conservative values as meeting budgets and deadlines. Well into a successful career that would subsequently

Adams's cameos

Right at the start of the TV series, when Arthur and Ford squeeze in a quick pint before the end of the Earth, Douglas Adams can be spotted among the extras at the far end of the bar. (You'll need to concentrate pretty hard to see him, or even resort to freeze-frame, but he really is there – in a beige-coloured jacket if that helps pick him out.) Appropriately for a series so partial to in-jokes, images of Adams also show up on several occasions amongst The Guide's graphics. He is a Sirius Cybernetics Corporation marketing executive; he appears, smoking, in front of his typewriter; and he even shows up – in drag – as the worst poet in the Universe, Paula Nancy Millstone Jennings.

Adams's longest and most notorious cameo – this time not as illustration but, quite literally, in the flesh – comes at the start of episode two. Clad in suit and tie, he walks into a bank to withdraw some money, only to emerge naked on a beach, flinging bank notes into the air as he walks into the sea. The script described this sequence as "doing a Stonehouse", a reference to Labour MP John Stonehouse, who in 1974 had tried to escape scandal by faking his suicide, leaving a pile of clothes on a Miami beach – only to be discovered in Australia a month later. Adams had not originally intended to play the part, but the scheduled actor rang in sick the day before filming. That evening, as Adams found himself being bought a suspicious number of drinks by cast and crew, it slowly dawned on him that he had been volunteered as the replacement.

include directing the enormously (if inexplicably) successful sitcom *Last of the Summer Wine*, he wasn't going to be bossed around by a young Cambridge upstart from the world of radio.

For his part, Adams had been somewhat spoiled on the radio series with Geoffrey Perkins, someone so passionately devoted to the cause that if the script called for two million robots singing a minor fifth out of tune, he'd damn well get that effect or die trying. Such meticulous attention to detail simply wasn't possible on TV – and while Adams seems to have felt slightly betrayed as a result, the fact that Bell apparently worked up to seventeen hours a day on the production suggests he wasn't exactly uncommitted.

The writer and director first clashed over casting: Adams wanted to keep as many actors as possible from the radio series, whereas Bell's inclination was to start afresh. In the end, a compromise was reached. Everyone agreed that Simon Jones was perfect as Arthur Dent; after all the role was partially modelled on him, and in behind-the-scenes footage the distinction between actor and character is sometimes hard to discern. (It was Bell, incidentally, who suggested that he stay in the now-iconic dressing gown throughout. In yet another example of the incestuous relationship between the different *Hitchhiker's* formats, Arthur's garb was only described in books written after the TV series.)

Several other actors were also retained, including Peter Jones, whose voice had come to so definitively represent The Book. Mark Wing-Davey remained as Zaphod, wearing an eyepatch on his second head and an outfit that could have been a prototype for Captain Jack Sparrow's in *Pirates of the Caribbean*. (Coincidentally, Johnny Depp was rumoured to be in the running for the part of Zaphod in the subsequent film version.) Richard Vernon stayed on

Reasons to be miserable: The Marvin costume that Stephen Moore declined to wear... in a rare respite from the torrential rain.

as Slartibartfast, with David Tate again providing the voice of Eddie, and Stephen Moore that of Marvin. However, it was David Learner, who had played Marvin in the stage version, who physically acted the part on TV, as Moore didn't like the robot's costume.

In fact, no one seems to have liked the robot's costume, least of all Adams himself. The author seems to have been unable to explain in detail how he conceived the character's appearance, but he had clear ideas about what he *didn't* want. A reported fifty design sketches by Visual Effects Designer Jim Francis were rejected, as was

Adams's own suggestion that Marvin be played by an actor in a metallic leotard. Eventually a design was settled upon, more because of time pressures than because any consensus had been reached, and Francis had to construct it in just two weeks.

Several new actors were introduced alongside these old hands, including the fey, fervent David Dixon as Ford Prefect. To work himself up to the feverish levels of enthusiasm the role required, Dixon would spend the time between takes jumping up and down on the spot, shouting "Psyche!", like an American footballer. Unlike most American footballers, however, he was clad in striped blazer, diamond jumper, Eton tie and floral shirt, with a yellow pocket handkerchief. The grotesquely incongruous patterns and colours were selected specially by costume designer Dee Robson.

The role of Trillian was also re-cast, going to Sandra Dickinson, sporting a series of piquant red outfits and speaking, at Adams's own suggestion, in her natural, rather piercing American accent. Adams later suggested that this had perhaps been a mistake, particularly as he believed her capable of doing an excellent "English rose" if asked. Apparently, at the time he was simply relieved to have finally found someone who could deliver the character's lines with the requisite sense of humour.

Filming

Filming for the *Hitchhiker's* pilot took place between March and June 1980. In July the episode was screened to a small test audience at the National Film Theatre, whose enthusiastic response was recorded as a laughter track – standard policy for BBC shows at the

time but not used for the broadcast version, much to Adams's relief. Despite the fact that the BBC top brass seemed confused by the show, apparently taking a while even to realize that the pilot was meant to be funny, another five episodes were soon commissioned.

There was talk of location filming in either Iceland or Morocco, but in the end it was a clay pit near St Austell in Cornwall that served as the barren planet Magrathea. The West Country phase of filming certainly had its attractions, with Adams's Golf GTI convertible leading regular convoys to nearby gourmet restaurants discovered by means of his latest enthusiasm, *The Good Food Guide*. A copy of the book actually appears briefly in episode six.

The filming itself was less luxurious, not least because Cornish clay pits are not renowned for their toilet facilities. The weather wasn't great either. Appropriately, David Learner, playing Marvin, had a little extra to moan about: his costume took so long to get on and off that it was sometimes necessary to abandon him during a downpour, leaving him with nothing but an umbrella for company.

Whilst in Cornwall, they also filmed the beach scenes, including the heavily bearded Arthur and Ford on their pre-historic raft, and Adams's most prolonged (and most revealing) cameo (see p.187). Marvin was filmed with a beach ball and a bikini-clad girl, for his depiction in a Sirius Cybernetics Corporation promotional video.

The pre-historic Earth sequence, meanwhile, was filmed in the Peak District National Park. The animal-skin-clad extras playing the indigenous population were frozen to the bone, as was Aubrey Morris as the Golgafrinchan Captain who loved baths almost as much as Adams himself. Even filling up the bath was no mean feat, the rather dubious-looking water having to be collected from a local paper mill and piped to the bath from a tanker.

More urban location shooting was required for the cityscapes of London in the moments before its destruction at the hands of the Vogons. This was filmed from the NatWest Tower, which would later be renamed … Tower 42. No mere serendipity, this fact clearly proves that the Ultimate Answer, at least, was printed in the TV crew's brainwave patterns. (For further proof, as if it were needed, the Deep Thought sequence was filmed in week 42 of the BBC's calendar. The TV show was clinging to its destined path as surely as a pre-Stavromula Beta Arthur Dent.)

Back in the studio, Adams remained as heavily involved in the production as he had on the radio series. Though he made himself useful by reading Eddie's lines, to be dubbed later by David Tate, Adams's presence probably didn't do much to help the relationship with Bell, who may have felt that the writer was encroaching on his turf. Certainly, they continued to disagree, with Adams apparently believing that Frankie and Benjy should be played by actors rather than real mice, and upset that Bell had changed the design of Slartibartfast's aircar.

Contrary to Adams's opinion, Bell actually did a pretty good job, particularly given the limitations of the situation. Apart from the technical problems of spacecraft and exploding planets posed by *Hitchhiker's*, his hands were further tied by union troubles that were at the time all too common. (Margaret Thatcher had become prime minister in 1979, just in time for the radio script's obnoxious Lady Cynthia Fitzmelton to be loosely modelled upon her, but it would take a while for the Iron Lady to crush the trade unions. The miners' strike, for instance, would not take place until 1984–85.)

The mass unemployment and civil unrest may have made Adams's bleak humour – shared by contemporaneous science-

Plot

Although there are small variations, such as Arthur and Ford eating a Hagra biscuit and touring the storeroom on the Vogon ship, the first four episodes of the TV series broadly follow the standard *Hitchhiker's* plot as detailed in Chapter One of this book. Arthur and Ford escape from Earth, spending time on the Vogon ship and the *Heart of Gold* before arriving on the planet Magrathea. It's as the protagonists leave that planet that the various incarnations of the story start to diverge.

In the TV series, the computer explosion at the end of episode four sends Arthur and his companions to Milliways. When they leave, the ship they steal belongs to Disaster Area (as in *The Restaurant at the End of the Universe*) rather than the Haggunenon Admiral (as in the radio series). The TV series ends with Arthur and Ford on pre-historic Earth, along with the population of the Golgafrinchan B Ark. In many ways, this plot most closely resembles that of the two *Hitchhiker's* albums – see Chapter Ten.

fiction TV such as the BBC's *Blake's 7* or *Sapphire and Steel* on ITV – all the more appealing to the nation at large. But the unions also had a more direct, and more detrimental, impact on *Hitchhiker's*. Problems began whilst they were on location, filming the sequence at Arthur's house and nearby pub, and continued back in the studio. The unions insisted on the gigantic Milliways set being reduced in size, and a dispute with the electricians' union meant that each day's

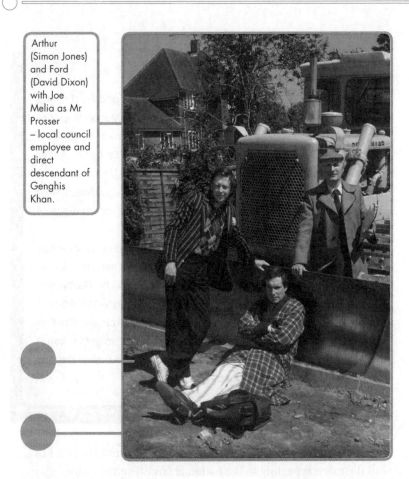

Arthur (Simon Jones) and Ford (David Dixon) with Joe Melia as Mr Prosser – local council employee and direct descendant of Genghis Khan.

filming had to stop on the dot at 10pm. This only worsened existing time pressures, with the result that Bell was forced to use a shot of a running "Arthur" that was in fact B-roll footage of Simon Jones returning to his mark between takes.

Giant sets and special effects

Despite these production difficulties, and although it may look a little shoddy to our CGI-spoiled eyes, at the time the TV show represented state-of-the-art production values. The pilot had cost four times the price of a *Doctor Who* episode, and even though the budget was reduced for subsequent programmes, the costs remained enormous by the standards of the time. True, the corridor of the Vogon ship had appeared in Ridley Scott's film *Alien*, and the *Heart of Gold*'s central platform was borrowed from the BBC game show *Blankety Blank* – but the set for Milliways, for instance, was the biggest ever put into a BBC studio.

One example of the high production values is the way the show fleshes out even fairly throwaway lines. A mention of Pan Galactic Gargle Blasters, for instance, is illustrated by a pair of gold-hued alien lovers drinking said intoxicant from elaborate goblets. Their costumes apparently cost almost £1000 (alright, but this was 1980…). An account of the history of the planet Magrathea warrants a cutaway to an overweight merchant, four scantily clad women, a dog and an erotically charged grape. Perhaps most impressive of all, an early reference to the fact that humans don't invite their distant ancestors round for dinner is represented by a brief shot of a chimpanzee at a dinner party, with the words "this never happens" flashing in red text.

Hitchhiker's was equally ambitious in terms of special effects, which proved so costly that they apparently wiped out the Light Entertainment department's budget for the entire year. The exploding computer in the Shooty and Bang Bang sequence had to be constructed on a special outdoor set in Henley-on-Thames,

packed with petrol bombs by Jim Francis. The explosion, at 2am, apparently fired pieces of shrapnel onto the nearby golf course and generated sufficient heat to melt the set walls.

Less incendiary, though no less terrifying, was the sequence portraying Arthur and Slartibartfast flying above Magrathea. It was partially filmed in the Cornwall clay pit, the airpod suspended from a crane with Jim Francis and his assistant acting as stunt doubles for Simon Jones and Richard Vernon. Elsewhere, the airpod was placed on the back of a low-loader lorry, which was driven through a long tunnel – the overhead fluorescent lights clearly reflected in the pod's glass dome in the final footage.

The relative expense of *Hitchhiker's* was epitomized by Zaphod's second head, which cost a reported £3000 – famously, more than Mark Wing-Davey himself. Though it may now appear more inert than even Hotblack Desiato, the rock star spending a year dead for tax reasons, it was at the time considered sufficiently cutting-edge to appear on *Tomorrow's World*, the BBC's science and technology showcase. The presenter details its capacity for radio-controlled head rolls, moving mouth and winking eye, all powered by complex mechanisms hidden within the "unnervingly human" skin (actually latex foam).

Sadly, little of this potential comes across on the actual TV show. There were various reasons for this, including batteries running out and Wing-Davey forgetting to turn on the mechanism, via the switch hidden inside his costume. It also relied on a very fragile internal mechanism, which would frequently stop working of its own accord; there wasn't always time to take it apart for repair.

By contrast, Zaphod's third arm was created in altogether less high-tech fashion, either stuffed or – when required to move –

Mark Wing-Davey and the fake extra head of the TV series. No prizes for guessing which is which.

provided by visual effects assistant Mike Kelt, standing behind Wing-Davey. So amateurish is the method that Kelt is clearly visible behind Zaphod when the characters arrive at Milliways but – unlike the failure of the big-budget second head – it simply doesn't matter. As the failure of the Rainbow stage version proved, *Hitchhiker's* works best when privileging wit and wordplay, whilst attempts to concentrate on big-deal special effects have tended to be less successful.

Likewise, one of the TV show's greatest characters is the Dish of the Day, who appears only briefly, in Milliways (along with Hotblack Desiato – somewhere between Elvis Presley and The Cure's Robert

Slartibartfast (Richard Vernon) and Arthur (Simon Jones) with the airpod on location in the Cornish clay pit. The actors would be replaced by stunt doubles for the more vertiginous flying sequences.

Smith – and his mobster minder, played by David Prowse, the man behind Darth Vader's mask). The Dish of the Day's costume is highly unconvincing, more like a giant brown lilo than a cow, but the appeal of the character renders such considerations irrelevant. At the time, viewers may have derived an extra layer of comedy from the fact that the role was portrayed by Peter Davison, not only married to Sandra Dickinson (Trillian) but well known for playing a vet on the TV series *All Creatures Great and Small*.

Though the budgets were large for the time, they were still insufficient to achieve all Bell's intentions, resulting in some feats of genuine ingenuity in terms of the actual filming process. Filmmakers have long created the illusion of distance, or of a more elaborate set, by means of "glass shots" – simply, filming through a sheet of glass with images painted upon it. This technique was used early on in *Hitchhiker's*, but was deemed prohibitively time-consuming to use on subsequent episodes. Instead, Alan Bell came up with an alternative: a given scene would be photographed, then painted, then made into a slide, which was perfectly matched to the film scene to create a convincing composite shot. This technique proved a great success, and was sufficiently cheap that they could use perhaps five or six of these "matte shots" per episode.

Graphics for The Guide

Nowhere did budgetary constraints produce as much innovation as in the creation of the visuals for The Guide itself – the one aspect of the TV series of which even Adams, who at times all but disowned the show, remained proud. It is also these "computer graphics" for which the TV show is best remembered, the irony being that they weren't created by a computer at all but rather by entirely traditional animation.

In fact, the original plan *had* been to use computers, but the budget proposed by the BBC graphics department had made everyone go weak at the knees. The solution arrived entirely by chance, when Alan Bell met Kevin Davies, a young animator who worked next door. Davies was a passionate *Hitchhiker's* fan, having

actually interviewed Adams for a fanzine in 1978, and, upon hearing that Bell was to direct the TV series, dragged him down the corridor to meet his boss, Rod Lord.

Lord's Pearce Studios were duly commissioned to provide The Guide's graphics, having first put together half of the Babel fish sequence as a kind of trial run. Not only was their budget rather more achievable than that proposed by the BBC graphics department, but ironically their hand-drawn computer images were far more convincing than anything contemporary computers could have provided.

The sterling work of Pearce Studios solved what could have been a major problem, namely that the role of narrator, so essential on radio, could have been rendered semi-redundant on TV. The animations instead make highlights of the Peter Jones sequences, the dizzying visuals including footnotes, illustrations, diagrams, statistics and equations to complement his lines. Often a number of the effects take place simultaneously, in any number of different colours, the combined effect far too much to take in on first viewing.

At times the effect is like an arcade game, at others more like a robot's point-of-view shot in a sci-fi film, a futuristic school textbook, or even a digital version of the Bayeaux Tapestry. There are also numerous drawings, usually cheekily comic, such as a detailed diagram of Eccentrica Gallumbits' erogenous zones. Other gags include a rock band named Lead Balloon, a nod to Led Zeppelin, and a Frogstar Scout robot in the *Encyclopedia Galactica* sequence as an in-joke for fans of the second radio series.

It is not only in retrospect that people have assumed these visuals were computer-generated. After the first episode, Pearce

Studios were phoned up by the staff of a computer magazine, convinced that the studio had access to technology not yet on general release. Since the graphics of the final episode had not yet been finished when the first episode was broadcast, Pearce Studios were able to incorporate the magazine's phone number into episode six, enclosed within the words "Who do they think they are?" (Elsewhere on the screen we see the words "arrogant bastards" and "they're so unhoopy". Readers may make up their own minds as to whether those messages refer to the real-life magazine or to The Guide's ostensible subject, the Belcerebon people of Kakrafoon Kappa.)

The methods utilized by Rod Lord and his team were far more impressive than any computer technology. Beginning with pencil drawings made from a storyboard, they would trace images in ink onto acetate animation cels. The cels were then taken into the darkroom and turned into large photographic negatives, reversing the colouring to provide clear letters and drawings on a black background. Frame by frame, the pieces of artwork were photographed onto movie film, each line of lettering and colour requiring a new exposure – for complicated sequences, more than a dozen exposures were required on a single strip of celluloid. To give the illusion of typing, text was covered with black card, then exposed a letter or a word at a time. Lighting gels were used to create the vibrant, neon-like colours.

In sequences where the graphics had to appear on The Guide in Arthur's hand, lateral thinking was once again called for – again contrary to popular belief, there was no flatscreen installed in the prop. Even bluescreen technology was useless in this instance as it would have required that the camera be locked off with no

movement, disabling even the zoom function. Instead, the effect was achieved by means of a projector and a series of mirrors.

In terms of graphics, then, the TV series undoubtedly pushed the boundaries of its medium in the same way the radio series had done. Bruce Bethke, science-fiction writer and software expert, has suggested that Rod Lord's visuals, created by hand because the technology of the time wasn't up to the job, would ironically go on to influence the evolution of subsequent computers. He argues that The Guide's displays – black backgrounds, neon artwork, sans-serif typefaces – live on in contemporary web design, an example of what he calls the "secret symbiotic relationship" between science fact and science fiction.

Reception and beyond

Deservedly, Rod Lord won a BAFTA for his work, as did sound supervisor Mike McCarthy. McCarthy was lucky to have alongside him Paddy Kingsland of the BBC Radiophonic Workshop (see p.145), who composed incidental music for the show as well as creating many of its sound effects (including the unscripted Vogon burp in episode one). Since the actors were wearing radio mics, many sounds were added after the event, often in painstaking detail. For instance, Kingsland re-created the sound of actors' footsteps on supposedly metal spaceship floors via the sophisticated method of stamping on upturned beer kegs. He also created the electronic beeps and bleeps for the Guide sequences.

Though Adams would always regard the radio version as definitive, the TV show met with a warm reception from fans and

Douglas Adams in the clay pit, watching the shooting of the Magrathean scenes – no doubt with a *Good Food Guide* handy to help plan that evening's cast excursion.

critics alike when it was screened in January and February 1981. Broadcast approximately three months after the publication of *The Restaurant at the End of the Universe*, it also provided a major boost to his profile that certainly didn't harm sales of the first two books.

There was much talk of a second series, and some preparatory work even took place. However, Adams refused to work with Bell again and the BBC would not agree to a new director. When the suggestion of Geoffrey Perkins as producer (alongside Bell as director) was rejected, Perkins was offered the job of script editor but turned it down. His time on the radio series had taught him that the odds of getting a finished manuscript out of Adams were second

only to those of getting blood out of a stone.

Negotiations for the proposed second series ended in impasse. Adams instead went off and wrote *Life, the Universe and Everything*, and the complex situation surrounding the film rights put paid to any subsequent TV plans. For a time it looked as though ABC might make an American version of the TV show but Adams soon backed off, afraid that they would drown the story's eccentricity in a sea of special effects. In any case, ABC themselves abandoned the project when the budget for the first programme came in at over $2 million.

Instead, the BBC series was broadcast in the US, but it didn't attract the viewing figures it had enjoyed in the UK. Particularly embarrassing was the Americans' dismissal of the special effects. Though they represented the very acme of BBC capability, they simply didn't impress the country that had brought the world *Star Trek* – the show Adams had mocked in episode three, with the line "To boldly split infinitives that no man had split before".

10

The movie

The chequered history of the *Hitchhiker's* film dates back almost to the story's first appearance in the public consciousness. One bizarre early scenario saw a woman, name long lost in the mists of time, buying the film rights for a mere £1000 or so, before Adams changed his mind and ordered that her cheque be sent back. For some reason, however, this never happened – and when film negotiations became more serious, the woman found herself being handsomely paid off. Things looked up when Columbia bought the rights in 1982, but it proved only the first in a string of false starts that would last more than two decades.

Among the producers and directors attached to the project at one point or another were Monty Python's Terry Jones, Ivan Reitman (*Ghostbusters*, *Junior*), James Cameron (*Terminator*,

Titanic), MTV co-creator and ex-Monkee Michael Nesmith, Spike Jonze (*Being John Malkovich, Adaptation*) and Jay Roach (*Austin Powers, Meet the Parents*). Meanwhile, Adams himself was probably more committed to the film version than to any other project in his career, even buying back the film rights around the time of *Mostly Harmless*. The prospect of a *Hitchhiker's* film was also a major factor in his decision to move to California in 1983 and again, permanently, in 1999.

Though a deal was signed with Disney in late 1997, they too had lost interest by 2000, when the executive who had bought the rights left the company. Adams's death the following year seemed to bring

Director Garth Jennings (left) and producer Nick Goldsmith.

Adams's cameos

The brief closing shot of Douglas Adams's face (see p.214) is only the most obvious of various posthumous appearances in the film. He appears, holding a glass of wine, in the *Heart of Gold*'s pictorial representation of the Infinite Improbability Drive – though you're best off getting hold of Robbie Stamp's book on the making of the movie if you want a proper look. Slightly easier to spot is an entire planet modelled on Adams's head during Slartibartfast's tour of Magrathea (it's blue, if that helps). One part of Adams's anatomy is singled out for particular attention: Humma Kavula's handkerchief-worshipping sequence is essentially an extended tribute to Adams's hooter, so large he even wrote an article on the subject for *Esquire* magazine in 1991. The writer's proboscis was the inspiration for several details in the temple, including the foot of the stairs and the side of the table, as well as the forty-foot-high temple itself. Other, more indirect Adams references include an Apple Mac logo on Deep Thought, just above and to the right of its single red eye.

down the curtain on any prospect of a movie version. Yet three years later, almost a quarter of a century after the idea was first mooted, filming finally began on *The Hitchhiker's Guide to the Galaxy*…

Subsequently responsible for the big-screen paean to 1980s boyhood *Son of Rambow*, director Garth Jennings and producer Nick Goldsmith were primarily working on music videos when

recommended for the *Hitchhiker's* film by Spike Jonze. The British duo joined a committed team that also included Robbie Stamp, Adams's business partner in The Digital Village, and Roger Birnbaum and Gary Barber at Spyglass Entertainment. Between them, they nurtured the film to a stage where they could persuade Disney back on board, Birnbaum and Barber apparently contributing a six-figure sum in the process. With Karey Kirkpatrick (*Chicken Run, James and the Giant Peach*) penning a script loosely based on Adams's own drafts, Disney finally gave the film the green light.

This, however, was by no means the final hurdle faced by Jennings and Goldsmith's production company, Hammer and Tongs. Conceived for individual radio episodes, the basic *Hitchhiker's* plot was hopelessly lacking in such filmic essentials as a beginning, middle and end. As well as restructuring, it also needed to be substantially cut to fit standard movie length, thereby removing many of the wild tangents and cerebral high jinks that made it funny in the first place. Nor did the costumes make things any easier. Each Vogon ("nine-foot-high baked potatoes", as performance director Peter Elliott put it) required a back-up team to help the actor into their costume, whilst at 25kg Marvin's outfit constituted three-quarters of actor Warwick Davis's own bodyweight. Improbably enough, however, the hardest costume to source was the most apparently everyday: material for Arthur's dressing gown came from the Czech Republic, whilst the pyjama fabric had to be sent over from Turkey.

To top it all, audience expectations were colossal. "This one will open with a bang", Goldsmith told the *Guardian* at the time. "And either it's 'Bang; it's a hit' or it's 'Bang; you're dead', which is obviously a little bit daunting."

In the event, both kinds of bang greeted the film's opening in April 2005. Though it received a positive review in *The Times*, which suggested that Adams would have been "flattered" by the adaptation, *Hitchhiker's* authority M.J. Simpson declared: "This is a terrible, terrible film and it makes me want to weep."

The truth, as ever, lies somewhere in between. The razzmatazz of the title sequence, inspired by 1950s musicals, sets the pace for a frenzied ride that just about makes room for bypasses, towels, the Ultimate Answer and

Director Jennings sharing a word with Warwick Davis's Marvin.

other such essentials. Many of the gags are lost along the way, but the film does at least strive to remain true to the spirit of the story whilst, as with all the more successful *Hitchhiker's* adaptations, reacting flexibly to the new medium.

Although the movie remains accessible for *Hitchhiker's* newcomers, there are plenty of in-jokes for hard-core devotees. Not

only is Trillian dressed as Charles Darwin at the fancy dress party, for instance, but Arthur is even reading Richard Dawkins' *The Selfish Gene*. The banjo twangs that accompany the first appearance of The Guide are warmly familiar, and there are also allusions to aspects of the story neglected in the main storyline, such as a glimpsed "dolphins vanish" newspaper headline. Even many of the additions – from the Point of View gun to the "Think Deep" T-shirts worn by the crowd surrounding Deep Thought – sit happily alongside the established story.

The casting of the main characters is well judged, if the core ensemble is overly Americanized. Martin Freeman and (the voice of) Alan Rickman are somewhat outweighed by Sam Rockwell, Zooey Deschanel and Mos Def (pictured below), the last apparently so sedate on-set that he was prone to falling asleep if he sat down for too long. The bigger names – Rickman, John Malkovich, Helen Mirren, Richard Griffiths and stand-out Bill Nighy, as well as comedian Bill Bailey and modern-day Renaissance man Stephen Fry – are

Other cameos

Teeming with in-jokes and visual references, the film features brief appearances not just from the late Douglas Adams but – in the scenes of panic in pre-demolition London – from several members of his family. Most noticeable is his mother, who sits reading the newspaper, apparently oblivious to the chaos all around her. Elsewhere, there are several nods to earlier versions of the franchise, of which the appearance of the TV series' Marvin on Vogsphere is perhaps the most obvious. Later in the film, the holographic head that warns the *Heart of Gold* away from Magrathea belongs to none other than Simon Jones. There's even a reference to Starbix breakfast cereal, as featured in the TV series, which Zaphod is eating during his first appearance here – although you might be distracted by the fact that he's clad in red robe, gold hot pants and cowboy boots. With a towel wrapped around his head.

restricted to less prominent roles, ensuring that the film never feels like a star vehicle.

Though the budget was modest in Hollywood terms, there are some noteworthy costumes and effects. The Magrathean planet factory tour, one of the more prominent set pieces, was impressively realized via state-of-the-art computer graphics by Cinesite (*Harry Potter*, *The Dark Knight*, *Casino Royale*). The Vogons, so disgusting that they wear socks with flip-flops, are another highlight, brilliantly designed and operated by the Jim Henson Creature Shop. Even

where budgetary constraints do become evident, they are overcome with lo-fi charm, perhaps the finest example being the sequence in which the Infinite Improbability Drive turns the crew of the *Heart of Gold* into woollen dolls.

Certainly, it's not an unmitigated triumph. For one thing, the magnification of the love triangle between Zaphod, Trillian and Arthur was not to all fans' liking. Not only does it give Trillian a bigger role, but it has a knock-on effect on other characters; when she gets kidnapped by the Vogons, in one of many plot deviations, an uncharacteristically heroic Arthur leads the rescue mission. Inevitably, he wins her heart at the denouement, although the

Zaphod (Sam Rockwell) and Trillian (Zooey Deschanel) – one relationship not helped by the Point of View gun.

arrival of Anna Chancellor (*Four Weddings and a Funeral*) as Zaphod's besotted deputy Questular – another addition for the film – means that the president too is happily paired off at the film's conclusion.

In fact, the quietly kooky Zooey Deschanel is in many ways more faithful to the original Trillian than the TV series' Sandra Dickinson – and all credit to her for bringing to life such a previously flat role (she also manages to be both genuinely entertaining and convincingly intelligent – after all, she is supposed to have a background in astrophysics). More of a problem than her character's increased presence was the heavy editing suffered by Marvin and The Guide itself, who seem particularly affected by the need to excise whole swathes of dialogue. (What most upset fans were the few instances where cut lines were replaced with slapstick gags, of the Arthur-asks-Marvin-for-a-hand-and-literally-takes-his-arm variety, about which the less said the better.)

Perhaps the most awkward change is that, whereas in most versions of the story the Ultimate Question is of little interest to the main characters, in the film version it is presented as Zaphod's driving quest. As part of this mission we get a whole section on the planet Viltvodle VI, and a backstory involving Zaphod's rival Humma Kavula, whose soft-spoken torso is almost as creepy as his centipede lower half. Ironically, it was Adams himself, presumably in an attempt to provide some kind of overall narrative arc, who suggested the Viltvodle VI detour (much of it actually filmed in the Freemasons' Grand Temple in London). But though Humma Kavula is a strong enough character in his own right, the sub-plot detracts significantly from the overall momentum, with the result that the film sags somewhat in the middle.

The pace picks up again for the Magrathean scenes, however, and there's a strong climax when the Vogons – replete with rusty laser guns and Hannibal Lecter facemasks – attack the Earth Mk 2. (Yes, it actually gets built in this version of the story.) As the theme tune is reprised over the closing credits, this time sung by the ever-arch Neil Hannon of The Divine Comedy, Douglas Adams's face flashes on the screen for a moment, ostensibly created by the Infinite Improbability Drive. He looks happy.

In its opening Bank Holiday weekend the film took £4.2 million in the UK, the resonance of which didn't escape the BBC, who reported that the film's box-office takings "mirrored its 'answer to life, the universe and everything'". In the US, it took $21.7 million in its first weekend – which, it has been suggested, is insufficient to merit a sequel.

11

Other incarnations

The proliferation of *Hitchhiker's* from its radio origins into stage, novel, TV and film versions might seem impressive, yet in truth those incarnations represent only the tip of the iceberg. Here, then, are its other manifestations, from computer games to albums, comics to towels – as well as those TV programmes that have gone so far beyond mere documentation of the *Hitchhiker's* canon that they can rightly be considered part of it.

The computer games

Adams's initial attitude towards computers was none too positive, likening them in 1982 to his fictitious creations Eddie and Hactar: ie either infuriating or iniquitous. Yet his time in the US, working on one of the innumerable aborted *Hitchhiker's* film scripts, seems to have dramatically altered his perspective, introducing him to the delights of computer games (as well as word processing and the Apple Mac). Whilst fast losing interest in the novels, Adams enthusiastically embraced the chance to extend his franchise into yet another format – and announced the computer game early in 1984.

Steve Meretzky and Infocom

With computer game graphics still very much in their infancy, the games that first piqued Adams's curiosity were text-based adventures, or "interactive fiction", particularly those produced by a Massachusetts-based firm named Infocom. Having contacted the company in 1983, he started work on a *Hitchhiker's* computer game early the following year, alongside programmer Steve Meretzky.

The basic modus operandi saw Adams writing blocks of text, together with some bridging ideas, which Meretzky then encoded. It is testament to their compatibility, however, that boundaries between author and programmer soon became blurred, with Adams keen to be involved in the technical side and Meretzky contributing some of the text.

A far cry from an arcade shoot-'em-up, Infocom's then-sophisticated software could cater for the sort of intellectual puzzles that so fascinated Adams, effectively combining his love of

```
You wake up. The room is spinning very gently round your head.
Or at least it
would be if you could see it which you can't.

It is pitch black.

Darkness                                        Score: 0
Moves: 1

>get up
Very difficult, but you manage it. The room is still spinning. It
dips and
sways a little.

Bedroom                                         Score: 0
Moves: 2
>turn on light
Good start to the day. Pity it's going to be the worst one of
your life. The
light is now on.

Bedroom
The bedroom is a mess.
```

crosswords with his new-found passion for technology. Not only did the player get to "be" different characters, for instance, but they also experienced the same events from different viewpoints at different stages of the game.

Adams's non-linear writing style, never happily adhering to anything so restrictive as a coherent plot, was perfectly suited to the multiplicity of "branches" offered by interactive fiction. While the game starts like most versions of the story, with a rather hungover Arthur waking up in his West Country home, it soon deviates wildly from the established plot – and of course, the detours change with every playing.

Bureaucracy

Before work began on the aborted sequel to the *Hitchhiker's* game, Adams persuaded Infocom to embark on another project, entirely unrelated to that franchise. Instead, it was based on the ever so slightly less cosmic subject of trying to get one's bank to acknowledge a change of address. Inspired by problems Adams had encountered after his move to Islington, the game's title, *Bureaucracy*, made explicit a theme that had long been prevalent in his work (see p.67). But although he had enthusiastically proposed the concept in 1984, Adams's involvement diminished somewhat during the game's production, with much of the work delegated to his friend (and Dirk Gently prototype) Michael Bywater. *Bureaucracy* eventually emerged in 1987, by which time text games were unfortunately somewhat outmoded.

Launched in New York in late 1984, the game was enthusiastically received, critically and commercially, on both sides of the Atlantic. *The Times* declared it "the best adventure ever seen on computer", and it topped the sales charts for months. Yet although work would eventually start on a sequel, the original Infocom contract having been for six games, it was never completed due to a decline in interest in both *Hitchhiker's* and text-games in general.

The original game does, however, live on via the Internet, the BBC having produced an updated – though still text-based –

version to mark its twentieth anniversary. Created by software engineer Sean Sollé (who had worked on *Starship Titanic*; see below) and TV show graphics guru Rod Lord, the game won a BAFTA for online entertainment in 2005. It is available at bbc.co.uk/radio4/hitchhikers/game.shtml, while the original game can still be found at douglasadams.com/creations/infocom.php. Charmingly retro though it is, first-timers should prepare for a rather frustrating experience, as commands are met with incomprehension or, occasionally, abuse: "You're talking complete nonsense; pull yourself together" is a representative insult against which to steel oneself.

The Digital Village and *Starship Titanic*

Douglas Adams had various projects in mind when he launched The Digital Village with Richard Creasey and Robbie Stamp in 1996. Yet, although Adams's own involvement was in fact relatively limited, the first project on which they embarked would effectively consume the company's entire workforce for several years.

Conceived as a multimedia franchise, *Starship Titanic* was at various stages envisaged as a TV series and film (neither of which ever happened) as well as a novel (which, unfortunately, did; see p.243). By far the most resources, however, went

Film tie-in games

Among the other Adams-related computer games, several don't exist. Some, like the *Milliways* sequel to the Infocom game, were never completed. Others were never started at all, such as proposals to make a computer emulate both Ronald Reagan and God (Adams expressing his desire to become the first person to have computer software burned in America's Bible Belt). The most recent example of a "missing" *Hitchhiker's* game is that intended for release in 2000 to tie in with the putative film. Since that film suffered the same fate as every other *Hitchhiker's* film during that quarter-century of false starts, the game was never completed, and the project was pulled in 2002 – despite having been "launched" the previous year. When the *Hitchhiker's* film did finally appear in 2005, however, it was indeed accompanied by two computer games. *The Hitchhiker's Guide to the Galaxy: Vogon Planet Destructor* was described by uk.gamespot.com as "a by-the-numbers shooter with decent, if hackneyed, gameplay", while uk.wireless.ign.com dismissed it as an "uninspired" cash-in. *The Hitchhiker's Guide to the Galaxy Adventure Game* fared better, praised for its sense of humour and closer links to the film – not that every reader would regard that as a good thing.

into the computer game. It set out to draw on the enormous technological advances that had taken place since the *Hitchhiker's* computer game, whilst maintaining that title's intellectual acumen – something that other games, however visually impressive, were

deemed to have neglected. (In the words of TDV.com, such point-and-click games had destroyed "500,000 years of language evolution" by sending players "back to the electronic equivalent of banging rocks together".)

Starship Titanic began with the titular spaceship crashing into the player's house, the main game taking place only once the player had climbed aboard to join a crew of malfunctioning robots and an unhinged parrot. Combining a central canal with the epic elegance of an Art Deco skyscraper, the setting itself was variously compared to Venice and the Chrysler Building, as well as the *Queen Mary* ocean liner, London's Ritz hotel and Tutankhamun's tomb. If the combination is a little hard to envisage, some sense of the ship's interior can be gleaned from starshiptitanic.com/game/tourindex.html.

If the design was audacious, it was symptomatic of the project as a whole. Attempts to develop a text-to-speak conversation engine, that would allow the computer to simulate (though not actually understand) audible speech, were rejected on the grounds that the characters sounded "like semi-concussed Norwegians". Instead, it was necessary to pre-record hour upon hour of words that the computer might conceivably require in the course of a game. (Among the contributing voices were Terry Jones, who also wrote the spin-off novel, and Adams's former hero John Cleese.)

With experience primarily in the world of TV rather than gaming, the directors of The Digital Village had simply underestimated the scale of what was in fact an almost insanely ambitious project. Even with investment from publisher Simon and Schuster, the company lacked the time and money such a project demanded. Despite being worked on by a grand total of over fifty

people, the CD-ROM still missed its September 1997 deadline by more than six months, while the Mac version didn't arrive until 1999.

The game met with a somewhat flat response. Its much-touted interactivity was to many an anti-climax, while others complained that the puzzles were frustrating, the solutions bordering on the capricious. Certain aspects were more positively judged, however, with particular praise going to designers Isabel Molina and Oscar Chichoni, while the game even won a CODiE award for Best New Adventure/Role-Playing Software Game.

Audio

The *Hitchhiker's Guide* to the *Galaxy* album

Douglas Adams and Geoffrey Perkins had been determined that the original *Hitchhiker's* radio show should adopt the production values of a rock album. They soon went one step further, recording a double LP that was made available via a coupon in the first novel. Since the BBC turned down the record, as they had the novel adaptation, it was released by tiny independent label Original Records.

The album script was essentially an edited version of the first four episodes of the radio series, and was recorded with something close to the original cast. The sole major change saw Cindy Oswin, from the ICA stage version, replace Susan Sheridan as Trillian. The recording was a success, benefiting from a little more time and slightly higher

Other records

The Eagles' "Journey of the Sorcerer", which had so memorably been used as the theme tune of the radio series, could not be featured on the *Hitchhiker's* album due to copyright issues. Instead, it was rearranged and rerecorded by acclaimed (and subsequently BAFTA-winning) composer Tim Souster. Souster's version of the theme, which would also be used for the *Hitchhiker's* TV series, was released as a single in early 1981, as part of Original Records' promotional drive. One of the B-sides was "Only the End of the World Again"; credited to Disaster Area, the rock band from *The Restaurant at the End of the Universe*, it featured Adams himself on rhythm guitar. (By all accounts, he was a competent player in every respect, save the rather crucial aspect of rhythm.)

Also released that year were the two Marvin singles detailed on p.39. But those were not the last *Hitchhiker's* records. Early the following decade, Germany's Klaus König wrote an avant-garde jazz work inspired by the saga, entitled *At the End of the Universe: Hommage à Douglas Adams*. And in 2005, the soundtrack to the film version was released – featuring Stephen Fry's version of the Marvin anthem "Reasons to Be Miserable".

production values than the radio series. And considering that it was available only by mail order, sales were impressive – so much so that it was decided to arrange proper distribution, making the album available from record shops all over the UK.

This, unfortunately, is where the *Hitchhiker's* album began its slow, steady nose dive. Apparently due to a malfunctioning computer system, initial sales figures were grossly exaggerated; Original wound up with an enormous excess of stock and a major cash-flow problem. Still, given the ongoing popularity of *Hitchhiker's*, there seemed cause for optimism with the follow-up record…

The Restaurant at the End of the Universe album

Although the first album adaptation had had its problems, it had nonetheless sold well in its original, mail-order format. With proper promotion and distribution, Original Records believed the follow-up LP could sell in significantly greater quantities. The cast, who had received a flat fee for the first album, transferred to royalty-based contracts in anticipation.

When the record was released in late 1980, loosely based on Fit the Fifth and Fit the Sixth but following the Disaster Area rather than the Haggunenon sequence (see p.153), it was indeed heavily promoted. A small fortune was spent on marketing, and the front window of HMV on London's Oxford Street even featured a bath of live ducklings – an allusion to the Golgafrinchan B Ark captain's rubber duck, which adorned the record's cover.

Despite all this, however, *The Restaurant at the End of the Universe* failed to sell any more copies than the first record, scraping into the top 50 and then dropping off the radar. This was a catastrophe for Original Records, who were unable to recoup their

substantial outlay, let alone make up the shortfall from the first record.

To make matters worse, Adams by this time had a new agent, Ed Victor – not a man to take pity on a small label out of its depth. Lawyers became involved, and Original Records was forced into compulsory liquidation.

Sheila's Ear

During Adams's brief tenure as a producer for Radio 4's *Week Ending*, the cast had included a Johannesburg-born actor named Sheila Steafel. In 1982, the pair were reunited when Adams contributed to her one-off Radio 4 show, *Steafel Plus*. The sketch saw a befuddled Arthur (Simon Jones) in a pre-historic cave, dreaming of being interviewed by Steafel; he's missed Mars bars, he explains, as well as tea and Radio 4. Since the dream presumably took place between the last episode of the first radio series and the Christmas special that kicked off series two, "Sheila's Ear" has become affectionately known as "Fit the Six and a Halfth". Absent from the BBC archives, it also earned a reputation as "the lost *Hitchhiker's* sketch", though it is featured (from an off-air recording) on the three-CD set *Douglas Adams at the BBC* (see p.245).

Audio books

Though talking books had long existed for the blind, it was not until the late 1970s and early 1980s that they began to gain mainstream acceptance, greatly helped by the popularity of the Sony Walkman. This was perfect timing for *Hitchhiker's*, and abridged versions of all four novels then in existence were released in this format, read by Stephen Moore. Unabridged versions, read by Adams himself, were

released in the 1990s, followed in 2005 by an audio book of the first novel, read by Stephen Fry. Since Fry read only the first novel, however, Adams's readings remain definitive – although now that the Tertiary to Quintessential Phases exist, it's arguable whether you wouldn't be better off just listening to the radio shows.

Books

The Utterly, Utterly Merry Comic Relief Christmas Book

Published in late 1986, *The Utterly, Utterly Merry Comic Relief Christmas Book* was co-edited by Douglas Adams and Peter Fincham, a Footlights alumnus and successful TV producer. Adams contributed three short stories, including "A Christmas Fairly Story"

Hitchhiker's on TV

The South Bank Show

In the early 1990s, flagship UK arts programme *The South Bank Show* approached Adams, hoping to document the process of writing *Mostly Harmless*. Since writer's block had rendered that writing process non-existent, Adams instead proposed a bizarre programme which would take his very inability to write as its central thread. The result, broadcast in January 1992, was a curious blend of drama and documentary, based in Adams's Islington flat. While the author is interviewed by Melvyn Bragg in the lounge, Marvin and the Electric Monk (from *Dirk Gently*) wait in the kitchen, moaning about the difficulties of being characters in a Douglas Adams novel. Simon Jones and David Dixon also appear in character, alongside interviews with Sue Freestone, John Lloyd and Richard Dawkins.

The Big Read

This half-hour programme from 2003 saw comedian Sanjeev Bhaskar championing *The Hitchhiker's Guide to the Galaxy* as part of a BBC survey to find the nation's favourite novel. Like *The South Bank Show* and the *Making Of...* documentary, it included a series of dramatized excerpts, this time with Bhaskar playing Arthur Dent. Astronomer Sir Patrick Moore voiced the role of The Book, scientist Stephen Hawking that of Deep Thought. The episode also featured cameos from Roger Lloyd Pack (*Only Fools and Horses*, *The Vicar of Dibley*) and Nigel Planer, aka clinically depressed hippy Neil from sitcom *The Young Ones* – an inspired choice for Marvin.

(nothing to do with *Hitchhiker's*) and "The Private Life of Genghis Khan" (connected to *Hitchhiker's* only in that it featured a cameo by Wowbagger the Infinitely Prolonged, who delivers the charming line "Genghis Khan, you are a wanker; you are a tosspot; you are a very tiny piece of turd. Thank you.").

Most definitely part of the *Hitchhiker's* canon, however, is the third story: "Young Zaphod Plays It Safe". In it, Zaphod embarks on an underwater expedition to a crashed starship, with a cargo of elderly, kind-faced humanoids that are in fact "the most dangerous creatures that ever lived". These creatures were meant to represent actor turned genially right-wing US president Ronald Reagan – though any political overtones were somewhat undermined by the fact that some fans thought Adams was referring to Jesus Christ.

The comics

By 1993, the *Hitchhiker's* film adaptation was so far into development hell that many fans had lost hope of its ever emerging the other side. But that October, a visual representation of the first novel did appear, in the form of a three-part comic-book adaptation by publishing giant DC Comics, home of Superman, Batman, Watchmen et al.

Despite this impressive pedigree, however, many fans were disappointed by the *Hitchhiker's* comics. The artwork, by Hawaiian-based Steve Leialoha, met with a mixed reception, the main criticism being that it was rather insipid while Arthur, for instance, looked curiously baby-faced. Another problem was the relatively high price tag.

Perhaps the main weakness, however, was that it failed to

embrace the fluidity of *Hitchhiker's*, which had hitherto adapted from radio to stage, to album, to novel, to TV, to computer game with an almost Haggunenon evolutionary zeal. Instead, pictures aside, the comic was essentially just an edited version of the first book.

To some extent, this was Adams's own fault; though not very heavily involved in the project, he did have sign-off on character designs and plot, and he seems to have wanted a fairly straight adaptation. (Though his revisions would delay the project for a whole year, it's probably fortunate that Adams did have power of veto: among the heretical changes proposed was a suggestion that digital watches be replaced by mobile phones.)

The three-part comic would be published as a graphic novel in 1997, by which time there had also been comic versions of *The Restaurant at the End of the Universe* and *Life, the Universe and Everything*. Adams himself seemed less than interested, however, later appearing not even to know which books had appeared in comic form.

The Illustrated Hitchhiker's Guide to the Galaxy

Like the comic-book adaptations that preceded it, *The Illustrated Hitchhiker's Guide to the Galaxy* was essentially just a version of the first novel with added pictures. Unlike the comic books, however, it was an artistic triumph, not least because it was overseen by Kevin Davies, in yet another major contribution to the canon. Adams himself was far more involved too.

The basic idea was to illustrate the story through photographs

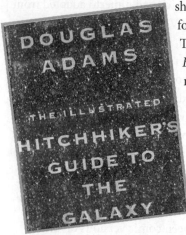

shot by Michael Joseph (best known for the image on the front cover of The Rolling Stones' *Beggars Banquet*). Crucially, these were then manipulated by computer, or what the dust jacket called "revolutionary digital graphic 'paintbox' technology". The result was billed: "the movie that doesn't move".

With the exception of Michael Cule as Mr Prosser, the established cast were jettisoned: Arthur was played by Jonathan Lermit, with Tom Finnis as Ford, Francis Johnson as Zaphod and a model called Tali as Trillian. Adams made a cameo as intergalactic cop Shooty (with Ed Victor as Bang Bang) and Kevin Davies appeared in the background as a bulldozer driver.

Of course, the book's cutting-edge appeal is long lost, yet most of the designs remain impressive: Marvin's appearance has been singled out for particular praise, though the Vogons, by contrast, are disappointingly cartoon-like. Another lasting strength is that the designs often don't illustrate obvious subjects. We see a towel employed as a tent in the desert of Kakrafoo, for instance, and a gold brick with a slice of lemon wrapped around it hurtling towards a Pan Galactic Gargle Blaster-sipping spaceman.

Though a resounding success with both fans and critics, the large, silver-jacketed book proved a commercial disaster upon publication in 1994. For many fans, it was simply too expensive (US price, if the resonance isn't too much to bear, $42). Tragically, it

ended up being remaindered, Adams buying up copies and selling them via his website.

Merchandise

Towels

One of the more bizarre *Hitchhiker's*-related phenomena, the idea of a souvenir towel was apparently discussed with quality chain store Marks & Spencer as early as 1979. They got as far as producing a prototype – a large beach towel emblazoned with relevant text from the novel – before the scheme lost momentum.

A few years later, Adams mentioned the aborted project to publicist Eugen Beer. So taken was he with the idea that he tracked down the M&S prototype and, having signed a deal with Adams, began producing them himself in 1985. (These have become very sought-after collector's items in certain circles.)

Though the *Hitchhiker's* bubble had burst by the time Beer's towel came into existence, and sales were less than astronomical, it started something of a trend. A pink and white *Hitchhiker's* towel has been produced by Pan Books and at least three different designs were used to promote the film version in 2005.

ZZ9 Plural Z Alpha, the Official *Hitchhiker's* Appreciation Society, also produce one, with the words "Don't Panic" woven in red onto a white background. The most recent towel bears the legend "And Another Thing…", along with that novel's release date and, in large friendly letters, the immortal instruction "Don't Panic".

T-shirts, teddies and more

Beyond towels, *Hitchhiker's* merchandise to date has run the gamut from a Disaster Area tour T-shirt to an Infinite Improbability Drive clock. The "I got the Babel fish" T-shirt, produced for the Infocom computer game, is now hard to find, but, should one desire, it is still possible to purchase a "Beeblebrox for President" mousepad, or a "Beware of the Leopard" fridge magnet.

The ZZ9 Plural Z Alpha appreciation society produce a range of merchandise, including Babel fish earrings and a T-shirt emblazoned with the legend "Vogons destroyed my planet and all I managed to save was this lousy T-shirt". Most famously, they also sell the Beeblebear, a two-headed, three-armed cuddly toy modelled on the president of the Imperial Galactic Government himself.

A further wave of merch arrived with the release of the *Hitchhiker's* film in 2005, including models of the main characters (as knitted dolls or action figures) and a replica of the Point of View gun. Those of a bureaucratic mindset, meanwhile, can now avail themselves of a replica Vogon desk-pen, mug and stapler.

Phase Three

12

Resources

Just as the *Hitchhiker's* trilogy continues to expand, so too does the number of books (and other media) documenting and interpreting the phenomenon. In this chapter is a selection of such *Hitchhiker's* resources, as well as the various non-*Hitchhiker's* titles by Adams himself.

Books

Books about *Hitchhiker's*

The Anthology at the End of the Universe: Leading Science Fiction Authors on Douglas Adams' The Hitchhiker's Guide To The Galaxy

Ed. Glenn Yeffeth (BenBella, 2005)

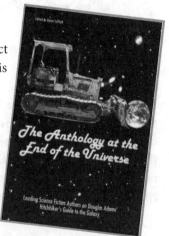

Featuring a series of science-fiction authors each tackling a particular aspect of the *Hitchhiker's* saga, this collection is something of a mixed bag. There are strong essays from Bruce Bethke (on Adams's impact on computer science) and Marie-Catherine Caillava (on *Hitchhiker's* and Zen Buddhism), while Vox Day takes an equally thought-provoking look at Adams's subversive political subtext. Fans will also be interested in a rare 1983 interview with Adams, originally conducted for *Heavy Metal* magazine. Other chapters are, in the nicest possible way, barmy. The religious allegory concocted by novelist and screenwriter Don DeBrandt – Marvin as Jesus, the Infinite Improbability Drive as the Holy Spirit and so on – is perhaps nearest to the faultline that separates genius from madness. The reader can decide on which side it falls.

The Making of The Hitchhiker's Guide to the Galaxy: The Filming of the Douglas Adams Classic

Ed. Robbie Stamp (Boxtree, 2005)

Due to its position (prior to *And Another Thing…*) as the most recent arrival in the canon, the film version is neglected by the majority of books on the *Hitchhiker's* phenomenon. Executive producer Robbie Stamp attempts to right the balance with this large hardcover book, which works its way through the film's basic plot whilst making frequent diversions into behind-the-scenes subjects such as costume or set design. It's packed with pictures, some never previously available, including on-set photos, storyboard images and sketches of early design proposals. The text also includes numerous quotes from those involved in the production, including director Garth Jennings.

The Pocket Essential Hitchhiker's Guide

M.J. Simpson (Pocket Essentials, 2005)

This compact book methodically works through all the different versions of the *Hitchhiker's* franchise, Simpson providing cast, plot summary, background details and commentary for each manifestation. It omits a detailed portrayal of Adams himself, but otherwise its only weaknesses are those imposed by the passing of time, from which no book is immune – save The Guide itself, which, we learn in *The Restaurant at the End of the Universe*, was sent back in time by a wily editor to

sue the breakfast cereal from which it had itself plagiarized. Lacking a facility for such temporal warping, the *Pocket Guide* was updated in 2005 to include the Tertiary to Quintessential Phases of the radio series, as well as references to the film (although the book was published before Simpson had actually seen it). But there is, of course, no mention of *And Another Thing...*

The Science of The Hitchhiker's Guide to the Galaxy
Michael Hanlon (Macmillan, 2005)

As an established writer in the field of popular science, Michael Hanlon is well placed to dissect the serious ideas beneath the comic surface of Douglas Adams's writing – and, like a real-life Babel fish, translate them for those of a less scientific mindset. He does his best to keep the tone accessible despite the heavy-duty subject matter, although his cause is not helped by the utilitarian layout, nor the complete absence of pictures. Some fans will find the balance overly skewed in favour of the science component, but as an Adams fan equivalent of Laurence M. Krauss's *The Physics of Star Trek*, it's clearly hard to beat.

Books about Douglas Adams

Don't Panic: Douglas Adams and
The Hitchhiker's Guide to the Galaxy
Neil Gaiman (Titan, 1988)

The first real attempt to examine the *Hitchhiker's* phenomenon in print, *Don't Panic* still stands up more than two decades later, its editorial content and rare source material more than making up for

The radio scripts

The Hitchhiker's Guide to the Galaxy: The Original Radio Scripts

Douglas Adams, ed. Geoffrey Perkins (Pan, 1985)

Reading lines from the radio series might sound as inadequate as perusing album lyrics, but this collection makes for a surprisingly enjoyable read. Even the directions can offer a laugh, since Adams takes the effort to make them funny despite the fact that he cannot possibly have imagined they would one day be subject to public scrutiny. We also get Adams's foreword and an introduction – two, in the case of 2003's twenty-fifth-anniversary edition – by producer Geoffrey Perkins. By far the book's most valuable component, however, are the comments by Perkins (and, occasionally, Adams himself) that follow each episode. They recall the general recording process, as well as specific details such as how they created the sound for the Total Perspective Vortex.

The Hitchhiker's Guide to the Galaxy Radio Scripts: The Tertiary, Quandary and Quintessential Phases

Douglas Adams, as dramatized and directed by Dirk Maggs (Pan, 2005)

As well as a foreword by Simon Jones, this second book of *Hitchhiker's* radio scripts boasts introductions by both Bruce Hyman (of Above The Title productions) and director Dirk Maggs. There are even reminiscences on the recording process from actors Susan Sheridan, William Franklyn and Philip Pope. As with the first book, however, the real gems are in the production notes following each episode. Among Maggs's recollections are his mantra "never cut Funny" (ie leave in ad-libs if they work) and the excitement among certain female cast members upon the arrival of Christian Slater.

a lack of pictures. Extracts of unused script are scattered throughout the text, while we also get Adams's comments on the origins of various key characters, a series of fan letters (with replies) and even a copy of the original *Hitchhiker's* synopsis. The book has been updated twice, by David K. Dickinson in 1993 and by M.J. Simpson in 2002, Gaiman presumably too busy with a highly successful subsequent career that includes the *Sandman* comic as well as forays into fiction and film.

Hitchhiker: A Biography of Douglas Adams
M.J. Simpson (Hodder & Stoughton, 2003)

Described (by Simon Jones) on the back cover as knowing more about Adams than Adams himself, Simpson goes on to prove it over the course of the book, puncturing several key pillars of *Hitchhiker's* mythology – including those from Adams's own mouth. Such a strategy might sound pernicious, but Simpson's fondness for his subject is almost tangible; the impression is rather of a biographer attempting a truly candid portrayal. Described by John Lloyd as "painstakingly researched and ineffably sad", *Hitchhiker* is the result of conversations with more than 90 friends and family members, as well as a further 200 pre-existing interviews.

Wish You Were Here: The Official Biography of Douglas Adams
Nick Webb (Random House, 2003)

Presumably named after Pink Floyd's tribute to departed founder Syd Barrett, *Wish You Were Here* is written by the man who commissioned the first *Hitchhiker's* novel – and who remained friends with Adams despite leaving Pan shortly after inking that deal. Unsurprisingly, it is very much a personal remembrance, and

Fan fiction

Although it has existed at least since the early days of the *Mostly Harmless* newsletter, current *Hitchhiker's* fan fiction is most easily found on websites such as *fanfiction.net/book/Hitchhikers_Guide_to_the_Galaxy*. Sometimes it is fused with other franchises, as on *community.livejournal.com/crossoverfic/tag/hitchhiker's+guide+to+the+galaxy*. The web is teeming with such outpourings, usually developing neglected aspects of the story such as the day-to-day life of a teaser, who visits planets that have not yet made interstellar contact with the sole aim of scaring their occupants. While some are pretty dreadful, other writers are both witty and articulate, and it's all (at least mostly) harmless enough.

You'll have to look far and wide, however, to find fan fiction on quite the scale of *jochenlembke.spaces.live.com/blog*. The site is maintained by a German taxi driver named Jochen Lembke, who has written an unsolicited sixth *Hitchhiker's* novel entitled *42 Is the Answer, But What's the Question Anyway?* A 42-chapter story that begins with a bulldog-owning Arthur Dent clad in a Union Jack costume and ranting against the "riff-raff of foreigners", it remains unpublished except on this blog. Having apparently submitted the manuscript to the late Adams's agent on several occasions, however, Lembke insists that the subsequent assignment of Eoin Colfer to the official sixth *Hitchhiker's* novel is "a scandal" – one he has sworn to fight with "a media campaign of intergalactic size, a cry for justice, so to speak, in a shark's business!". Watch this space.

Chapter 12

one that betrays a bias towards the novels (and the mechanics of the publishing industry in general). As an "official" biographer, authorized by Adams's widow Jane Belson, Webb had extensive access to his subject's files, including private correspondence. There's also a lot on Adams's childhood, to the extent that we don't reach Cambridge until Chapter 3 of 14 – although the book's slightly unusual structure is in any case only semi-chronological.

Books by Douglas Adams

Dirk Gently's Holistic Detective Agency
Douglas Adams (Heinemann, 1987)
The Long Dark Tea-Time of the Soul
Douglas Adams (Heinemann, 1988)

The back-cover blurb mentions "a dead cat, a computer whiz-kid, an Electric Monk who believes the world is pink, quantum mechanics, a Chronologist over 200 years old, Samuel Taylor Coleridge (poet) and pizza". Published in 1987, *Dirk Gently's Holistic Detective Agency* is every bit as wide-ranging as that summary suggests. At times it makes for rather a confusing read – the ending, in particular, is all but impenetrable – while the novel also drew to some extent on material previously conceived for *Doctor Who* (sound familiar?). Nevertheless, it was

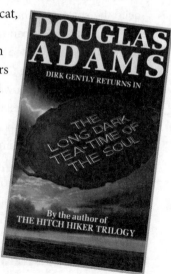

DOUGLAS ADAMS

DIRK GENTLY RETURNS IN

THE LONG DARK TEA-TIME OF THE SOUL

By the author of THE HITCH HIKER TRILOGY

Douglas Adams's Starship Titanic: a Novel by Terry Jones

Terry Jones (Pan, 1997)

Amazingly, the story behind this book is even more convoluted than the somewhat contradictory title would suggest. Adams had originally asked Robert Sheckley, one of his few predecessors as a writer of humorous science fiction, to novelize the *Starship Titanic* computer game, but the results were deemed unsatisfactory. It was then that Adams turned to Jones, who was already involved in the game, and asked him to flesh out an existing plot synopsis into a fully fledged novel – a sequential, rather than simultaneous collaboration. Essentially, this sees "THE SHIP THAT CANNOT POSSIBLY GO WRONG" crashing on Earth, its human cargo then struggling against sometimes menacing automatons, a talking bomb and a lascivious journalist. Though it's no disgrace, Adams's claim that his friend had written "an altogether sillier, naughtier and more wonderful novel than I would have done" was, sadly, almost certainly untrue.

sufficiently successful for the titular private investigator to reappear the following year, in the arguably superior *The Long Dark Tea-Time of the Soul*.

Last Chance to See

Douglas Adams and Mark Carwardine (William Heinemann, 1990)

Though it didn't sell as well as his novels, many would agree with Adams that *Last Chance to See*, documenting his real-life hunt for

various near-extinct species, was the best book he ever wrote. It's certainly the most educational – but, vitally, not at the expense of entertainment, and what could have been off-puttingly worthy is in many ways as amusing as his fiction. There's much fun to be had in Adams's encounters with people and places in various far-flung corners of the globe, not to mention the physical hardships endured by a wealthy writer by then well accustomed to luxury. The stars of the book, however, are the animals themselves, every bit as weird and wonderful as Adams's most fanciful alien creations, though every (dis)appearance is inevitably tempered with melancholy.

The Meaning of Liff
Douglas Adams and John Lloyd (Pan, 1983)
The Deeper Meaning of Liff
Douglas Adams and John Lloyd (Faber and Faber, 1990)

Co-written with John Lloyd, *The Meaning of Liff* was a spoof dictionary ascribing place names to familiar but as yet unnamed situations and experiences. Symond's Yat, for instance, here means "the little spoonful inside the lid of a recently opened boiled egg", while Shoeburyness refers to "the vague uncomfortable feeling you get when sitting on a seat which is still warm from somebody else's bottom". Each letter is also illustrated with a thoroughly useless map. The concept was revived in *The Deeper Meaning of Liff*, featuring illustrations by *Private Eye*'s Bert Kitchen.

The Salmon of Doubt: Hitchhiking the Galaxy One Last Time
Douglas Adams (Macmillan, 2002)

Though this volume takes its name from a third Dirk Gently novel, upon which Adams was working at the time of his death, that eleven-chapter fragment is in many ways the least rewarding

element of this posthumous collection. "Young Zaphod Plays It Safe", the only one hundred percent gen-u-ine *Hitchhiker's* short story, will be of interest to fans that missed its 1986 arrival, although in truth it occupies only a fairly minor place in the canon. Instead, highlights include several of Adams's interviews and pieces of non-fiction, as well as an introduction by Stephen Fry, paying eloquent tribute to his late friend's "acute and quizzical gaze". In many ways, however, the climax is a letter Adams wrote to Disney executive David Vogel in 1999, whingeing about a lack of communication and attaching a mammoth list of contact numbers – including that of his daughter's nanny and various favourite restaurants.

Audio

As well as the shows already detailed, from *Steafel Plus* to *Last Chance to See*, Adams was involved in several other radio programmes, including presenting Radio 4's *The Hitchhiker's Guide to the Future* and *The Internet: The Last 20th-Century Battleground*. He also made numerous guest appearances, as both panellist and interviewee, and was the subject of several tributes following his death. The Simon Jones-presented three-CD set *Douglas Adams at the BBC* collects together almost four hours of such extracts, from early sketch writing (1974's *Chox*) to *So Long, and Thanks for All the*

Fish, the 2001 posthumous tribute by Geoffrey Perkins. In addition, the box-set edition of the full five *Hitchhiker's* radio series also includes a fifty-minute bonus CD, containing Radio 4's *Kaleidoscope* from 1980, and 2002's *Six Characters in Search of an Answer*. Both feature interviews with Adams, as well as Geoffrey Perkins and cast members including Peter Jones.

Audiovisual

Adams's TV appearances were almost as numerous as his radio spots, from guest slots on comedy panel shows such as *Have I Got News For You* to presenting the documentary *Hyperland* in 1990. Again, there were also posthumous tributes, including *Douglas Adams: The Man Who Blew Up the Earth*, and *Life, the Universe and Douglas Adams*. Perhaps the most interesting, however, are the two making-of documentaries, one detailing the TV series, the other the film. Included among the extras on the DVD releases of their respective subjects, they are the most easily accessible *Hitchhiker's* audiovisual resources.

Animator Kevin Davies played a vital role in the *Hitchhiker's* TV series, working on the graphics as part of Rod Lord's team – and, of course, introducing Lord to director Alan Bell in the first place. Davies was also responsible for two of the more impressive spin-off projects, the first of which was a 1993 documentary of the making of the TV series (see p.229 for the second).

As a passionate *Hitchhiker's* fan, Davies had been an enthusiastic presence on set during the TV series, even earning himself such spoof credits as "bath supervisor" and "mouse trainer". He used the

opportunity to film the behind-the-scenes footage that, more than a decade later, was interwoven with then-current interviews with Adams and other cast and crew members.

Blurring the boundaries between fact and fiction in much the same fashion as *The South Bank Show*, a framing device depicts Arthur, played by Simon Jones, arriving home on Earth (as in *So Long, and Thanks for All the Fish*). David Dixon and Michael Cule also reprise their roles, as Ford and the Vogon guard respectively, while the original Marvin costume is also seen briefly on Arthur's garden path.

The other making-of film is subtitled "Don't Crash" (it also goes by the cheekily verbose title *The Documentary of the Making of the Movie of the Book of the Radio Series of the Hitchhiker's Guide to the Galaxy*). More of a straight documentary than the TV series making-of, it features interviews with cast and crew, as well as behind-the-scenes footage right from the first read-through to the film premiere. Some of its strongest scenes relate to the Vogons, from building the costumes themselves to "Vogon boot camp" for the actors, where exercises included marching in time to a metronome, as well as footage of puppeteer Mak Wilson at work. Other highlights include the development of Zaphod's second head and Warwick Davis's Marvin costume.

Online resources

As Adams himself acknowledged in 2000, he was "a bit of a turncoat" when it came to technology: though he had made his name ridiculing sulking robots and argumentative elevators, he ended up a

Just for laughs

Here are two more *Hitchhiker's* sites, which, while they may not be as informative as the others detailed in this chapter, should at least make you smile.

scintilla.utwente.nl/anythingyoulike

Like the site that follows, a one-dimensional, light-hearted webpage, this time dedicated to Marvin. If it looks as though it hasn't loaded properly, don't give up – rather direct your attention to the web server error message.

wowbagger.com/insult.htm

Modelled on the *Life, the Universe and Everything* character Wowbagger the Infinitely Prolonged, this entire site is dedicated to generating verbal abuse. It has tremendous breadth too, boasting a repertoire of 6,401,641,950 possible insults. Those accrued in the course of researching this book included "you tremulously squashy spankabitch" and "you tetchily rubber Sonic The Hedgehog".

public champion of the Apple Mac (and gadgets in general). This makes online resources particularly pertinent to *The Hitchhiker's Guide to the Galaxy*. They run the gamut from Japanese fanpage **home.u08.itscom.net/hedgehog** – sadly, all but impenetrable to those who don't speak Japanese – to official sites like eoincolfer.com. Keeping up to date is further complicated by the relatively short

lifespan of some sites. Though M.J. Simpson maintains mjsimpson. co.uk, for instance, his dedicated *Hitchhiker's* site is no longer in existence (although his review of the film, for instance, is still available in archive form at **planetmagrathea.com/shortreview. html**). Here, though, are some of the sub-etha network's most useful *Hitchhiker's* sites at the time of going to press…

BBC.co.uk

A sort of real-life Hitchhiker's Guide, **h2g2.com** (see p.138) was launched by Adams's The Digital Village in 1999 but two years later moved to the BBC. Though Wikipedia has in many ways taken its "creative content written by you" mission statement a whole stage further, it lives on at **bbc.co.uk/dna/h2g2**.

Meanwhile, **bbc.co.uk/radio4/hitchhikers** is dedicated to the Tertiary, Quandary and Quintessential Phases of the radio series. Though no longer being updated, it features interviews with Dirk Maggs, Simon Jones and Geoffrey McGivern, as well as behind-the-scenes video clips. Also not being updated is **bbc.co.uk/cult/ hitchhikers**, which covers the phenomenon in more general terms. It offers a downloadable Babel fish screensaver and various quizzes, including a "Marvin" level that insults you when – inevitably – you get an answer wrong.

Most recently, **bbc.co.uk/blogs/lastchancetosee** follows zoologist Mark Carwardine as he re-creates the trips he and Adams took to observe animals on the edge of extinction, this time with Stephen Fry. The half-shark-half-whale off the coast of Mexico may have been an April Fools' joke, but the expeditions are real enough – also documented on **anotherchancetosee.com**.

ZZ9 Plural Z Alpha

Though it would not become the "official" appreciation society until 1993, ZZ9 Plural Z Alpha has been at the forefront of *Hitchhiker's* fandom ever since its formation in 1980 – the same year the first dedicated convention, Hitchercon 1, took place in Glasgow. Subsequent events include the Lazlar Lyricon convention in 1985 and a follow-up, twentieth-anniversary bash in 1998. Named after the galactic sector that contains planet Earth, the society has also spawned at least two ongoing social occasions: the annual water fight with fans of rival British sci-fi series *Blake's 7* and the annual picnic for Beeblebears (see p.232). Perhaps ZZ9's most lasting contribution, however, at least for the purposes of this chapter, is the *Mostly Harmless* newsletter, first published in 1981 – over a decade before the novel of that name – and still going strong today. This quarterly magazine, only available to members, features news, reviews and interviews, as well as details of the informal meetings known as "slouches".

Douglasadams.com

Once Adams's own site, this is now essentially an archive, although the news section does feature recent events (or rather event, since the focus doesn't seem to extend beyond the annual Douglas Adams Memorial Lecture). It remains an interesting resource, however, reproducing the short story "The Private Life of Genghis Khan" and several works of Adams's non-fiction – including, appropriately, the article "How to Stop Worrying and Learn to Love the Internet". Though the forum is no longer active, it still carries the 9000 messages of condolence which were posted in the wake of Adams's death.

Douglasadams.info

Dedicated to "Life, DNA & H2G2", this site includes up-to-date news as well as a moderately active forum. There are also pieces on Adams's relationship with various subjects – God, science, music

and so on – and exclusive interviews with M.J. Simpson, Nick Webb, Michael Hanlon and even Frank Halford, the teacher who gave young Adams that famous 10 out of 10.

Douglasadams.se

One of the most popular *Hitchhiker's* sites, the Douglas Adams Continuum features a lively forum and exclusive content including interviews and webchats with Nick Webb, Terry Jones, Stephen Fry, Dirk Maggs and Robbie Stamp.

Floor42.com

Offers an active forum although not much else at present, for reasons that – to judge by the greeting message – possibly relate to the recent arrival of a baby. Talk about getting your priorities mixed up.

Hitchhikersmovie.com

This official film website (see opposite) now explodes within a few seconds – apparently the work of a Vogon Destructor Ship – and viewers are led to a "back-up site". Still, those who want to do more than merely order the DVD can access behind-the-scenes photos, *Hitchhiker's* facts, and detailed close-ups (with accompanying text) of the Infinite Improbability Drive. If so inclined, one can also zap bar-top peanuts in the Games section.

Liff.comegetsome.at

Based on *The Meaning of Liff*, this simple site continues that book's matchmaking service for sensations and experiences in need of terms with which to describe them. They're not all in the Adams–Lloyd league, but some are inspired, even if activity seems to have died off somewhat of late. The piece of plastic that separates one person's shopping from that of another on a supermarket checkout conveyor belt should forever be known as a "Bloxham".

ZZ9.org

Home to the "official *Hitchhiker's Guide to the Galaxy* appreciation society". Primarily for members, the site offers themed merchandise and a diary of ZZ9 events. The site is pretty limited unless you join – but at £8 a year for UK citizens, it's not likely to break the bank.

Index

Picture credits

p.5 NASA; p.7 © Dorling Kindersley; p.9 Neil Mersh © Dorling Kindersley; p.14 © Simon Mills/zefa/ Corbis; p.18 John Woodcock © Dorling Kindersley; p.19 Courtesy of Penguin Books; p.21 Dave King © Dorling Kindersley; p.23 Norman Hollands © Dorling Kindersley; p.26 Courtesy of Penguin Books; p.30 © Touchstone/Everett/Moviestore Collection Ltd; p.32 Getty Images; p.34 NILS JORGENSEN/Rex Features; p.38 © Touchstone/Everett/Moviestore Collection Ltd; p.39 Courtesy of Polydor/Depressive Discs; p.45 BBC Image Archive; p.50 Dave King © Dorling Kindersley; p.52 David Ward © Dorling Kindersley; p.53 © Touchstone Pictures/ZUMA/Corbis; p.56 © Dorling Kindersley; p.59 © Peter Buckley; p.60 © Dorling Kindersley; p.60 Giuliano Fornari © Dorling Kindersley; p.62 © Peter Buckley; p.65 Paul Bricknell © Dorling Kindersley; p.66 Michael Spencer © Dorling Kindersley; p.70 Alessandra Santarelli / Jeoff Davis © Dorling Kindersley; p.74 Demetrio Carrasco © Dorling Kindersley; p.78 © Touchstone/Everett/Moviestore Collection Ltd; p.80 Stephen Hayward © Dorling Kindersley; p.83 Akhil Bakshi © Dorling Kindersley; p.87 BBC Image Archive; p.91 Time & Life Pictures/Getty Images; p.92 Steve Gorton © Dorling Kindersley; p.96 NASA; p.101 Courtesy of AppleMothership.com; p.104 © Sophie Bassouls/Sygma/Corbis; p.106 BBC.co.uk; p.111 © Bettmann/CORBIS; p.113 NASA, ESA, R. Massey and California Institute of Technology; p.118 Getty Images; p.123 Ken McKay/Rex Features; p.124 © Touchstone/Everett/Moviestore Collection Ltd; p.129 Stuart Clarke/Rex Features; p.130 Ben Smith/Rex Features; p.134 Rex Features; p.137 Rex Features; p.139 JEREMY YOUNG/Rex Features; p.146 © Hulton-Deutsch Collection/CORBIS; p.144 ITV/Rex Features; p.148 BBC Image Archive; p.150 BBC Image Archive; p.159 Courtesy of Pan Macmillan; p.160 Forbidden Planet; p.162 Courtesy of Pan Macmillan; p.164 Courtesy of Pan Macmillan; p.168 Dave King © Dorling Kindersley; p.169 Courtesy of Pan Macmillan; p.172 Courtesy of Pan Macmillan; p.177 © Tate London, 2009; p.179 NILS JORGENSEN/Rex Features; p.180 © Donald Cooper/Photostage; p.181 Alan Messer/Rex Features; p.189 BBC Image Archive; p.194 BBC Image Archive; p.197 BBC Image Archive; p.198 BBC Image Archive; p.200 BBC Image Archive; p.206 © Rex Features; p.209 © Touchstone/Everett/Rex Features; p.210 © Touchstone/Everett/Rex Features; p.212 © Touchstone/Everett/Rex Features; p.219 Starshiptitanic.com; p.225 © Dorling Kindersley; p.226 Courtesy of Random House Audio; p.230 Courtesy of Harmony Books; p.232 Jim Mowatt; p.236 Courtesy of Benbella Books; p.237 Courtesy of Pocket Essentials; p.242 Courtesy of Simon and Schuster; p.245 Courtesy of Del Rey Books; p.250 Courtesy of ZZ9.org; p.251 Douglasadams.info; p.253 Hitchhikersmovie.com.

Index

Index

Index

off
off
off

Index

Index

DON'T PANIC!

And don't miss the least expected comeback of all space and time

DOUGLAS ADAMS'
HITCHHIKER'S GUIDE TO THE GALAXY
PART SIX OF THREE

by
EOIN COLFER

EXPECTED
12.10.09

www.6of3.com